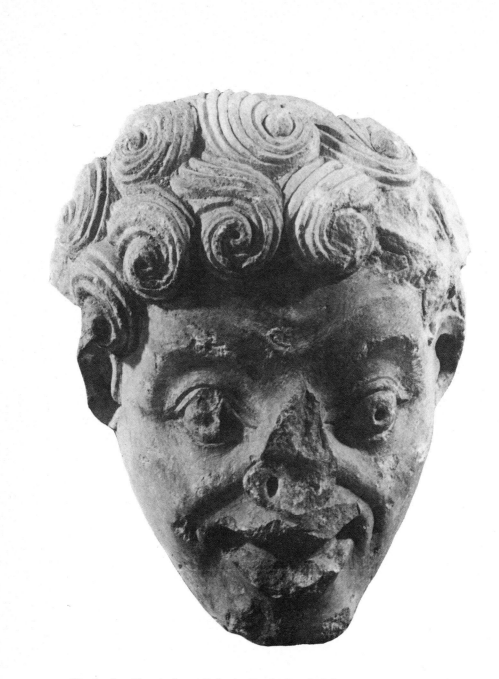

Head of a Youth from Belvoir Castle, Rockefeller Museum, Jerusalem

CRUSADER
FIGURAL SCULPTURE
IN THE
HOLY LAND

CRUSADER FIGURAL SCULPTURE IN THE HOLY LAND

Twelfth century examples from Acre
Nazareth and Belvoir Castle by

Moshe Barasch

Rutgers University Press
New Brunswick, New Jersey

ISBN 08135–6680–8
Library of Congress Catalogue
card number 74-129513
International Copyright © 1971 by
Massada Press Ltd., Ramat Gan

Designed by Asher Oron

Printed in Israel by
Peli Printing Works Ltd., Givatayim.

CONTENTS

LIST OF ILLUSTRATIONS

PREFACE

The purpose of this study is to present some works of Crusader figural sculpture that have survived in the Holy Land. Most of the works discussed here have not yet been published (Chapters One, Four and Five), some of them have only recently been excavated (Chapter Four). Among sculptures already known only two have been included (Chapters Two and Three), but of these the new and detailed photographs supplied may prove useful to scholars of medieval art.

It should be clear from the outset that this book does not aim at a comprehensive analysis of Crusader figural sculpture (of which I have completely excluded ornamental sculpture), nor does it claim to completeness in the presentation of the material. At the present moment a comprehensive analysis of this art cannot be attempted since the material at our disposal is too fragmentary to permit the drawing of broad outlines or to reach definite conclusions. In this respect one may safely assume that systematic excavations will bring to light new works and reveal new aspects. However, the sculptures that have come down to us are worth studying both for their intrinsic value as individual works of art, and for what they reveal of Romanesque sculpture in the West.

The study of Crusader art in the Holy Land often poses specific and difficult problems. The works of art created in the comparatively short period, and in the rather narrow area of the Latin Kingdom, reflect the multitude of trends current in European art of the twelfth century. The Crusaders, coming from various parts of Europe, carried with them different, highly crystallized artistic heritages. They never succeeded in blending these traditions, or in fully absorbing and recreating the motifs which they encountered in the East. Thus the limited area and period of their creation stands in marked contrast to the wide spectrum of stylistic tendencies to be traced in their works. With this

situation in mind one is often tempted to ask whether it is at all permitted to use the term "Crusader art" with the implied intention of establishing a certain, more or less definite, image of style, or whether we should not simply speak of the artistic production of the Crusaders, characterized only by the specific historical conditions in which the works were created.

This general problem becomes particularly clear when studying figural sculpture. The lack of a distinctive character in Crusader art varies in degree according to the medium. In the illumination of manuscripts the artists of the Latin Kingdom were deeply influenced by Byzantine models and traditions, and succeeded, to a higher degree than in all the other fields, in combining these "Eastern" elements with their own, Western heritage. In consequence, they developed a style which, to a certain degree, can be regarded as specific of Crusader art.[1] In the realm of icon painting, with which we are still insufficiently acquainted, one also finds attempts to combine Western traditions with Byzantine models, resulting in a certain quality which, as it has no exact counterpart in the West or in the East, may be considered characteristic of Crusader art and culture.[2] Crusader sculpture, however, does not seem to have effected a synthesis of East and West. The sculptors who came from western or southern Europe to the Holy Land did not find there a sculptural tradition comparable in achievement and crystallization to book illumination or panel painting. Perhaps for this reason Crusader sculpture in the Holy Land remained more pronouncedly Western than did the other visual arts. Moreover, as no unified and lasting school of sculpture seems to have emerged in the Holy Land, the different Western traditions did not blend. The pieces of sculpture produced in the Latin Kingdom in the twelfth century usually bear the imprint of a particular Western school or regional tradition, and the origin of the sculptor can sometimes be established.

This situation necessitates the separate study of each work of Crusader sculpture. In the course of our investigation we should bear in mind that all the works discussed in the following chapters originated in a

1 Cf. H. Buchthal, *Miniature Painting in the Latin Kingdom of Jerusalem* (Oxford, 1957), *passim*.
2 See the studies of the Sinai icons by Professor Kurt Weitzmann, particularly "Icon Painting in the Crusader Kingdom," *Dumbarton Oaks Papers*, xx (1965), pp. 51–83; *idem.*, "Thirteenth Century Crusader Icons of Mount Sinai," *Art Bulletin*, xiv (1963), pp. 179–203. Only after the corpus of the Sinai icons is published will it be possible to establish in greater detail the position of Crusader icon painting between Eastern and Western traditions.

rather limited area of the Crusader Kingdom. They were all found, and – as I shall attempt to show – were also carved, in three places, i.e., Acre, Nazareth, and Belvoir Castle. Hence it is in these three places, not too distant from each other, that the multitude of sources and traditions is reflected.

While engaged in the preparation of this study I had the privilege of discussing some of the problems involved with several scholars. Needless to say, I alone am responsible for all shortcomings or errors. In the illustrations I have attempted to present the Crusader material as fully as possible. Works of art cited for comparison have therefore not been reproduced, the few exceptions representing works that are not well known, or not easily accessible.

In addition to acknowledgement made at the proper place I wish to express here my gratitude to the museums and other institutions for kindly allowing me to study works in their possession and prepare photographs. I am also grateful to the Israel Exploration Society for cooperation in the preparation of this study. I would further like to express here my appreciation to Mr. Meir Ben-Dov in placing at my disposal the materials he excavated in Belvoir Castle (Chapter Four), for providing photographs of the works, and above all for permission granted to publish these finds even before he himself has presented them in his report on the excavation campaign.

Finally, I should like to thank Mr. Gershon Polak, the executive publisher; Mrs. Yvonne Eshanu for her patient and careful copy-editing; Mr. Asher Oron who gave the book its graphic form; Mrs. Mira Reich who assisted in editing; Mr. Hillel Burger who was responsible for taking many of the photographs; and Mr. Gustav Kühnel who prepared the bibliography.

Moshe Barasch

Jerusalem 31 March, 1971

11

A
HOLY-WATER
BASIN
IN ACRE

I

Some twenty years ago a small vessel was found in Acre,[1] a work of Crusader sculpture of the early twelfth century similar to vessels to be found in several places in Europe. Originally these basins usually served either as holy-water basins or as that liturgical implement known as *piscina*. Our vessel was found in a garden not far from the so-called crypt of St. John in Acre. However, no proof, or clear indication was found enabling us to assume that the vessel has been taken from the crypt, which it probably antedates.[2] Neither does the stratification of the site where the vessel was found provide any further clue as to its provenience. The vessel bears no inscription that might help us in tracing its origin, and, of course, no document can be related to it. The origin of this interesting object being consequently rather obscure, its study relies almost exclusively on analysis of its iconography and style. I shall begin with a short description.

The vessel is carved in a greyish stone, common in the region of Acre, it is round in shape, its radius being 27 cm. (10.53 in.). It has a slightly protruding spout allowing the water to flow out, a feature often found in twelfth century *piscinae*.[3] In looking at the vessel, our interest is

1 This chapter has made the subject of a lecture delivered at the Israel Academy of Sciences and Humanities. The finding was published in a brief notice by Dr. Z. Goldmann, director of the Museum in Acre, in *Maaravo shel ha-Galil* (1961), pp. 159–160 (Hebrew).

2 The term "crypt" is here, of course, a misnomer; originally the hall served as a refectory. The early Gothic elements of its construction clearly show that it cannot antedate the middle of the twelfth century. Cf. Z. Goldmann, "The Hospice of the Knights of St. John in Akko," *Archaeology*, xix (1966), pp. 182–189. For the churches of Acre cf. C. Enlart, *Les Monuments des Croisés dans le Royaume de Jérusalem* (Paris, 1928), ii, pp. 2–35. When Enlart wrote his work the "crypt" had not yet been cleared.

3 C. Enlart, *Manuel d'archéologie française*, 2nd ed. (Paris, 1920), i, p. 857 ff., adduces only later examples of similar vessels with a beak. He mentions also two similar basins (although of the fourteenth century) in Franciscan churches at Famagusta, Cyprus. For the relationship between Crusader art in the Holy Land and in Cyprus, especially in Famagusta, cf. Enlart, *Les Monuments des Croisés*, ii, pp. 21, 27. The history of the holy-water basin in medieval art still remains to be written.

15

captured by the relief—heads and flowers—that adorn it. On both sides

Figs. 1, 2 of the vessel (figs. 1, 2) bulky heads stand out from the wall; one face
Fig. 3 presents a sad, gloomy expression (fig. 3), the other is illuminated by a
Fig. 4 radiant smile (fig. 4). The style of these heads may be described as
"archaic." By using this term I do not mean a level of achievement; I
rather mean to suggest an artistic type. In spite of the lively and con-
trasting expressions that characterize the faces, and of some other
naturalistic elements of representation, the faces are quite remote from
nature. It is even difficult to state whether these are beardless male, or
female faces. It is, however, obvious that the same face is portrayed on
both sides of the basin, or else that models of the same type were used
for both heads. This close physiognomic resemblance of the two faces
emphasizes the difference of countenance; it shows that the main pur-
pose of the artist was the expression of opposite emotions, or states of
mind, of sadness and joy, of weeping and smiling.

The common structure of the two heads can easily be described. They
are round, bulky masses, the outlines of which form almost perfect
Fig. 3 circles (particularly clear in the sad face, fig. 3). The faces are broad
and fleshy, nowhere revealing the bony structure. The hair is a com-
Fig. 4 pact, almost amorphous mass. On one head (fig. 4) some rather
shallow chisel marks can be seen, vaguely indicating an ornamental
Fig. 3 pattern; on the other head (fig. 3) the hair is completely smooth,
showing no attempt at carving locks or strands. The forehead is low
and smooth, undisturbed by wrinkles or other modulations. The eye-
brows are a highly stylized geometrical pattern. The eye is an abstract
design, the complexity of which is revealed only upon close observation.
It consists of independent and well-defined elements that do not over-
lap or encroach. The lids, each a separate member, are outlined by
Fig. 4 clear-cut contours (best seen in the smiling face, fig. 4) together form-
ing an elliptical shape. Contrary to nature, the upper lid is straighter
than the lower one, clearly showing that the shape of the eye was not
observed from nature but was drawn from the fund of traditional
artistic formulae. The linear, graphic pattern of the eye is somewhat
obscured by the protuberant, bulging eyeball that lends it a rather
plastic character. The somewhat slanting position of the eyes, lending
the whole face a certain "oriental" character (see especially the sad
face), is perhaps also derived from some artistic tradition.[4]

4 See, for example, the face of the Cross-bearing Christ in the "Tomba di Rotari" (lintel of the
western portal of the church in Monte S. Angelo (Foggia) (cf. A. Kingsley-Porter, *Romanesque*

16

The eyeballs themselves, although protuberant, are smooth; the artist has made no attempt to drill holes for pupils. The plastic character of the eyeballs stands in marked contrast to the linear conception of the lids and other portions in the two faces.[5] The lack of holes for pupils cannot be explained, I believe, by assuming that the vessel was not finished. Actually, no clearly unfinished part can be detected in the whole vessel. Moreover, the smooth, massive character of the eyeballs fits in perfectly with the almost equally smooth, massive character of the hair, and — more generally — of the face as a whole. The contrast between smooth, projecting mass and sharply incised line should be understood here as a consistently applied artistic principle.

The nose is of a particular shape: large and flat, by far exceeding both natural proportions or any of the well-known canons that governed the representation of the human face. Its size and shape, although basically unaltered, are marvellously adapted to the need of expressing different moods: in the sad figure the bulk of the nose dominates the whole face, while in the smiling figure the chin and the mouth are accorded greater prominence. In the latter, a deeply carved furrow runs from nose to mouth (especially in the right half of the face), emphasizing the ascending arc of the lips, which is the formula of smiling.

In both faces the mouth is clearly the focus of expression. In the representation of the lips the artist surprises us by his fine, immediate observation of curves, of concavities and prominences in nature, although he never completely abandons traditional formulae. The smiling mouth reminds us better of a well established formula than the mouth of the sad face. However, neither in the smiling face has the formula been taken over mechanically. The artist, who here reveals himself as a master with an intimate knowledge of the formula, has recreated it with remarkable inventiveness both in the general pattern and in details. The line separating the lips—which may be considered the core of the visual formula of smiling—is clearly asymmetrical,

Sculpture of the Pilgrimage Roads [1923], ill. 198). Here the eyes slant up towards the center of the face. See also the face of the angel wrestling with Jacob in the Cathedral of Trani (cf. Kingsley Porter, ills. 204–205), and one of the faces decorating the apse of S. Lionardo di Siponto; cf. A. Petrucci, *Cattedrali di Puglia,* 2nd ed. [Rome, 1964], pl. 50). The slanting position of the eyes in Romanesque sculpture is however not restricted to South-Italian art. Cf. Meyer-Schapiro "The Romanesque Sculpture of Moissac," *Art Bulletin,* xiii (1931), p. 270, note 59, where the oblique position of the eyes is regarded as an element of "archaic art," both Greek and Romanesque.

5 See especially the ears which are represented by sharp but shallow lines.

corresponding to, and emphasizing the asymmetry of the whole face. The corners of the mouth are not equally raised, the right corner being considerably higher than the left one. Since the left eyebrow is higher than the right, the left side of the face shows a greater distance between eyebrow and mouth corner than the right one. This asymmetry is emphasized by the deep furrow from nose to mouth in the right half of the face, optically further shortening the right side. The rim of the lips is not drawn at all, the soft transition clearly contrasting with the rather sharp outlining of the eyelids. The edge of the lower lip is suggested by the undercutting that creates deep shadows which, however, form a wide and irregular area rather than a line. At the upper lip even this slight suggestion is omitted. Instead of a line we see here a rugged, uneven surface, an area that is of definitely non-linear, "pictural" character.

The mouth of the sad face is even more suggestive, immediate in expression, and remarkably free of stereotyped formulae. The usual formula of sadness and dejection was the mouth with the line separating the lips descending at the corner.[6] In our vessel the lips of the sad face are not pulled down at all. The strong expression of sadness is attained by other, more sophisticated means, more difficult to isolate and to analyze exactly. In comparison with the smiling mouth, the lips of the sad face are thin, and look as if they were pressed together. Remarkable is the irregular separation line of the lips which does not seem to have been copied from a traditional model, but is probably the creation (perhaps based on the observation of nature) of an original artist. It is also interesting to note that he used the whole area around the mouth to suggest the opposed moods. Compare, for example, the chin in both faces; in the smiling face the chin is quite large, jutting, and rather smoothly polished; the chin of the sad face is short, receding, wrinkled and of a rugged texture. Only in few medieval works of sculpture is the chin similarly treated to achieve expressive effects. A close observation of the relationship between the vessel as a whole and the two heads reveals both a certain stylistic attitude, and the artist's consistency in combining formal and iconographic motifs.

The surface of the vessel is well rounded and rather smooth; it shows neither lumps nor deep hollows. The heads, on the other hand, are projecting and of considerable mass. In spite of this obvious difference,

6 As far as I know, no study was written about these physiognomic formulae in medieval art.

18

the artist did not mark the limit between the heads and the body of the vessel by any line or other graphic means. Nor can one detect any significant difference of texture between the faces and the wall of the basin itself. The surface of the vessel and that of the heads is of a similar degree of smoothness, and it is obvious that the stone has been similarly treated in all parts of the basin, carved and non-carved alike. It is thus only the volume of the heads that distinguishes them from the vessel itself. Describing this relationship in art-historical terms we might say that the heads are not placed "in front" of the basin, its bare surface serving merely as a "background." Such a description would imply that the vessel and the heads are separated, that they are of a different character, texture, and the like. Since this is not the case, we should rather say that the heads are nothing but an "outcrop" of the vessel itself, or a kind of "condensation" of the stone.[7] This betrays an eminently sculptural approach which avoids purely optical effects or graphic means (such as texture or outlines).

The exact position of the heads shows some variation which, although slight, deserves close attention. The heads occupy almost the whole height of the vessel wall but there are narrow strips of bare surface forming a separation between the heads and the edges of the basin. Interestingly enough, these bits of empty surface are not to be found at the same place on both sides. The chin of the head with the sad expression (which, as already said, is very short) reaches the lower edge of the vessel, while above it there is left a narrow strip of smooth, bare surface. The opposite is true for the smiling face. Here the hair merges with the rim of the basin, while below the head we see a comparatively large portion of bare space. In other words, the sad head occupies a lower, the smiling a higher position. The artist, then, exploits the intrinsic meanings of "high" and "low," granting them, so to speak, an emotional reality connecting the high with an expression of joy and the low with an expression of sadness. The consistent concordance of a certain facial expression with a certain meaningful position (smiling with the higher, sadness with the lower place) precludes, I think, any possibility of chance. We are faced here with an artist who masters the various means of expression, or else with a fully crystallized tradition.

An additional feature of our basin are the flowers that symmetrically

7 I am applying here the concepts developed by E. Panofsky in his *Die deutsche Plastik des elften bis dreizehnten Jahrhunderts* (Munich, 1924), p. 12 ff.

19

flank the heads. Although the flowers project considerably less than the heads, they have, in carving and in relationship to background, a quality in common with them.

A remarkable fact about the flowers is their diversity. The smiling

Fig. 2

face (fig. 2) is flanked by two fully blooming, open flowers; these flowers are completely self-contained sculptural forms, like the head

Fig. 1

between them. The flowers framing the sad face (fig. 1) are different. They are obviously flatter. One flower, to the right of the face, is of the same type as those adorning the smiling face, but besides being flatter, it also has a considerably larger number of smaller leaves, and the whole form is less prominent and self-contained. The flower to the left of the sad face is of a different type. Do the differences in form and "expression" of the flowers have any significance? Do they supplement the expression of the faces? This is a question to be dealt with later.

II

The decoration of the Acre vessel, although not often encountered, does not seem to be an isolated phenomenon. In the Romanesque period, holy-water basins and similar liturgical objects were sometimes adorned with carved heads, and in some cases a certain stylistic affinity to our vessel may even be perceived. As far as I know, the figurative decorations of liturgical vessels produced in that period have not been systematically studied.[8] Neither do I claim that the few objects which I shall mention in this section constitute a representative sampling of such decorations in Romanesque art. Moreover, our examples are scattered over too wide a geographical area, and are of too diverse an artistic form and composition to suggest — even slightly — a crystallized tradition. They may, nevertheless, show that the heads of the vessel of Acre belong to a broad realm of imagery which, in Romanesque art, has certain common artistic elements and perhaps also a common spiritual background.

A first example is the holy-water basin in Chamalières (Haute Loire), a work of the twelfth century.[9] In the niches carved in it four figures are represented. From the point of view of form and composition we cannot, of course, compare the small vessel of Acre, showing two isolated faces, with the monumental basin of Chamalières, where four standing, almost life-size figures are represented full length. However, the

8 The *piscina* has a venerable history in the Christian Church. Gregory of Tours mentions it in *De virtutibus S. Martini,* ii (cf. Enlart, *Manuel,* i, p. 861). Interesting material may be found in V. H. Elbern, "Der eucharistische Kelch im frühen Mittelalter," *Zeitschrift des deutschen Vereins für Kunstwissenschaft,* xvii (1963), pp. 1–76, 117–188. Cf. also Enlart, *Manuel,* i, pp. 857–861, 878–902. For earlier periods, see Cabrol-Leclerq, *Dictionnaire d'archéologie chrétienne et de liturgie,* ii, i, col. 72 ff. (s.v. "Bains"), and Daremberg-Saglio, *Dictionnaire des antiquités grecques et romaines,* s.v. "balneum." See also J. Braun, *Das christliche Altargerät in seinem Sein und seiner Entwicklung,* (Munich, 1932).
9 Kingsley Porter, *Romanesque Sculpture of the Pilgrimage Roads,* ills. 1153–56.

Chamalières font shows that liturgical objects of this type could be adorned with figures. There is perhaps even a certain, very general, similarity of tendencies in the style. The rather soft carving, the emphasizing of round, projecting masses in the heads of the Chamalières figures recall the heads of the Acre vessel. Although this similarity should not be pressed too far, it is in our context perhaps not altogether meaningless that the holy-water basin of Chamalières probably originated in Italy.[10] In iconography, the two works differ widely. Not only has the Acre vessel two heads while the basin of Chamalières portrays four figures, but in the latter the two opposite moods of sadness and joy are not even suggested. As far as can be seen, the faces of all the four figures bear the same serious, serene expression.

Some twelfth century baptismal fonts of French origin are decorated with isolated faces. At Cluny, for example, such a basin, of modest proportions, is adorned with four heads surrounded by a rich floral ornamentation. These heads have been interpreted as the personifications of the four cardinal virtues.[11] Another French example is the baptismal font of Charenge (Nord) decorated with strongly projecting heads.[12] The specific physiognomic motifs of smiling and crying do not appear in them.

Interesting examples of holy-water basins or baptismal fonts decorated with carved heads originate from Italy, especially from the Adriatic coastal districts.

Fig. 5 Remarkable is a holy-water basin in the Cathedral of Torcello (fig. 5), probably a work of the late eleventh century, of which little seems to be known.[13] At the top of a half-column four seated — or standing — Atlas-like figures support the large basin.[14] The vessel itself is decorated at the rim with a floral ornament that recalls certain late classical forms. From the wall of the basin four heads emerge. Between

10 Kingsley Porter, *Romanesque Sculpture*, p. 225, believes that the Chamalières basin is one of Niccolo's works, and dates it to the Ferrarese period of this artist. P. Toesca, *Storia dell' arte italiana*, i, *Il Medicevo* (Turin, 1927), p. 887, note 14, describes it as "in the manner" of Niccolo. Geza de Francovich, *Benedetto Antelami* (Milan-Florence, 1952), i, p. 476, note 38, sees in it a Tolosan influence.

11 Viollet-le-Duc, *Dictionnaire raisonné de l'architecture*, v, p. 539.

12 Reproduced by Enlart, *Manuel*, fig. 442.

13 I was unable to find a scholarly investigation of this basin. For a short description, cf. the guidebook by G. Masolino, *Torcello: The Jewel of the Lagoon* (Venice, 1964), p. 26.

14 For supporting figures in medieval art continuing the classical Atlas-motif, cf. H. von Einem, *Das Stützengeschoss der Pisaner Domkanzel* (Arbeitsgemeinschaft für Forschung des Landes Nordrhein-Westfalen, Heft 106) (1962), p. 37 ff.; F. Saxl, "Atlas der Titan im Dienste der astrologischen Erdkunde," *Imprimatur*, iv, 1933, p. 44 ff.; J. Seznec, *The Survival of the Pagan*

them, that is, in the position where the artist of the Acre vessel carved flowers, are represented apes tumbling, or climbing down. Owing to the vessel's location in the cathedral (it is placed near a wall) I was not able to observe all the four faces closely; only one head which is clearly visible can be carefully studied. Concentrating our attention on this head we find, of course, many differences in style and proportion between the basins of Torcello and of Acre. In Torcello the heads are smaller in proportion, when compared to the vessel as a whole, than in Acre; the carving seems to be more pointed and linear, and the artist seems to have made some rather hesitant attempts to use the drill.[15] There are also similarities between the two works in general conception as well as in carving. The faces bear a certain physiognomic resemblance. As in the Acre vessel, the faces on the holy-water basin of Torcello are full, the nose is broad and flat, the eyebrows arched, and the ball-like eyes protuberant. The one face that is clearly visible has a strongly emphasized expression of gloom and sadness. In spite of all the stylistic differences, a certain similarity in conception — perhaps a distant family-likeness — to the faces in Acre cannot be overlooked. Particularly noteworthy, I think, is the prominence and carving of the mouth, which is of an irregular shape. Another common element is the short chin. I have already mentioned the short chin as a significant physiognomic feature in the sad face of the Acre vessel. In the Torcello basin the shortness of the chin is further emphasized by the slightly slanting position of the head which places the chin in deep shadow, hiding it, so to speak, from the beholder. It is conceivable, I think, that in medieval art the short chin was a traditional motif in depicting a sad face.

Another remarkable holy-water basin, an Italian work of the late eleventh century, may be seen in the Cathedral of Borgo San Donnino. According to some scholars, it also served as a baptismal font.[16] The

Gods (Kingsport, 1953), pp. 15, 22; E. Panofsky, *Studies in Iconology* (New-York, 1939), p. 20, note 10; Gh. Seymour, "XIII Century Sculpture at Noyon and the Development of the Gothic Caryatid," *Gazette des beaux arts*, 1944, ii, p. 173 ff. (None of these studies, however, deals with the Atlas-motif in connection with baptismal fonts or holy-water basins). For the ancient source of the supporting figures, cf. G. Thiele, *Antike Himmelsbilder* (Berlin, 1898), p. 17 ff.

15 See the small but sharply drilled holes in the eyes of the face shown on our reproduction (fig. 5) and the holes in the eyes of the ape.

16 Reproduced by Francovich, *Benedetto Antelami*, ii, fig. 433 (pl. 261). For its use as a baptismal font, cf. *Benedetto Antelami* i, p. 373 ff.; Kingsley Porter, *Lombard Architecture* (New Haven, 1917), ii, p. 173 ff., interprets the scene represented as a kind of memorial tablet commemorating the granting of privileges by Alexander II (1061–1073) to the Church of Borgo. If this interpretation is correct, this would represent a rather unusual type of holy-water basin decoration.

large basin is borne by an Atlas figure of great expressive force resting on a pillar. The whole circumference of the vessel itself is decorated with groups of half-length figures, apparently representing four scenes of a ritual character; the benediction of a novice nun, and the consecration of the holy-water. In the last mentioned scene there appears, as some scholars believe, the figure of Pope Alexander II who prescribed the use of holy-water.[17] In its general pattern this work may have been influenced to some degree by a holy-water basin in the cloisters of St. Trophime at Arles, which also displays a figure bearing the basin.[18] The sculptor of the holy-water basin of Borgo San Donnino emphasized expressive movements and gestures, but he did not concentrate on facial expressions, hence the specific features of sadness and smiling are not to be found in the decoration of this basin.

Interesting in the present context is yet another holy-water basin from
Fig. 6 Pomposa (fig. 6),[19] an Italian town roughly midway between Torcello and Ravenna. This basin is supported by four crouching figures. Their faces, which are primitively carved, seem to bear a sad, or grave expression.

Another example which should be mentioned in our context, although it is somewhat later in date, is a holy-water basin in the church of Soleto in Apulia.[20] In its basic pattern and in decorative conception, this basin differs in many respects from the vessel of Acre. The octagonal Soleto basin rests on a half-column, and is covered by a rich and highly stylized ornamentation. From among the decorative tendrils and bands four heads emerge. Contrary to the Acre vessel, the heads of the Soleto basin are not treated in the same manner as the background; here heads and background are clearly separated and distinguished from each other both by outlines and by a difference in texture. The faces themselves are of different types: in Soleto the faces are oblong while in Acre they are almost round. It is, however, remarkable that in one of the faces of the Soleto basin the expression of smiling is strongly emphasized by the formula of the mouth with corners turned upwards. This basin, is, as already mentioned, the creation of a later period, probably of the late thirteenth century,[21] but it seems to reflect

17 Cf. Francovich, *Benedetto Antelami,* i, p. 372, note.
18 For a reproduction see Francovich, *Benedetto Antelami,* i, fig. cxliv a (p. 423).
19 I am grateful to Dr. Eva Baer for providing a photograph of this basin (our fig. 6).
20 Cf. Petrucci, *Cattearali di Puglia,* fig. 283.
21 Petrucci, *Cattedrali di Puglia,* p. 558, believes this basin to be a work of the fourteenth century.

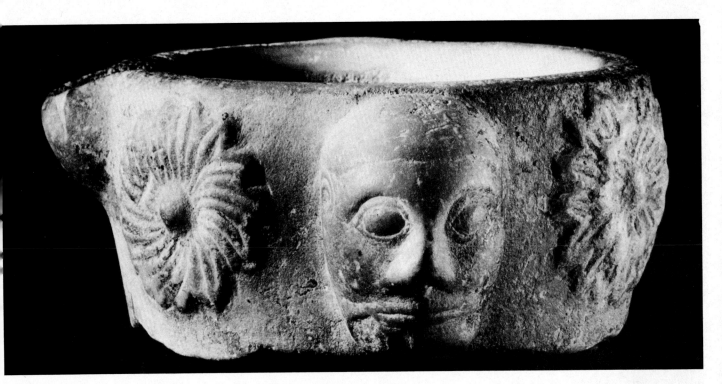

1. Holy-water basin, Municipal Museum, Acre.

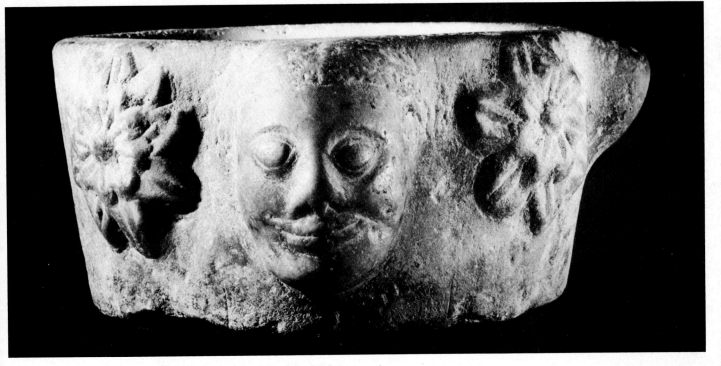

2 Holy-water basin, Municipal Museum, Acre.

25

Next two pages:
3 Left—Holy-water basin, detail (the sad face), Municipal Museum, Acre.
4 Right—Holy-water basin, detail (the smiling face), Municipal Museum, Acre.

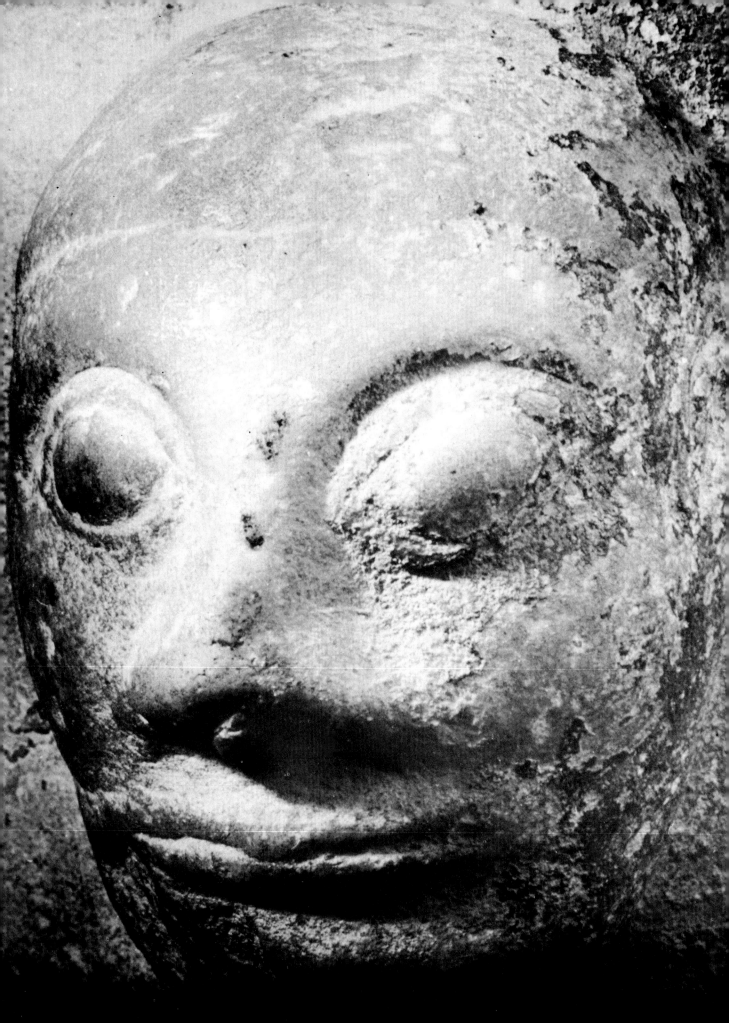

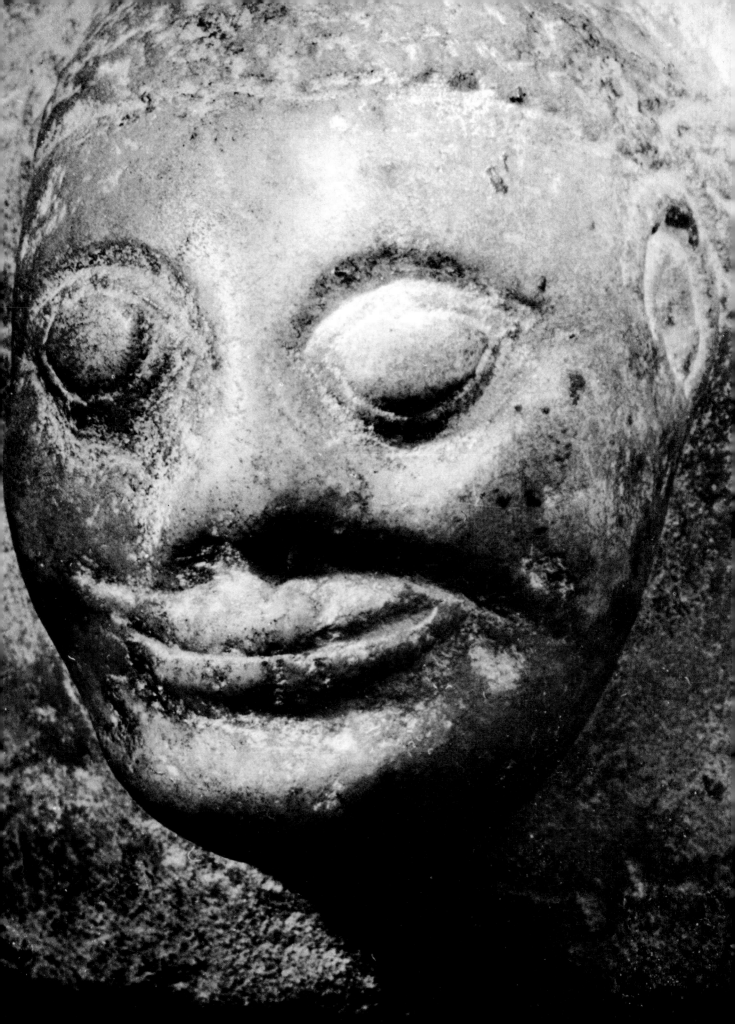

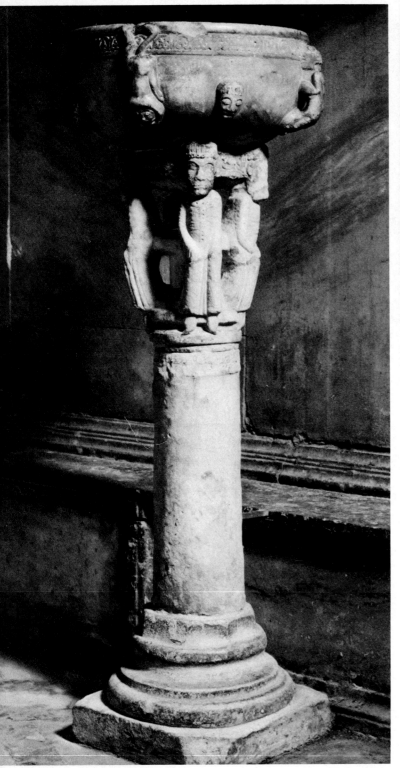

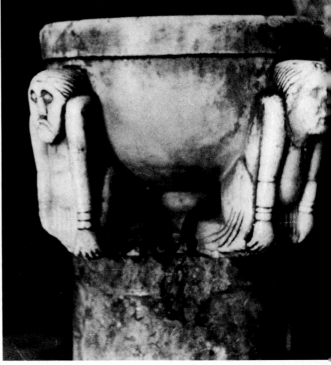

5 Left—Holy-water basin, Torcello Cathedral.
6 Top—Holy-water basin, Pomposa Church.

28

a South-Italian tradition that may go back to earlier times. In this connection it is worth recalling that in southern Italy remnants of the Graeco-Roman tradition of the *hermae* never completely disappeared, and this tradition may have kept certain physiognomic formulae alive. In the Cathedral of Taranto, for example, a large Graeco-Roman *conca*, resting on four nude female busts, was probably used in the Middle Ages as a holy-water basin.[22]

In our present context it should also be recalled that isolated heads and faces are sometimes found as motifs in church decoration, on capitals for instance. (I refer, of course, only to isolated human heads that do not suggest a body, and which do not fulfill any additional function in the composition. I leave out both the manifold forms of beasts' heads that populate Romanesque churches, as well as the human heads which serve as pedestals, etc.). I shall mention a few examples in which those faces bear a strong emotional expression recalling that of the Acre vessel:

1. A capital in the nave of St. Androche at Saulieu (Côte d'Or) displays acanthus leaves ending, or crystallizing in faces. The strong physiognomic expression of the faces agrees well with the naturalistic tendencies in the representation of the foliage. However, the faces have a certain classic, masklike character that goes beyond any naturalistic representation.[23]

2. Another interesting example is an early thirteenth century capital from the campanile of Badia, now in the Bargello in Florence.[24] It is decorated with four heads, but only two of them are clearly visible. One of these faces is sad and gloomy, the other is happily smiling.

22 Petrucci, *Cattedrali*, fig. 223. In this context one should also remember the influence of ancient sarcophagi on baptismal fonts and similar implements. Enlart, *Manuel*, p. 898, notes 3, 4, gives a list of French baptismal fonts of the twelfth century that faithfully reproduce ornaments typical of sarcophagi (strigilation and undulating cannelures). Enlart, *Manuel*, also believes that some of the decorative masks found on baptismal fonts of the period are carved at an angle similar to the ones that were carved on the sarcophagi.

23 Cf. Kingsley Porter, *Romanesque Sculpture of the Pilgrimage Roads,* ill. 58, and pp. 87 ff., 114 ff. This motif, needless to say, is widely diffused in medieval art, and is encountered also in Italy. Cf., for example, the so-called "Capitello dei Mascheroni" in the Duomo of Modena, ascribed to Wiligelmus (see R. Salvini, *Wiligelmo e le origini della scultura romanica* [Milan, n.d.], fig. 56, and p. 93). For the broad context cf. also J. Adhémar, *Influences antiques dans l'art du Moyen Age français* (Studies of the Warburg Institute, vii) (London, 1939), p. 168 ff. For this and the following example it may be worth recalling that some twelfth century baptismal fonts are carved in the form of capitals – cf. Enlart, *Manuel,* p. 890, note 2, for a list of French examples.

24 Inv. no. 356. As far as I know, this capital as well as the one mentioned in the following note have not been published.

Flowers are carved between the faces, not constituting a continuous ornament (as in the basin of Soleto) but as isolated motifs on a bare or smooth surface, recalling the arrangement of the flowers on the vessel of Acre. Another capital, also from Badia, bears only a smiling —actually a laughing—face.[25]

On corbels and façades isolated faces are found even more frequently. Again a few examples will suffice for our purpose:

1. On the southern façade of St. Sernin in Toulouse, the volutes are decorated with two heads: to the right the head of a prophet (?) to the left the head of a rapacious animal (wolf?). Although they differ in style from our vessel, the representation of extreme contrasts by means of isolated heads is remarkable.[26] A similar juxtaposition may be found on the façade of Notre-Dame-de-Beaucaire (Gard) where the head of a saint or prophet is represented on the right, and the head of a horse (?) on the left.[27]

2. A row of faces is represented on the western portal of Montsaunes (Haute Garonne). The heads are grouped in pairs both by their position on the wall and in the slight movement, or angle, at which they are turned to each other. As far as can be seen, the faces bear a strong emotional expression.[28]

3. The façade of the Cathedral of Ruvo di Puglia is decorated by a row of heads (heads of animals alternating with human heads). Among the human heads there is at least one face clearly expressing gloom and another which is smiling.[29]

As already pointed out, the above mentioned examples do not represent a survey, or even a representative list of the multitude of physiognomic motifs that are found on liturgical objects or on the walls of churches. A systematic collection and careful investigation of the vast material to which our examples belong would probably lead to interesting results. Even on the basis of our few examples, however, some tentative conclusions can be drawn.

First, holy-water basins and related liturgical objects do not show a

25 Inv. no. 357.
26 Kingsley Porter, *Romanesque Sculpture,* ill. 319.
27 Kingsley Porter, ill. 1292.
28 Kingsley Porter, ill. 505. Cf. also the heads decorating the corbels of the southern transept in the Cathedral of Maguelonne (Kingsley Porter, ills. 1285–86) which differ in style from the faces of the Acre vessel, but show a certain element of contrast in expression.
29 Petrucci, *Cattedrali di Puglia,* fig. 146.

single, or even prominent, type of decoration,[30] but figures, or heads
do sometimes occur on such basins.

Second, isolated heads, in certain cases of a strong emotional expres-
sion and even juxtaposing sadness and smiling, are sometimes carved
on liturgical objects of the twelfth century. The artist of the Acre vessel
could, then, draw such images from several European traditions.

30 Viollet-le-Duc, *Dictionnaire*, v. p. 538, stresses that in the decoration of these implements the
artists enjoyed more freedom than in other fields. In this connection it is interesting to observe
that the holy-water basin is one of the few liturgical implements discussed by Durandus, that
careful liturgist of the thirteenth century. Cf. J. Sauer, *Symbolik des Kirchengebäudes und seiner
Ausstattung in der Auffassung des Mittelalters* (Freiburg, 1902), p. 209.

III

Having established, in very broad and general outlines, the artistic and liturgical realm to which our vessel may be related, we now turn to the question of its meaning, and primarily to the meaning of its decoration. Before entering into a more detailed discussion of the specific iconographic problems posed by the holy-water basin of Acre, a few general remarks may prove useful.

In medieval art there does not seem to have existed a crystallized iconographic tradition in decorating holy-water basins and related liturgical objects. Although these objects — baptismal fonts, holy-water basins, *piscinae* for the washing of the priest's hands and of the chalice after use in the Mass — fulfill different liturgical functions, their iconography seems to be interrelated, and, to a large degree, inspired by the same ideas and images.[31]

The rather wide range of the imagery on these vessels probably has several explanations. It should be borne in mind that some of the basins which actually served as baptismal fonts were not created for that purpose. Even in the eleventh and twelfth centuries, the main period in the production of baptismal fonts,[32] some of the holy-water basins and baptismal fonts in use were in fact of older origin, their initial purpose having been an altogether different one.[33] As some of these objects were decorated, this fact must obviously have exerted a certain influence on the iconography of the whole group of liturgical imple-

31 It might be worthwhile mentioning in this context that in the so-called *"Gelasianum"* the formula of consecrating the holy-water exactly corresponds to the formula of consecrating the water of baptism. Cf. Ernst Schlee, *Die Ikonographie der Paradiesesflüsse* (Studien über christliche Denkmäler, N. F. Heft 24) (Leipzig, 1937), p. 130. And cf. Cabrol-Leclerq, *Dictionnaire*, II, col. 697.

32 Cf. Enlart, *Manuel* I, 2, pp. 883, 886, 889, 891.

33 Enlart, *Manuel,* p. 887, mentions several examples, among them the large basin regarded by tradition as the baptismal font of St. John at Ephesus, which was originally an oilpress (it is doubtful whether it ever actually served as a baptismal font).

33

ments, and may have helped to establish that characteristically wide diffusion and rich variation of form and imagery. The lack of a unified and crystallized tradition may be seen even in the basic patterns of baptismal fonts: some were circular, others rectangular or polygonal.[34]

The iconography of the baptismal font proper is often more specific. On very elaborately decorated baptismal fonts, medieval artists sometimes represented, as one knows, biblical scenes related in meaning to baptism (the Flood, the Passage of the Red Sea, and the Crossing of the Jordan — from the Old Testament — ; the Baptism of Christ, the Walking on the Water, and the Issuing of Blood and Water from Christ's Wound — from the New Testament).[35] However, this iconography, is by no means rigid or of a general validity.[36] Needless to say, many baptismal fonts show altogether different types of decoration. As a single example I shall mention the baptismal font of Cividale which is decorated with roses and figs, with the symbols of the Evangelists carved among them; an inscription speaks of the rebirth brought about by baptism.[37]

In medieval thought, however, the mystery of baptism was invested with a whole range of meanings that were wide and general enough to be significant in the iconography of the other liturgical implements belonging to the same group. In Patristic and medieval literature one finds, of course, many formulations of the idea that baptism is a spiritually cleansing bath, a purification of the soul. This idea could easily be applied not only to the specific act of baptism, but to all acts of liturgical purification, and, by implication, it invested all the implements used in these rites with a common meaning, or at least closely connected them to each other.

Moreover, the passages from the Old Testament which the Fathers of the Church considered as prefigurations of baptism are, of course, also of a general character, lending a common meaning to all acts of ritual

34 Enlart, *Manuel,* p. 887.

35 For the main literary sources see the liturgy of the Blessing of the Water, recited on Good Saturday. Cf. Cabrol-Leclerq, *Dictionnaire,* II, i, col. 685 ff., s. v. "Bénédiction de l'eau". The more important texts are Bruno Astensis, *Expos. in Exod.,* ch. 15 (Migne, P. L., CLXIV, 266); Durandus, *Rationale divinorum officiorum,* iv, 81, n. 4 and 82, n. 1; Sicardus, *Mitrale, sive de officiis ecclesiasticis summa,* vi, 13 (Migne, P. L. CCXIII, 330 D ff.). For a still useful summary, cf. J. Sauer, *Symbolik des Kirchengebäudes,* p. 138.

36 Cf. Enlart, *Manuel,* p. 898. And see above, note 30.

37 For this font, cf. Cabrol-Leclerq, *Dictionnaire,* iii, 2, col. 1827 ff., 1931 ff., (s.v. "Cividale en Frioul"). In our context it should be noticed that in the twelfth century Cividale (Civitella) belonged to Apulia. For the symbolism of flowers, particularly of roses, see below, p. 46 ff. For the connection with rebirth see the following pages.

purification as well as to all objects used in these acts. As an example I shall mention St. Cyril, who was bishop of Jerusalem in the fourth century and an influential writer on baptism. St. Cyril quotes Isaiah 4:4 ("When the Lord shall have washed away the filth of the daughters of Zion, and shall have purged the blood of Jerusalem from the midst thereof by the spirit of judgment, and by the spirit of burning") and Ezekiel 36:25 ("Then will I [sprinkle clean water upon you, and ye shall be clean: from all your filthiness, and from all your idols,] will I cleanse you") as allusions to baptism.[38] It need not be stressed, however, that these quotations could be applied to different ritual acts (e.g. the priest washing his hands, or sprinkling holy-water) as they could be applied to baptism proper.

The Fathers of the Church also looked for biblical models of the baptismal font itself. The descriptions of the objects to which they referred, and which they invested with the specific meaning of the baptismal font, must have read to medieval minds like descriptions of holy-water basins. Thus, Eusebius, in his *Ecclesiastical History*, describes the entrance to the biblical temple:

And here he hath placed symbols of sacred purification, by erecting fountains right opposite the temple, whose copious streams of flowing water supply cleansing to those who are advancing within the sacred precincts. And this is the first stopping place for those that enter.[39]

St. Cyril of Jerusalem also says that

An image of the baptism was the washing-basin that had been erected within the Tabernacle.[40]

Such descriptions must have furthered a connection, or at least a close relationship, between baptismal fonts and other liturgical implements connected with holy-water.

That this link was not restricted to the East or to Early Christian times can be seen, for example, from the writings of Durandus. This thirteenth-century Western liturgist seems to relate the biblical washing-basin just mentioned to the *piscina*, in which the Eucharistic chalice and other objects used in the Mass were cleansed, and in which the priest washed his hands. The interpretation he gave the *piscina* is very

38 Third Catechesis to the baptized, 16. For a German translation cf. *Des Heiligen Cyrillus Catechesen* (Bibliothek der Kirchenväter) (Munich, 1922), p. 59. (Author's translation).
39 Eusebius, *Ecclesiastical History*, x, 4, 40 ff. Quoted from the English translation by H. L. Lawler and J. E. Leonard (New-York, 1927), p. 309.
40 Third Catechesis, 5. German translation, p. 52. (Author's translation).

close to that of the baptismal font. The *piscina*, Durandus says, should be placed near the altar, because of its symbolic connection with it.[41] While the altar symbolizes Christ himself, the *piscina* symbolizes his mercy. It is, therefore, in Christ's mercy that believer and penitent wash their hands to be cleansed of the filth of sin.[42] Even before the twelfth century pious Christians used to drink the water of this basin, and in some churches were placed two such vessels.[43]

I have adduced these few quotations, to which others could be added, to show that the meaning of the holy-water basin, the *piscina* and the like, was intimately connected with the meaning of the baptismal font, and with the ideas, moods, and images implied in the notion of baptism. All these vessels were invested, in a more or less articulate form, with the ideas of purification from sin, redemption, and salvation. These connections necessarily influenced their iconography, and any attempt to interpret the iconography of the Acre vessel should, I think, be based on these ideas.

Turning now to the Acre vessel one notices, first of all, that its decoration consists of two groups of motifs: one group consists of the four flowers, the other of the two heads. In medieval thought and symbolic imagery these numbers, Two and Four, are so invested with allegorical meaning that one finds it difficult to accept their presence as merely accidental in the case of our basin.

As one knows, the number Four haunted the imagination of the Middle Ages, and found very wide applications. It suffices to recall the four rivers of Paradise, the four cardinal virtues, the four major prophets of the Old Testament and the four Evangelists. It may not be superfluous to mention that the number Four was expressly brought into relation with the church. In the prologue *Plures fuisse,* which in medieval Evangeliaries usually precedes the sacred texts, it is said:

The church has four corners and rings by which, she, like the Ark of the Covenant, and the guardian of the law of the Lord, is carried by four immovable pieces of wood.

and further

41 Viollet-le-Duc, *Dictionnaire,* vii, p. 187 ff., mentions several examples which show that the *piscina* was indeed placed near the altar.

42 Durandus, *Rationale,* i, 1, n. 39. As Sauer, *Symbolik des Kirchengebäudes,* p. 137, note 5, points out, the same idea is expressed by Honor. Aug., *Gemma animae,* 1., 136 (Migne, P. L. CLXXII, 587 B).

43 Durandus, *Rationale,* iv, 55, says that the priest should drink the water of the *ablutio,* i.e. the water in which he washed his hands after offering the sacrament to the believers. "Post sumptum Eucharistie sacramentum, sacerdotes digitos abluit et perfundit et perfusionem sumit."

36

The church resembles the roe and the young stag as, from Paradise, four rivers issue from her.[44]

The paradisiac symbolism of the number Four has also been applied directly to baptism. As a single example I shall mention the famous baptismal font of Hildesheim which rests on figures that are personifications of the four paradisaic rivers, the latter being referred to in the clearly legible inscriptions.[45] In texts, too, the four rivers of Paradise are sometimes brought into connection with the literary image of a well or a basin.[46]

The symbolical significance of the number Four is also known in medieval liturgy. *Inter alia,* it found its way into the rite of consecration of holy-water, thus bearing a direct relation to the holy-water basin. In that consecration, the *Missale Romanum* relates, the priest sprinkles holy-water in four directions, representing the four quarters of the world. Of the persistence of that symbolic gesture we learn from Durandus, who also mentions it.[47]

The symbolism of the number Two also fascinated the medieval mind. In the literature and folklore of the Middle Ages this number was often used to denote either complementary or opposite phenomena. It could, therefore, serve as symbol of both unity and disjunction; sometimes it is difficult to decide which of the two is really meant. Among the well-known examples of the medieval application of the symbolism of Two are the two natures of Christ, the love of God and the love of

44 Cf. Elbern, *Der eucharistische Kelch,* p. 136 ff.

45 For the inscriptions of the baptismal font in Hildesheim, cf. Sauer, *Symbolik des Kirchengebäudes,* p. 139, note 1; and E. Panofsky, *Die deutsche Plastik des elften bis dreizehnten Jahrhunderts,* p. 110 ff., esp. p. 112.

46 I shall mention only one text (of Carolingian origin) which suggests a connection between the four rivers and the image of a basin:

> Aspice pandecten vitae de fonte scatentem
>> Ubere quae gemino clara fluenta gerit.
> Hic Geon Fison Euphrates Tigris et amnis
>> Potant Christicolas nectare quoque pios.
> Mel caeleste fluens, oleum, lac, suaveque vinum
>> Ydria metretis hic redoletque novis.
> Mystica nam tropicis anagoge floret in arvis
>> Arboris hic vitae dulcida poma virent.

Cf. Schlosser, *Schriftquellen zur karolingischen Kunst,* (Vienna, 1892), 1072. These lines were written in the middle of the ninth century, by Sedulius Scotus *(Carmen,* II, 69). Cf. Elbern, *Der Eucharistische Kelch,* p. 135.

47 The formula of consecration in the so-called *Gelasianum* mentions the four rivers of Paradise. The *Missale Romanum,* the text of which agrees, word for word, with that of the *Gelasianum,* adds: "Hic manu aquam dividit [sacerdos] et effundit eam versus quator sundes partes." This has been noticed by E. Schlee, *Die Ikonographie der Paradiesesflüsse,* p. 113. Durandus mentions that gesture in *Rat. div., off.,* VI, 82, 7.

men, *vita activa* and *vita contemplativa*, the "two great lights" (i.e. the Sun and the Moon), the Right and the Left, the virtues and the vices and so on.[48] In our specific context it might prove useful to recall that in medieval symbolism the number Two could also be interpreted as referring to the two Apostles, Peter and John, going to the tomb of the risen Christ.[49]

It need not be stressed that the two aspects of antagonism and complementarity could very well go together; in fact, they sometimes merged into one complex attitude best described by the term "ambivalence." The classic example of such an ambivalence is the medieval conception of the relationship between Judaism and Christianity, the Synagogue being regarded "both as the enemy and the ancestress of the Church" and the Jews being considered as "blind and wicked in that they did not recognize Christ as the Saviour, yet as clear-sighted and saintly in that the Old Testament announced His coming on every page".[50] In the present context it is interesting to note that from the twelfth century onwards baptismal fonts were sometimes decorated with representations of Christ crowning the Church and blindfolding the Synagogue.[51]

Something of this ambivalence seems to prevail in the two faces that decorate the holy-water basin of Acre. As already stated in this paper, the two faces are practically identical in type, structure, and physiognomic features; it is indeed very likely that, in carving the two heads, the artist used the same model. But this need not be the sole reason for the similarity; a conscious artistic intention to make the faces identical is not necessarily excluded. Contrary to what was believed in the nineteenth century, Romanesque as well as Byzantine artists had a high command of the art of rendering faces; they could rely upon a rich repertoire of models, and sometimes the same artist could represent many and widely differing physiognomic types. Recent scholarship has

48 I shall mention some of the best-known quotations. For the two Testaments, cf. Augustinus, *Contra Faust.*, xxii, 52 (P. L. XLII, 432) and Innoc.III, *De sacro alt. myst.*, i, 59 (P. L. CCXVII, 796); for Sun and Moon, cf. Bruno Segn., *Expos. in Genes.*, i. (P. L. CLXIV, 154); for the two loves and ways of life, cf. Honor. Aug. *Spec., Eccl., De Nativ. Domini* (P. L. CLXXII, 819d); for right and left, cf. Durandus, 4, 23 n. 2. Sauer, *Symbolik des Kirchengebäudes*, p. 69 ff., gives a more extensive list of the main sources.
49 Sicard., vii, 15 (P.L. CCXIII, 359 A).
50 E. Panofsky, *Early Netherlandish Painting* (1953), p. 137.
51 Enlart, *Manuel,* p. 900, note 1, mentions several twelfth-century baptismal fonts displaying this type of decoration; see especially the font from Tirlemont, now in the museum of Brussels. In Gothic art such representations occur more frequently, also on baptismal fonts. For the meaning of blindness, see the well-known discussion in E. Panofsky, *Studies in Iconology*, p. 110 ff.

shown it to be very probable that a medieval artist's selection of a physiognomic model often betrays an explicit intention.[52] Consequently, if the structure and type of the two heads are as identical as they are in the vessel of Acre, this may well be due not to a restricted repertory, or a lack of understanding, or ability of variation, but the result of volition. Moreover, it is precisely this identity in structure and physiognomic type that suggests an intention, since it sharply emphasizes that the two faces of the Acre vessel represent diametric opposites in mood and expression. The expression of the two faces cannot be accidental; it must have been carefully thought out. The very success of the artist in clearly articulating the different moods makes it all the more likely that the identity of structure, and thus the whole ambivalent character of the faces, is deliberate. In looking at the holy-water basin of Acre the spectator cannot help asking himself: is it not possible that the artist wanted us to be aware that he is portraying the same person in different moods or states of spiritual experience? In other words, is not the combination of unity and difference of an essential iconographic significance?

Although it seems likely that the symbolic meaning of the numbers Four and Two played a significant role in the decoration of the Acre vessel, it cannot be proved that this is indeed the case. Any interpretation of this vessel based only on the meaning of these numbers remains, perforce, hypothetical. However, a specific and definite iconographic problem is posed by the holy-water basin of Acre; this problem arises from the two opposite facial expressions of sadness and joy. To repeat it: there can be no doubt that the artist wanted to focus our attention on this antagonism. The understanding of the Acre basin depends, therefore, on the correct interpretation of these facial expressions, and of their relation to the vessel as a whole.

Although the problem is clearly definable, the answer is not easily given. As already mentioned, holy-water basins do not seem to have had a crystallized and conventional iconography to which one could simply refer. The most striking feature of our vessel, the sad and the smiling faces, although not altogether unique, is far from being a common element in the decoration of such objects. If one tries, under these circumstances, to interpret the symbolic meaning of our basin and its

52 For Romanesque art, cf. Meyer Schapiro, "The Romanesque Sculpture of Moissac," *Art Bulletin*, xiii (1931), p. 249 ff., esp. p. 262 ff.; for Byzantine art, cf. K. Weitzmann, "The Classical in Byzantine Art as a Mode of Individual Expression," *Byzantine Art – An European Art* (Athens, 1966), pp. 151–177, esp. p. 170 ff.

39

decoration, one can only trace some general tendencies, and show that the images that appear on our vessel have deep roots in Christian culture and thought alive in the twelfth century.

As holy-water basins do not have an iconography of their own, any attempt to understand the meaning of the two faces on our vessel should, I think, start with the broad realm of ideas associated with holy-water and baptism. It is from these concepts that the meaning of the holy-water basin is derived.

It is not our intention to enter into a comprehensive discussion of the ideas of baptism, the extremely rich and complex history of which has often and thoroughly been studied. For our purpose it suffices to recall that since Early Christian times baptism has been considered as a re-birth. The classic formulation of rebirth given in the Gospel of St. John ("Verily, verily, I say unto thee, Except a man be born of water and of the Spirit, he cannot enter the kingdom of God" [3:5]) has early been related to baptism.[53] St. Paul, in his Letter to Titus (3:5), describes baptism as the "washing of regeneration." Since the Early Christian period the Sacrament of Baptism has been called by the dogmatic name of *sacramentum regenerationis*.[54] In the *Benedictio fontis,* the liturgy of Easter-night, it is said of the baptismal water

Sit fons vivus, acqua regenerans, unda purificans.[55]

The idea of rebirth implies, of course, a certain ambivalence, it has necessarily two aspects; besides indicating birth it also suggests death. In Christian theological interpretation of the Mystery of Baptism this ambivalence has indeed been clearly brought out. It was formulated by Paul in his Letter to the Romans:

Know ye not, that so many of us as were baptized into Jesus Christ were baptized into his death?

Therefore we are buried with him by baptism into death: that like as Christ was seized up from the dead by the glory of the Father, even so we also should walk in the newness of life. (6:3–4).

And in the Epistle to the Colossians (2:12) we read:

53 As early as Tertulian's *Concerning Baptism,* 13, which is probably the earliest Christian treatise on this subject.

54 For a brief summary of the meanings implied in this notion, and their impact on European thought, cf. K. Burdach, *Reformation, Renaissance, Humanismus,* 2nd ed. (Berlin-Leipzig, 1926), p. 31 ff. From the almost inexhaustible store of quotations that may be adduced in this context I should like to refer only to Augustine's description of the baptismal font as "laver of regeneration", and "font of regeneration" in *Civitas Dei,* xxii, 8.

55 This sentence is taken from a sermon of Pope Leo the Great; Sermo 49 (Migne, P. L., LIV, 303A). See the well-known study by P. Underwood, "The Fountain of Life," *Dumbarton Oaks Papers,* V, 1950, p. 43 ff.; Elbern, *Eucharistische Kelch,* p. 134 and note 45.

Buried with him in baptism, wherein also ye are risen with him through the faith of the operation of God, who has raised him from the dead.

Throughout the Christian world, theological and mystical literature has extensively dwelt on the ambivalent meaning of rebirth. It suffices to quote a few passages. Isidor of Sevilla says:

The transition from this mortal life to the other, immortal life, that is, from death to life, is revealed in the Passion and Resurrection of the Lord. The transition mentioned is now accomplished by us through faith, granted to us as the absolving of sins, that is, when by [through?] baptism we are buried with Christ, passing over as it were from death as from worse to better, from corporeal to spiritual, from the conservation of this life to the hope for future resurrection and magnificence.[56]

At the other end of the Christian world, Cyril of Jerusalem said in his Second Mystagogical Catechesis on Baptism:

And at the self-same moment, ye died and were born; and that Water of salvation was at once your grave and your mother.[57]

The same idea is sometimes also found in liturgy. The already quoted *Benedictio fontis* suggests that there is an immediate link between the Holy Sepulcher, Christ's tomb, and the baptismal font.[58]

However, the idea of death implied in the notion of baptismal rebirth does not always necessarily refer to the death of Christ; another meaning of it, no less common than the former, was sin, or death as the result of original sin, and which is redeemed by baptism. "In former times death was mighty and devoured," says Cyril of Jerusalem; but after baptism "thou shalt no more mourn."[59] An ancient rite, attested by many Christian authors, required that the newly baptized turn first toward the West, i.e. the "evil side" where Satan dwells, and then toward the East, the side of salvation, light, and Christ.[60]

56 *De ecclesiasticis officiis,* i 32 (P. L. LXXXIII, 767). Cf. also Origen, *Selecta in Psalmos,* to Psalm 73, 4 (Migne, Patr. Gr., XII, 1532) as quoted by Underwood, "The Fountain of Life" note 246.

57 Mystagogical Catechesis II, 4 *(St. Cyril of Jerusalem's Lectures on the Christian Sacraments,* ed. F. L. Cross [London, 1951], p. 61).

58 Cf. Elbern, *Eucharistische Kelch,* p. 158, ff. R. Bauerreiss, *Fons sacer: Studien zur Geschichte des frühmittelalterlichen Taufhauses auf deutschsprachigen Gebiet* (Munich, 1949), was not available to me while writing this chapter.

59 Mystagogical Catechesis, I, 10 (English transl. p. 58).

60 Dionysius Areopagita, *Ecclesiastical Hierarchy,* II, 2, 6; St. Jerome, *In Amos lib.,* III, 6, 14; Cyril of Jerusalem, First Mystagogical Catechesis, 9 (English translation, p. 57 ff.). Cf. P. Glaue, "Zur Geschichte der Taufe in Spanien," II, *Sitzungsberichte der Heidelberger Akademie der Wissenschaften,* phil. hist. K1., 1927/28, p. 23 ff., for interesting information on this rite in the sixth and seventh centuries. The baptized entered the font by descending three steps, renounced the devil, and left the font, after being baptized, by ascending three steps ("tres in descensu, tres in ascensu").

Whatever the specific meaning of death—the mystical death of Christ or death as the wages of sin—it is obvious that the idea of rebirth includes that of death.

We may come one step closer to the understanding of our iconographic problem by noting that in the early Christian literary sources the spiritual rebirth undergone through baptism has not only been interpreted theologically, but has also been associated with emotional states. Especially the joy and gladness that accompany that rebirth have often been stressed. Thus, to adduce but a few examples, St. Zeno of Verona addresses the neophytes:

Jubilate in Christ, brethren, congregate in yearning and receive the heavenly gifts. The healing warmth of the eternal font already invites you. Our mother [the Church] already accepts you for birth.[61]

In the *Invitations to the Font*, St. Zeno describes baptism in exalted language "O wondrous and truly divine and sacred birth! Here she who brings forth does not groan; he who is reborn does not cry."[62]

Similar expressions are to be found in the sermons of St. John Chrysostom, one of the most influential preachers of Eastern Christianity. He describes baptism as a "Spiritual birth, birth by Grace and lovingkindness of God, birth full of joy and gladness."[63]

Cyril of Jerusalem often and elaborately dwells on the cosmic joy that is connected with baptism. In his first sermon to the baptized he describes the joy that prevails in Heaven over the penitent who, in being baptized, is cleansed of sin. He quotes a passage from Isaiah (which has often been regarded as a prefiguration of baptism) that reads: "I will greatly rejoice in the Lord, my soul shall be joyful in my God; for he hath clothed me with the garments of salvation, he hath covered me with the robe of righteousness."[64] In his Third Mystagogical Catechesis Cyril of Jerusalem says:

Of this in ancient times the blessed Esaias prophesying said 'And in this mountain shall the Lord make unto all people a feast; they shall drink

61 Zeno of Verona, Tract., 30 (P. L. XI, 467). Cf. also Tract., 32 (P. L. XI, 477–78). Quoted by Elbern, p. 135.

62 *Invitatio ad fontem* IV, (Migne, P.L. XI, col. 479).

63 In principium actorum III, vi *(S.P.N. Joannis Chrysostomi Operum,* pars I, classis II, Vol. XXXV [Homiliae in Novum Testamentum], p. 527).

64 Catechesis to the baptized III, 2 (Bibliothek der Kirchenväter [see above, note 40] p. 49). The passage is from Isaiah 61:10. Interestingly enough, in the following sentence St. Cyril brings a physiognomic metaphor by quoting Ephesians 5:27: "not having spot or wrinkle." Cf. also Cyril's Catechesis I, 1, and III, 1 (Bibliothek der Kirchenväter, pp. 29, 48) for additional connections between baptism and joy. (Author's translation).

wine, they shall drink gladness, they shall be anointed with ointment'.[65]

From these quotations, that can easily be multiplied, it clearly emerges that in Christian thought the baptismal rebirth had definite emotional connotations, particularly of exuberant joy, but also of sadness. The two faces of our vessel, expressing both emotions, conform to this tradition.

In this context we should remember that one of the physiognomic motifs encountered in the Acre vessel, namely smiling, is not only one of the very first facial expressions to be represented in art and to reach a formal crystallization; it also had a symbolic meaning beyond that immediately communicated by the countenance. In archaic art, where it first appears, smiling is not necessarily connected with joy; it has the broader meaning of expressing the life that is assumed to permeate the represented figure. Therefore, figures conceived as experiencing quite different emotions (e.g. anger or pain) are also represented as smiling; even the face of a dying warrior, who attempts to draw the weapon from his wound, is smiling, probably to indicate that he is still alive.[66]

In some of the mystery cults of Antiquity, smiling or laughing acquire an additional meaning, which is closely related to the subject of this study: they are symbols of spiritual rebirth, or the resurrection of both nature and man. Thus Homer speaks of the laughing earth in a context suggestive of rebirth.[67] In Greek and Roman religion, the priest's ritual laughter sometimes symbolically represents the rebirth of a goddess.[68] Pausanias describes a rite of initiation which combines the

65 Mystagogical Catechesis III, 7 (English translation, p. 67). St. Cyril here quotes Isaiah 25:6.
66 See Hedwig Kenner, "Lachen und Weinen in der griechischen Kunst," *Österreichische Akademie der Wissenschaften*, phil.-hist. Kl. 234 Band (Vienna, 1960), p. 62 ff., esp. p. 66 ff. See the smiling face of the dying warrior on the western gable of the temple of Aphaia in Aegina (F. Gerke, *Griechische Plastik*, pl. 71). It has been suggested that smiling has a similar meaning in Gothic art of the twelfth and thirteenth centuries. Cf. Max Dvořák, *Geschichte der italienischen Kunst*, i (Munich, 1927), p. 191 ff. See also some scattered observations in H. Schrade, "Früh-christliche und mittelalterliche Kunst: Ein Literaturbericht (ii)," *Deutsche Vierteljahrsschrift für Literaturwissenschaft und Geistesgeschichte*, vii (1929), pp. 348–422, especially p. 383 ff. (with some additional bibliographical references), and A. Goldschmidt in *Jahrbücher der preussischen Kunstsammlungen* (1900), p. 239 (the latter study was not available to me while writing this chapter). As far as I know, the facial expression of smiling in medieval art has not been compre-hensively studied, neither in its formal patterns nor in its iconographic context. Some interesting suggestions have, however, been made. See, e.g., E. Kitzinger, "The Hellenistic Heritage in Byzantine Art," *Dumbarton Oaks Papers*, xvii (1963), pp. 97–115. See especially p. 110, with the important observation "that in all Byzantine painting and sculpture there is not a single laughing figure."
67 *Iliad*, XIX, 362.
68 See the interesting study by S. Reinach, "Le rire rituel," *Cultes, Mythes et Religions*, iv (Paris, 1912), pp. 109–129 [published originally in *Revue de l'Université de Bruxelles*, 1911, pp. 585–602], esp. pp. 111 ff., 121 ff.

images of death and resurrection. The initiated is borne by the priests as a dead man into a cave; he comes out of it manifesting his spiritual resurrection by laughing.[69] In another Roman rite, the initiated express their rebirth to a "better life," which is, of course, of a spiritual nature, by laughing.[70]

These meanings of smile and laughter in pagan culture are sometimes reflected in Patristic writings. Thus Eusebius, in his *Praeparatio Evangelica,* refers to a pagan custom of ritual laughter.[71] The somber mood which prevailed in Christian thought did not allow for ritual laughter. Nevertheless, the Greek Orthodox Church has conserved a trace of the exuberant joy that in pagan cults greeted the resurrection of a god or a hero; this is the joy of Easter Sunday. The *risus pascalis,* the laughter which, according to an old custom, the priest evokes among the believers on Easter Sunday, has the same meaning as the ritual laughter in Antiquity: it is an expression of the joy experienced at the resurrection of Christ.[72] When considered against this broad background, some of the literary images associated with baptism may bring us closer to the representations on the holy-water basin of Acre. I refer to metaphors of a distinctive physiognomic character that sometimes read as if they were meant to describe the sudden change from sadness to joy as mirrored in the face of man.

Again, these metaphors are to be found as early as in the text of the New Testament. In certain passages of the *Revelations,* which are based on verses from the Old Testament, salvation is several times imagined as a wiping off of tears:

For the Lamb which is in the midst of the throne shall feed them, and shall lead them unto living fountains of waters: and God shall wipe away all tears from their eyes (7:17),

an image obviously derived from Isaiah 25:8, which reads:

He will swallow up death in victory; and the Lord God will wipe away tears from off all faces; and the rebuke of His people shall He take away from off all the earth: for the Lord hath spoken it.

A similar formulation can be found toward the end of the Apocalypse.

And God shall wipe away all tears from their eyes; and there shall be no

69 Pausanias, IX, 39, 14, Cf. Reinach, "Le rire rituel," p. 121, and Kenner, "Lachen und Weinen in der griechischen Kunst," p. 67.

70 Plutarch, *Rom.,* 21. Cf. Reinach, "Le rire rituel," p. 121 ff.

71 III *init.* (cf. Reinach, "Le rire rituel," p. 109).

72 For the *risus pascalis* see Reinach, "Le rire rituel," p. 127 ff.

more death, neither sorrow, nor crying, neither shall there be any more pain; for the former things are passed away. (11:4).

Here, then, we clearly have an expression of redemption as wiping off of tears.

These images and formulations were taken up by later writers who interpreted them as referring to baptism and to the joy of man reborn in the baptismal font. I quote again Cyril of Jerusalem who says:

In former times death was mighty and devoured; but at the holy Laver of regeneration, God has 'wiped away every tear from off all faces.' For thou shalt no more mourn.[73]

Cyril also uses another physiognomic metaphor, that of the "shining face," to indicate the joy of the baptized. In his Fourth Mystagogical Catechesis (on the Eucharistic Food), based on a verse from Psalm 104, he speaks of the face that mirrors the soul.

...and of this David sang of old, saying 'And bread which strengthens man's heart, and oil to make his face shine,' 'strengthen thine heart,' partaking thereof as spiritual, and 'make the face of thy soul shine.'[74]

We may now summarize the main points of our argument: (1) The idea of rebirth implies that of death, and Christian authors were well aware of this; (2) in Christian literature, the spiritual rebirth of baptism is associated with the emotion of joy, while, though less often, death (either the redeeming death of Christ or death as the wages of sin) is connected with sadness and tears; (3) in the New Testament as well as in the writings of the Fathers one finds some metaphors suggesting a reflection of these emotions in human physiognomy.

It would, of course, be erroneous to regard these ideas and metaphors as a "source" of the faces on the Acre vessel, i.e. to conceive of them as literary models that directly influenced the artist. These literary images show, however, that the representation of a crying and a smiling face on a holy-water basin or a baptismal font is not accidental; such faces have deep roots in Christian thought and imagery.

The other figurative element of the Acre vessel is the floral. Two of the flowers—those framing the smiling face—are evidently blooming roses (fig. 2). The two others are more difficult to identify; one of them—to the right of the sad face—seems to be a wilted, tattered rose, while the

Fig. 2

73 Mystagogical Catechesis I, 10 (English transl. p. 58).
74 Mystagogical Catechesis IV, 9 (English transl. p. 71). St. Cyril here quotes Psalm 104:15; "And wine that maketh glad the heart of man, and oil to make his face shine, and bread which strengthens man's heart."

Fig. 1 fourth flower is of a more ornamental form. (fig. 1).

The rose played a significant part in the symbolism of early Christian and medieval art; its meaning, although sometimes complex, is always articulate. Since Cyprian, bishop of Carthage and a prominent writer of the third century, the *rosa*, together with the *corona purpurea*, has been an accepted symbol of martyrdom.[75] In early Christian art the rose is a common motif, appearing not only as an explicit symbol of Christian martyrdom, but also in scenes from the Old Testament that have the connotation of martyrdom. As a single example I shall mention the representation of the Sacrifice of Isaac on the ivory pyxis in Berlin, a work created circa 400.[76] In the upper portion of the scene, between Abraham's raised sword and a huge chalice that stands on the altar, the artist represented a fully plastic, blooming rose. Here the rose obviously symbolizes Isaac's sacrifice (which, needless to say, was understood as a *figura* of Christ's death) and may perhaps also be understood as a suggestion of Paradise, or eternal life which is the reward of the sacrifice. In early Byzantine culture this symbolism was apparently so well understood that on a sarcophagus two lambs representing two Apostles, could be identified as the *principes martyrum*, i.e. Peter and Paul, by the appropriate placing of a large symbolic rose.[77]

The rose had, of course, other meanings as well. Roses, together with other emblems, frame the monogram of Christ or the Cross, indicating both the redeeming death of Christ and his heavenly victory.[78] The rose was also an early symbol of Mary who was called *rosa mystica*.[79]

75 See St. Cyprian's Letters, X, 5 *(Des Heiligen Kirchenvaters Caecilius Cyprianus sämtliche Schriften* [Bibliothek der Kirchenväter] [Munich, 1928], II, p. 33 ff.). Cf. F. Gerke, "Der Tischaltar des Bernard Gilduin in Saint Sernin in Toulouse," *Akademie der Wissenschaften und Literatur* (Mainz, Abhandlungen der Geistes-und Sozialwissenschaften, 1958), p. 481 ff. As one knows, many post-classical representations of Paradise contain two flowers, the rose as the symbol of those who entered it *de sanguine* (i.e. as martyrs) and the lily as the symbol of those who entered it *de merito*.

76 Cf. C. R. Morey, *Early Christian Art* (Princeton, 1942), fig. 80.

77 See the sarcophagus in the Museum of Ravenna (cf. Lawrence, *The Sarcophagi of Ravenna* [1945], fig. 52). In a similar scene, the two Apostles are sometimes identified by martyrs' crosses (cf. Lawrence, *The Sarcophagi of Ravenna*, fig. 69). Although symbolic roses seem to have been particularly frequent in the fifth and sixth centuries (cf. Gerke, *Der Tischaltar des Bernard Gilduin*, p. 483) this specific meaning of the rose was well known in later periods. Thus Bernard of Clairvaux described the rose as a symbol of martyrdom. Cf. J. Jungmann (mit einen Anhang von S. Sauser), *Symbolik der katholischen Kirche* (Stuttgart, 1960), p. 88.

78 See, e.g., the fragment of a sarcophague in Beziers, St. Nazaire (Gerke, *"Der Tischaltar des Bernard Gilduin,"* fig. 20) and particularly the later Merovingian Sicvald plate in Cividale *(ibid.,* fig. 22) For additional examples, cf. Gerke, p. 484 ff.

79 This term was probably derived from the well-known verse of *Ecclesiasticus* 24:14 ("I was exalted like a palm tree on the sea shore, and as a rose plant in Jericho"). See also Jungmann,

In our context it is important to notice that the rose was also a symbol of Paradise. As early as the third century an anonymous artist represented Paradise in the Catacomb of Callistus in Rome by rendering five saints linked by garlands of roses.[80] It is clear, then, that the predominant meaning of the rose is that of both sacrifice and redemption. The latter meaning at least seems to have been taken over from pagan funerary monuments where the rose appears as one of the symbols of immortality and apotheosis.[81]

Symbolic roses often appeared on sarcophagi.[82] Considering the close relationship between the sarcophagus and the altar that prevailed in early Christianity it is not surprising that roses found their way into the decoration of the altar and of ritual objects connected with the altar and liturgy. In the early Middle Ages they occur on liturgical implements, specifically on those connected with the Mass.[83]

It is not our task to examine the history of the symbolic rose in medieval art. For our purpose it suffices to say that this history apparently displays continuity. The symbolic rose migrated from one cultural region to the other, its representation was transferred from one artistic medium to the other; its meaning, however, remained essentially unaltered. Throughout the periods, roses symbolized sacrifice and paradisaic bliss. In the eleventh and twelfth centuries we find many representations of symbolic roses in the main centers of artistic creation. I shall mention here only a few examples. In Moissac roses adorn the reliefs of Sts. Peter and Paul, principal martyrs.[84] At St. Sernin in Toulouse the arcades (beneath which are represented cross-bearing angels and an

Symbolik der katholischen Kirche, p. 88. For a brief summary of medieval symbols of the Virgin Mary (in which floral imagery played an important part) cf. F. Raby, *A History of Latin Christian Poetry from the Beginnings to the Close of the Middle Ages* (Oxford, 1927), p. 363 ff., especially p. 366.

80 Often reproduced; see L. von Sybel, *Christliche Antike*, (Marburg, 1906), p. 169.

81 Cf. E. Michon, "Les sarcophages de Saint-Daussin des Soissons" *Mélanges G. Schlumberger*, (Paris, 1924), II, pp. 376–385, and pl. xv. As Gerke, *Der Tischaltar des Bernard Gilduin*, p. 484, note 3, has noticed, on ancient funerary monuments the rose sometimes appears on the gable, a place which is usually reserved for symbols of apotheosis and immortality, such as the eagle. For interesting Eastern examples, cf. F. Cumont, *Études Syriennes* (Paris, 1917), figs.19–22.

82 Especially frequent in the sarcophagi of Ravenna. See the sarcophagus of Theodorus in S. Apollinare in Classe (Lawrence, *The Sarcophagi of Ravenna*, figs. 6, 10); the Rinaldo sarcophagus in the Cathedral of Ravenna (Lawrence, fig. 4); the Certosa sarcophagus in the Cathedral of Ferrara (Lawrence, fig. 11). For a further development, both in form and meaning, cf. the Sicvald plate in Cividale mentioned above (note 78).

83 Cf. Gerke, *Der Tischaltar des Bernard Gilduin*, p. 482 ff., for a brief summary.

84 Often reproduced. Cf. Meyer Schapiro, "Romanesque Sculpture of Moissac," figs. 5, 6. See also Kingsley Porter, ill. 267 (St. Simon). But roses also adorn the representation of the Abbot Durandus (Schapiro, fig. 4).

Evangelist) are also decorated with prominent roses.[85] In the late eleventh century roses appear on a marble slab that served as an altar, the work of Bernard Gilduin.[86] In eleventh and twelfth-century art of southern Italy we also find roses, as for example, on the pulpit of Bitonto.[87] In all these works the roses have essentially the same meaning they had in early Christian art and thought.

As symbols, then, the roses on the holy-water basin of Acre belong to a venerable tradition still very much alive in the early Romanesque period. Their meaning further reinforces the ideas of sacrifice and redemption that we have already found associated with the vessel.

As already mentioned, one cannot overlook the contrast in the character of the two groups of flowers: while two roses are in full bloom, the two other flowers are tattered and wilted. That this is more than a mere formal contrast emerges from the fact that the blooming roses accompany the smiling face while the wilted flowers frame the sad face. The barren and the flowering, the dry and the verdant are frequent and important metaphors in medieval religious literature, and occupy a central position in the imagery of the period. It is true that this particular symbolism is usually applied to the image of the tree, yet the connotation of barrenness and flowering seems to be wide and general enough to be valid in the case of flowers also.

In Christian literature these symbols indicated a multitude of meanings. One of these is the contrast between the Old Law and the New Grace,[88] another is the reward and fate of the sinner and the just. The verse "and the just shall flourish like a palm tree" (Psalm 91[92]:13) has often been repeated and commented in Christian thought. One of the principal meanings of floral symbolism is that of salvation and rebirth. The medieval artist may have remembered that "some of the great Messianic prophecies of the Old Testament are expressed in metaphors

85 Cf. Kingsley Porter, ills. 297, 298, 300, 303, 304.

86 Cf. Gerke, *Der Tischaltar des Bernard Gilduin, passim,* esp. p. 481 ff.

87 Cf. Petrucci, *Cattedrali di Puglia,* pl. 136, Kingsley Porter, *Romanesque Sculpture,* ills. 244, 245. For additional examples of roses in South-Italian sculpture of the twelfth century, cf. below, p. 60.ff.

88 See, for example, the mosaic in the Upper Church of San Clemente in Rome where the representation of the Cross with Christ Crucified flanked by Mary and John the Evangelist is surrounded by a rich growth of acanthus. "The antithesis of the old law and the new dispensation is here combined with the symbolism of the dry and the verdant tree." Cf. G. Ladner, "Vegetation Symbolism and the Concept of the Renaissance," *De Artibus opuscula XL: Essays in Honor of Erwin Panofsky* (New York, 1961), pp. 303–322, esp. 310 ff., and note 38. For a color reproduction, cf. F. Bologna, *Early Italian Painting,* (London, 1963), pl. 19.

of vegetative renewal, in terms of the dry and the green tree or of flowering from the root."[89] In this broad traditional context, I believe, we should also place the tattered and wilted, and the blooming roses of the holy-water basin in Acre. The contrast between the flowers is a variation of the main theme of this vessel, i.e. the contrast between the sad and the smiling faces. Both the physiognomic and the floral symbolism express the death and the rebirth implied in the holy-water of baptism and salvation.

89 Cf. Ezekiel 17:24: "And all the trees of the field shall know that I the Lord have brought down the high tree, have exalted the low tree, have dried up the green tree, and have made the dry tree to flourish." See also Daniel 4:11 ff. And cf. Ladner, "Vegetation Symbolism," p. 312, note 41.

IV

While attempting to place the holy-water basin of Acre in its proper historical context and to define its immediate sources, one is faced with difficult problems. As already remarked, the basin bears no inscription, no document can be related to it, and its origin is obscure. The only way, then, of tracing the origins of the artist is stylistic analysis. Such an analysis, however, is made difficult by the comparatively small size of the basin and the rather limited number of elements represented on it. A suitable starting point for the discussion is a comparison of our vessel with other works of Crusader sculpture in the Holy Land. It is known that most of the works of Crusader sculpture in the Latin Kingdom that have come down to us (the capitals of Nazareth, the two heads of Nazareth, and the relief on the lintel in the Church of the Holy Sepulcher in Jerusalem) seem to belong to one broad tradition.[90] Does the Acre vessel belong to the same tradition?

Even a superficial comparison of the most obvious element, the physiognomic type, in the sculptures of Nazareth and of Acre reveals a deep and basic difference. The tendency towards oblong, slim, and intricate forms which prevails in the Nazareth capitals can also be observed in the shape of the heads (figs. 18, 27, 42). In Acre, as mentioned above, the physiognomic type is full and round, contrasting in every feature with that of Nazareth. It is doubtless, I think, that the models familiar to the respective artists were of an altogether different origin.

Figs. 18, 27, 42

This impression is further strengthened if we compare the manner in which the heads are carved. In spite of the general conception of the Nazareth capitals — the figures are situated "within" a deeply carved

90 See below, Chapters Four and Five. Although the lintel of the Church of the Holy Sepulcher is more Provençal in style, while the Nazareth capitals and the two heads are more Burgundian, they all belong to French art of the twelfth century.

51

space — the heads are usually conceived as flat surfaces in which deep and clean-cut lines are incised. This character stands in obvious contrast to the conception of the heads on the Acre vessel as broad, bulky masses.

It is interesting to compare the carving of certain details, such as the eyes, or the hair. As already said, in the Acre vessel the eye is a ball-like mass; it is characterized mainly by its volume, and the form is suggested by the soft modeling of the mass. In the Nazareth capitals the eye usually is a flat, unmolded surface, to which sharp lines lend a shape *Fig. 27* (fig. 27). The carving of the hair reveals similar tendencies. In Acre the hair is conceived as an almost amorphous mass, with little detail or particular form, emphasizing only the shape of the skull. In Nazareth the hair and beard are a rich linear ornament often blurring the outline of the heads.

Figs. 44, 45 The same contrasts become evident if we compare our vessel to the two heads of Nazareth (figs. 44, 45),[91] a work which, by its very nature, comes closer in general shape to our basin than the historiated capitals of Nazareth or the lintel in the Church of the Holy Sepulcher. But again we find that the heads are long and narrow, the faces are more or less flat surfaces in which clean lines are traced, the hair and beards are elaborate, linear ornaments, and eyes are of distinctly graphic quality. By comparing the two heads of Nazareth to the two heads of the Acre vessel the difference of the two types grows particularly evident.

If we now turn from details to a comprehensive approach to sculpture and to the means employed by the artists, we are faced with the same difference. It is characteristic of the Nazareth capitals that the artist tries to distinguish between the objects he represents not only by outlines, but also by creating different textures. The face is highly polished, the deeply carved lines of the hair create a texture different *Fig. 33* to that of the rather flatly carved concentric lines of the halo (fig. 33). By polishing the stone to different degrees, or by leaving it rough, the artist of the Nazareth capitals creates different types of luminosity. He thus introduces certain "pictorial" means and effects which acquire major significance in his work. In other words, he conceives the sculp-

91 Although this piece of sculpture has been reproduced (rather poorly) several times (cf. Germer-Durand, "La sculpture franque en Palestine," *Conférences de Saint-Etienne:* 1910–1911 [Paris, 1911], pl. ii, 2; Enlart, *Les Monuments des Croisés,* pl. cxxxvi, fig. 428; W. Oakeshott, *Classical Inspiration in Medieval Art* [London, 1959], pl. 29b), it has not been properly studied. See below, Chapter Three.

ture not only as a material object in space, but also as a field of lines and textures.

In the vessel of Acre both the sculptural conception and the means employed by the artist are altogether different. As stressed several times, the artist who produced the holy-water basin of Acre did not distinguish sharply between the objects (heads or flowers) and the vessel itself. He employs neither emphatic outlines nor varied textures as stylistic elements. Disregarding all "pictorial" means, he achieves his effects by the distribution of sheer bulk and mass. His work, therefore, is less complex than the Nazareth capitals, but, in a way, of a more pervasive unity.

The difference in general conception is reflected in each detail. As an example I shall briefly compare the representation of an object in the Nazareth capitals (a crown) and in the Acre vessel (a flower) in relation to the background. The crown (fig. 39) is isolated from the rest of the *Fig. 39* capital by sharp outlines, angular forms, a highly polished surface, and an extensive use of the drill. Here one can really speak of an object that, detached from its background, stands out from it. The flower in Acre (fig. 2), on the other hand, lacks all these characteristics. The *Fig. 2* polishing is similar in the vessel and the flower, sharp outlines do not exist at all, and the forms of the flowers are curved and rounded as are those of the faces and of the vessel as a whole. The artist, one might say, did not attempt to give the flower a character different from that of the vessel as a whole.

From these comparisons it clearly emerges that the Acre vessel cannot have derived from the same sources as the Nazareth capitals and the other works of Crusader sculpture related to them. The origin of the artist, or artists, of Nazareth is fairly well established. There are somewhat divergent opinions as to the specific region or schools to which these artists belonged; one may perhaps even assume that Nazareth, or the Latin Kingdom in general, was the meeting ground of several specific traditions of European sculpture.[92] It is, however, obvious that the sculptors who worked in Nazareth came from France, and that they represent the fully developed Romanesque style of the third quarter of the twelfth century. French art of this period does not provide works of sculpture that can be regarded as models, or sources, of the

92 Cf. Kingsley Porter, *Romanesque Sculpture*, p. 167, who writes: "It is with this group of sculptors partly Chartrain, partly Burgundian, partly Provençal, that should be classed the hand which executed in far-away Palestine the capitals of the Church of the Annunciation in Nazareth." For a fuller discussion see below, p. 155 ff.

Acre artist. The general conception of sculpture, the specific features and motifs, the carving techniques, and even the tools employed (e.g. the drill), are altogether different in Nazareth and in Acre. What, then, are the sources of the Acre vessel? From what traditions did its artist draw?

In asking these questions one remembers certain works of early Romanesque sculpture in southern Italy that have an affinity to our vessel. It is well known that in the second half of the eleventh century an important school of sculpture, characterized by certain monumental tendencies, had emerged in southern Italy.[93] Our task is not to investigate the rather complex problems which this school, its sources, and the range of its influence still present to the historian. For the purpose of the present study it is sufficient to accept some of the rather obvious conclusions that have been reached: The school is primarily south-Italian, and developed mainly in Apulia, on the eastern, Adriatic coast of the peninsula. Its influence spread along the commerce and pilgrimage routes that ran from the north to the region of Bari; these roads may also have served as channels of inspiration and along them may have travelled models (and perhaps even artists) who determined the character of Apulian sculpture. A certain affinity of that sculpture to the art of southern France has often been noticed.

Although it is related to other schools and traditions, Apulian sculpture is individually characterized both by some broad, general tendencies and by certain particular features (among them physiognomic motifs) which frequently recur in the works of that region. Both the general tendencies and the specific motifs seem to be reflected in the Acre vessel.

I shall begin our brief discussion of a possible relationship of the Acre vessel to South-Italian sculpture with a reference to some fragments from the Cathedral of Monopoli which are now preserved in Bari. In Monopoli, a small town on the Adriatic coast to the south of Bari, situated on what used to be the continuation of the pilgrimage road which led from Monte San Angelo to Bari, the erection of a large cathedral was begun in 1107; a few fragments from the archivolt of a portal of that cathedral have come down to us. These fragments, showing heads of angels, represent an important crystallization of the South-

93 Cf. Kingsley Porter, *Romanesque Sculpture*, p. 59 ff.: E. Bertaux, *L'art dans l'Italie méridionale* (Paris, 1904); M. Wackernagel, *Die Plastik des XI. und XII. Jahrhunderts in Apulien* (Leipzig, 1911). For a recent account cf. G. H. Crichton, *Romanesque Sculpture in Italy* (London, 1954), p. 149 ff.

Italian school of sculpture. A comparison of the angel-heads of Monopoli with the faces on the holy-water basin of Acre reveals, I think, a similar spirit and common motifs.

The heads of Monopoli[94] show a basic conception of sculpture that bears a close affinity to that underlying the vessel of Acre. The bulk and mass of the stone are the main means of the sculptor. He achieves his effects by sheer modeling, rather soft and with a definite quality of roundness. "Optical" elements, although not altogether absent, play a rather insignificant part. On the heads of the angels a few lines can be seen, but they are rather shallow and do not lend the sculptures any linear quality. As in our vessel, the difference of textures, which is granted such an important role in the Nazareth capitals, plays only a marginal part in the Monopoli heads.[95]

A quite close resemblance between the physiognomic types of the heads of Monopoli and Acre can also be discerned. In both sets of heads the forehead is low, the nose broad and flat, the eyebrows have the shape of regular arches, the eyes are oversized, and of similar shape in both sets of heads, and a deep furrow runs from the nose to the mouth. The chin is flabby and short, and in both cases we find the same dimple between mouth and chin.

The similarity of the heads of Acre and of Monopoli is not exhausted by their resemblance in stylistic tendency and physiognomic type; the interest of both artists is focused on the same motifs and themes. The sculptor of Monopoli, like the one who worked in Acre, was deeply attracted by the expressive contrast between sadness and joy, a theme that was certainly not very common in the art of their time. Moreover, like the artist of Acre, the sculptor of Monopoli portrays these contrasting emotions by means of facial expression only. Of particular interest is the fact that both artists pay much attention to the mouth.

94 Kingsley Porter, *Romanesque Sculpture*, ills. 158–162.

95 The main "optical" or "texture" elements in the Monopoli heads are (a) the hair, which, with clearly carved strands, differs from the smooth surface of the face, and (b) the eyes, in which the deeply drilled holes represent the pupils. The lack of both features on the Acre vessel can perhaps be explained. As to the first point, we know that on baptismal fonts heads were sometimes represented as wearing hats (cf. Schlee, *Die Ikonographie*, p. 122, note 34). One wonders, therefore, whether the rendering of the hair as a compact mass on the Acre basin may not have some connection with such models. As to the second point, it is probably reasonable to assume that the small size of the Acre vessel induced the artist to restrain himself in the representations of details (the thin wall of the vessel may have been a further reason for avoiding the drilling of holes). In South-Italian art of the period one also finds, however, large-size sculptures in which both the hair and the eyes are treated as in the Acre vessel. See, for example, the *Majestas Domini*, in S. Leonardo, Foggia (cf. Kingsley Porter, *Romanesque Sculpture*, ill. 214).

While in French art of the early twelfth century the mouth is usually rendered in a rather schematic, regular shape (although there are noticeable exceptions),[96] the Apulian artist gives it a pronouncedly irregular and organic form. This is especially evident in the mouth of the sad face in Acre (fig. 3) and the mouth of the sad, or stern, angel of Monopoli. In both works the lower lip seems to be broader on the left side of the face than on the right one, and the line separating the lips is slightly diagonal, descending to the left. Another asymmetry, common to both works, may be found in the rendering of the smiling mouth. As pointed out earlier, the right-hand corner of the mouth of the smiling face in the Acre vessel rises higher than the left-hand one. The same slight irregularity may also be found in the face of a smiling angel from Monopoli. Another minute detail, common to the smiling face in both places, is the small wrinkle in the outer corner of the eye. In early Romanesque sculpture one does not frequently find a great variety of, and emphasis on, facial expressions. In South-Italian sculpture, however, this is a rather widespread feature which may perhaps be regarded as characteristic of this artistic tradition. Note, for instance, the pain distorted face of one of the figures supporting the famous Episcopal Throne of S. Nicola in Bari where the expression is achieved, *inter alia,* by an exaggerated asymmetry of the open mouth. See also the similar motif in the face of the man devoured by the lion, represented on the same throne, where the dramatic distortion of the mouth follows also a diagonal pattern.[97]

A close relationship between the heads of the angels from Monopoli and the heads of the Bari Throne has been mentioned on several occasions. Some scholars have even expressed the opinion that both works were executed by the same hand.[98] The date and sources of the Bari Throne have aroused a well-known disscussion that need not be gone into. It seems, however, to be generally accepted that the Bari Throne "represents the invasion of the northern Romanesque style into Apulia."[99] We shall restrict ourselves to one aspect only, which is of interest for the study of the Acre vessel, namely, the types of heads and the facial expressions.

Fig. 3

96 For some exceptions, cf. Meyer Schapiro, "The Romanesque Sculpture of Moissac," p. 262 and figs. 15, 16. Even in these examples, however (the heads of St. Peter and St. Paul on the pier of the cloisters of Moissac), the mouth is of a more schematic shape than in Acre.

97 Often reproduced. Cf. Kingsley Porter, *Romanesque Sculpture,* ills. 152, 154, 155.

98 Wackernagel, *Die Plastik,* p. 44; Kingsley Porter, *Romanesque Sculpture,* p. 59.

99 Cf. Crichton, *Romanesque Sculpture,* p. 152 ff.; Salvini, *Wiligelmo,* pp. 58, 105 ff. (note 2).

Some rather close affinities of the Bari Throne to the work of Master Wiligelmus and his successors at Modena Cathedral have frequently been discussed. Do these affinities also extend to motifs and aspects significant for the Acre vessel? In other words, do they include facial types and physiognomic expressions that may throw some light on the sources, however distant, of our basin? Looking at Master Wiligelmus' works at Modena one cannot help noticing a certain type of face, and the specific shape of certain features (especially of the eyes) encountered both in Monopoli and in Acre. See, e.g., the broad face, the large and flat nose, and especially the shape of the eyes of the prophet Ezekiel in Modena.[100] Remarkable in our context is also the physiognomic type of the *Cupid with Inverted Torch* on the west façade of the Modena Cathedral.[101] Another example of a similar facial structure may be found in the so-called *Capital of the Sirens* of Modena.[102] Needless to say, there are also significant differences. Wiligelmus' treatment of the hair, for instance, is different, not only from the compact, almost amorphous mass in Acre, but also from the hair strands seen in the angels' heads from Monopoli. However, in spite of such differences of detail, one cannot overlook a certain affinity in the type of the face in its general stylistic tendencies.

In Modena and its surroundings we also find some faces bearing a dejected expression, although usually they are more restrained than in Bari-Monopoli, or Acre. Above one of the Cupids in the Modena Cathedral there is a mask of an emphatic physiognomic expression, of which it is, however, difficult to say whether it is smiling or weeping.[103] Among the other Modena examples that may be mentioned is the face of one figure on the so-called *Capital of the Centaurs*.[104] It shows the physiognomic type that we have encountered several times

100 Cf. Salvini, *Wiligelmo*, fig. 19.
101 Often reproduced. Cf. Salvini, *Wiligelmo*, fig. 49. Compare the proportions of the Cupid's face (very low forehead, very large chin) with the proportions of the smiling face on the Acre vessel (our fig. 4).
102 Salvini, *Wiligelmo*, fig. 55.
103 Salvini, *Wiligelmo*, fig. 52. The difficulty of discerning between a smiling and a weeping face is, of course, not surprising. See the well-known statement by Alberti on this specific difficulty (cf. *Leone Battista Albertis kleinere kunsttheoretische Schriften*, ed. Janitschek [Vienna, 1877], p. 120 ff.). Even Leonardo still echoes this difficulty (cf. Leonardo da Vinci, *Das Buch von der Malerei*, ed. H. Ludwig [Vienna, 1882], p. 384). Another interesting Lombardic example of such a physiognomic expression is the face of a supporting figure in Pieve (cf. Salvini, *Wiligelmo*, fig. 119) which is different in structure but also bears the characteristic feature of the diagonal mouth.
104 Cf. Salvini, *Wiligelmo*, fig. 135 (the beardless face).

57

(broad face, extremely low forehead, broad and flat nose, furrow between nose and mouth), and a convincing suggestion of sadness, the lips being drawn downwards at the corners of the mouth. Further examples are the faces of two figures (probably of Adam and Eve) on the architrave of the left portal in the Cathedral of Piacenza. These heads again belong to the same physiognomic type; Eve's face suggests that she is smiling, while the face of the other figure is of a grotesque character that further contributes to the significance of the facial expression.[105]

According to several scholars, some features and elements of Apulian sculpture betray a connection with early Romanesque art of southern France, especially Aquitaine and Provence.[106] Again we shall content ourselves with a brief observation concerning physiognomic types and expressive forms of the face. In the sculpture of Aquitaine we sometimes find a physiognomic type that, in its structure, bears a general resemblance to the type discussed. I shall mention here the famous Saint in Toulouse who in other respects differs from Apulian sculpture.[107] In the sculpture of Aquitaine one also finds some rather hesitant renderings of joy and sadness, as for instance, two angels holding the Labarum on the western portal of Montsaunes.[108] The faces of the angels bear a dramatic expression: the left one, with lips drawn downwards at the corners, clearly suggests sadness, while the face of the angel to the right is difficult to decipher.[109] It is also interesting to note that the two angels rest on an arch decorated with heads arranged in pairs and facing each other. It is difficult to determine the specific expression of the faces, but as far as I can see they suggest sadness, the formula of the downward-drawn corners often occurring in them.

In Provençal art, too, one finds expressive physiognomic features. The famous faces on the western façade of St. Gilles clearly indicate

105 Salvini, *Wiligelmo*, fig. 113. The other figures on the same architrave reveal, both in gesture and in physiognomy, a marked expressive tendency. See, e.g., the figure beside Adam.

106 For a recent account, cf. Crichton, *Romanesque Sculpture*, p. 153.

107 Kingsley Porter, *Romanesque Sculpture*, ill. 305. For the difference between the Tolosan figure and the sculptures in Apulia (let alone the one of Acre) it is enough to mention the treatment of the hair.

108 Kingsley Porter, ill. 505.

109 The mouth of this angel is drawn upwards at the corners, and in a purely mechanical classification this feature may be read as an indication of smiling. The general expression of the face, however, contradicts such a reading.

smiling.[110] A more serious, but equally emphasized, facial expression is found in other works at St. Gilles.[111]

These examples suggest that the facial expressions of joy and sadness were certainly known in the artistic traditions cited in connection with Apulian sculpture, and that some attempts were made to render such expressions in isolated heads. It seems, however, that the motifs of sadness and joy are more frequent in Apulian art, and they are certainly more articulate in the faces of the Bari Throne and of the angels from Monopoli than in all the other traditions mentioned. (Among the representations of joy and sadness in Apulian sculpture I shall also mention the row of heads decorating the central apse of S. Lionardo di Siponto, a work of the late eleventh century.[112] These faces, expressing sadness, bear the specific features of asymmetric distortion, and particularly the diagonal mouth with downward-drawn corners.) Such sad and distorted faces sometimes remind one of medieval grotesques, and in formal motifs they may indeed have some distant relationship to the fantastic creatures that populate the imagery of the Middle Ages. It is, however, obvious that in the examples mentioned the facial asymmetry and distortion were meant to convey the emotions of sadness and pain; they were not meant, nor were they understood as representations of grotesque creatures.

In Apulian sculpture one also finds smiling faces. The smile is usually indicated by the well-known formula of the lips rising at the corners of the mouth, but there are also examples of a more intuitive representation of this facial expression which is not based on any stereotyped formula. In the *Annunciation* relief over the western portal of Rutigliano (Bari), the angel seems to smile; his lips are exaggeratedly raised at the corners.[113] Similar, though less pronounced, is the expression on the face of the angel (and perhaps also of the Madonna) on the tympanum of the northern portal of the same church.[114] In the *Adoration of the Magi* in S. Lionardo di Siponto, Christ seems to smile. Here the smile is suggested by the overall expression of the face, but it cannot be localized in the mouth; the formula of the upward-drawn lips has not

110 Kingsley Porter, ill. 1322. Kingsley Porter, on p. 60, stresses the similarity of these faces to those of the angels from Monopoli. For possible classical models of the faces in St. Gilles, cf. E. Panofsky, *Renaissance and Renascences in Western Art* (Stockholm, 1960), p. 59.
111 See, e.g., Kingsley Porter, ill. 1323.
112 Petrucci, *Cattedrali di Puglia*, fig. 50.
113 Kingsley Porter, ill. 164.
114 Kingsley Porter, ill. 259.

been applied. Looking at this face one also notices a kind of distant family likeness between the physiognomic type of Christ and the faces on the Acre vessel. In another example, the relief on the portal of the Cathedral of Barletta,[115] the physiognomic formula of smiling has been applied rather mechanically. At the base of this relief, which was carved in the third quarter of the twelfth century, stands a square figure with clearly smiling face. The emotion of joy and satisfaction is not only suggested by the expression of the broad, round face; here the mouth, rendered more schematically then in the smiling face on the Acre vessel, is clearly patterned in the shape of an arc with rising corners.

Considering these examples, we may say that the motifs of sad or smiling faces were well known in Apulian sculpture, and that they attracted the attention of South-Italian artists. If the sculptor of the holy-water basin in Acre did indeed come from southern Italy, he probably brought with him this physiognomic imagery.

The other element of the Acre vessel, the rose is, as already remarked, a common motif in medieval art, often imbued with a symbolic meaning. As roses or similar flowers can be found in many periods and regions of the Middle Ages, their appearance on the holy-water basin of Acre does not point to any specific tradition or school. One notices, however, that in Apulian sculpture roses are very common both in the decoration of buildings and liturgical implements, and that they are represented in a great variety of forms. I shall mention only a few examples which, for one reason or another, might be of some interest in our discussion.

The tympanum of the southern façade of the Cathedral in Troia is framed by an ornamental border, consisting of interlaced bands, roses and different other floral motifs. Some of the roses bear a remarkable resemblance to the blooming roses on the Acre vessel.[116] The roses on the western portal of the same church[117] are flatter and more schematic. A fragment from the destroyed church of Monopoli also shows roses that are remarkable in our context.[118]

Another type of rose, more elaborate than in Acre, can be seen on the southern portal of S. Leonardo (Foggia) and on the tympanum of S.

115 Petrucci, *Cattedrali di Puglia,* fig. 163.
116 Kingsley Porter, ill. 172.
117 *Ibid.,* ill. 173.
118 Wackernagel, *Die Plastik*, pl. xi/a.

Clemente di Casauria.[119] Although these are fully blooming roses, the forms are more pointed than in Acre; in the process of carving the sculptors used the drill, a tool that was never used in the holy-water basin of Acre. Still another interesting example, although somewhat later, is that of two roses on the western portal of the Cathedral of Bitonto (Bari), where they appear beneath a representation of Christ in Limbo.[120] One of the roses is concave, the other convex. Does this juxtaposition of the full and the empty, the projecting and the recessing, follow only decorative considerations, or is it meant to convey a meaning? Does it perhaps reflect the contrast of Limbo and Redemption? Be that as it may, it is worth noting that such a juxtaposition of flowers, faintly recalling the juxtaposition of the blooming and the barren, wilted, in Acre, occurs in South-Italian sculpture.

It is also remarkable that in Apulian sculpture we find several times the juxtaposition of full and flat flowers, a juxtaposition that not only shows different types of flowers but is also suggestive of the different stages of flowering and wilting. A fragment of an ancient iconostasis from the church of Trani combines the two types in a horizontal pattern.[121] A capital from the church of S. Nicola in Bari combines them in a vertical composition: in the upper part a flat "palmette" is represented, in the lower a round, full flower.[122]

Roses are encountered not only on the walls of cathedrals; they are frequently found on twelfth century pulpits carved in southern Italy. Remarkably close to the flowers of the Acre vessel is a rose on a pulpit from S. Lionardo, in the relief representing *The Tree of Jesse*.[123] A pulpit in Groppoli (Pistoia) is framed by a border of rather simply shaped roses which also recall the blooming roses on the Acre vessel.[124] Although roses, being a widely diffused motif, cannot prove a relation of the Acre vessel to any specific school or artistic tradition, the frequency of such roses in South-Italian sculpture, the fact that they appear on liturgical implements, as well as the variety and the characteristic features of their forms deserve our attention in the present context. They may perhaps lend additional support to the assumption that

119 Kingsley Porter, ills. 213, 220.
120 *Ibid.,* ill. 233. Kingsley Porter dates the relief around the year 1200.
121 Wackernagel, *Die Plastik*, pl. iii.
122 *Ibid.* pl. xviiie. Wackernagel describes the flower as an "artichocke." The round form of that flower makes it, however, very close to the usual type of the rose.
123 Kingsley Porter, ill. 226.
124 *Ibid.,* ill. 229.

the artist who produced the holy-water basin of Acre drew from south Italian sources.

In sum, the evidence discussed in this section may be divided in two parts: the one concerning what this evidence excludes, the other what it suggests.

As to the first part, one can be fairly positive. Even a cursory comparison with the other works of Crusader sculpture in the Holy Land that have come down to us clearly shows that the typical French models and traditions, which played such an overwhelming part in the artistic production of *Outre-mer*, were not the sources upon which drew the sculptor who worked in Acre. Our holy-water basin must be traced to other traditions.

As to the second part, our evidence is admittedly loose and rather circumstantial, and does not permit to draw definite conclusions. However, taking into account the different considerations that have been mentioned above, it seems possible that an early twelfth century artist belonging to the group of the Bari-Monopoli master travelled to the Holy Land where he carved the Acre basin. In his work he reflected both the broad current which nourished his imagery (i.e. the tradition of South-Italian sculpture) and the specific stage reached in the development of this school.

V

These assumptions are hypothetical and, as already stated, they cannot be proved conclusively. We must therefore ask whether the historical circumstances prevailing at that time make such an assumption likely, or at least possible.

Before the period of the Crusades, active trade links had already been established between southern Italy — particularly Bari and Brindisi — and the East. Bari maintained particularly close relations with Constantinople, and sailors from Bari are said to have been familiar with the Syrian countryside.[125] Other Apulian cities, especially Trani and Tarento, also entertained commercial relations with the East.[126] These mercantile routes served as pilgrimage roads too, and inevitably acquired religious meanings, as can be seen from the many legends woven around them. Perhaps the most famous legend, told in the *Legenda aurea*, relates of the miraculous salvation of the body of St. Nicholas by sailors from Bari. The saint's body was brought back to Bari and buried in the cathedral that was built for this very purpose.[127] It was, as we know, for that church that the famous Episcopal Throne mentioned in the earlier section of this study was carved.

In the period of the Crusades, Bari was one of the main harbors from which the Crusaders sailed to the Holy Land and through which both

125 Cf. W. Heyd, *Histoire du commerce du Levant au Moyen Age,* i (Leipzig, 1923), p. 96 ff. I am grateful to Prof. J. Prawer of the Hebrew University, Jerusalem, who has generously put at my disposal his knowledge of the sources of Crusader history used in this section.
There were also close relations between Bari and Constantinople, cf. W. Schaube, *Handelsgeschichte der romanischen Völker des Mittelmeergebiets bis zum Ende der Kreuzzüge* (Munich-Berlin, 1906), p. 27 ff. When, in 1058, the Abbot Desiderius of Monte Cassino wished to go to Constantinople, he went to Bari, where he was sure of finding a boat to the Byzantine capital.
126 Cf. Heyd, *Histoire*, i, p. 97; Schaube, *Handelsgeschichte*, p. 27.
127 For the church, including its history, cf. R. Krautheimer, "San Nicola in Bari und die apulische Architektur des 12. Jahrhunderts," *Wiener Jahrbuch für Kunstgeschichte*, ix (1934), pp. 5–42; see also the brief remarks by K. J. Conant, *Carolingian and Romanesque Architecture: 800–1200* (Pelican History of Art, 1959), pp. 214–218.

their envoys and Eastern products reached Christian Europe.[128] Since even boats sailing from other ports of the Adriatic Sea, like Venice, often put in at Bari, one may assume that many of the passengers made the pilgrimage to the cave of St. Michael in Siponto at Monte San Angelo on the northern border of the duchy of Apulia. Many documents attest to the close connections between the Latin settlements, particularly monasteries, in the Holy Land and Apulian institutions. It will suffice to mention here a few of these sources.

A document of 1133, written in Benevento, ratifies and enumerates the properties of Sancta Maria della vale Josaphat (a Crusader monastery near Jerusalem) in southern Italy, suggesting strong and diverse ties between the Crusader monastery and the main centers of Apulia.[129] In 1128 William, the first Archbishop of Sidon and later of Jerusalem, returning from a visit to Europe, was received by the Pope, who gave him a letter written in "the territory of Bari."[130] In 1139 Pope Innocence II wrote to William I, Patriarch of Jerusalem, and to the Canonics of the Holy Sepulcher, informing them that they had been granted monasteries in Bari and Brindisi.[131] In 1179 King William II granted to the Order of St. John warehouses in Barletta which, as the document specifies, were required for the maintenance of connections with the Holy Land.[132]

Along these routes of trade and pilgrimage there must have also travelled artists and images; commercial and religious relations must also have helped to establish relations in the domain of art. It has been shown recently that in several cases Italian art influenced the artists who worked in the Latin Kingdom. If this has been proved for manu-

128 Heyd, *Histoire*, i, p. 93 ff., says that in the Middle Ages no other European country imported so many Oriental products as Italy did. In the twelfth century even fruits from the Holy Land, and other Eastern countries, were offered by wealthy people to their guests. These fruits were probably imported via Bari or Trani (cf. Heyd, i, p. 178).

129 Cf. H. F. Delaborde, *Chartes de Terre Sainte provenant de l'Abbaye de N. D. de Josaphat* (Paris, 1880), pp. 24–26. The document was drawn up on January 3, 1113. Among the properties and privileges mentioned in it there is a baptistery in Trani, other property in Taranto, and the right to keep a boat. The document is signed, *inter alia*, by the archbishops of Bari, Capua, and Benevento. For the monastery of S. Maria della Vale Josaphat, cf. Enlart, *Monuments des Croisés*, ii, p. 230 ff.

130 William of Tyre, xiii, 23. And cf. H. Buchthal, *Miniature Painting in the Latin Kingdom of Jerusalem* (Oxford, 1957), p. 22.

131 De Rozière, *Cartulaire de Saint Sépulcre*, pp. 74–76.

132 Delaville le Roulx, *Cartulaire de l'ordre de Saint Jean*, i no. 562; cf. also Schaube, *Handelsgeschichte*, p. 141.

script illumination and icon painting,[133] it must also be true for sculpture. One should view the possible origin of the Acre basin in the light of these facts.

In the rich history of the routes between southern Italy and the Holy Land a specific event stands out that may have some bearing on the subject of this study. In 1113 Adelaide, widow of Roger I and mother of Roger II of Sicily (to whose realm Apulia belonged), married Baldwin, King of Jerusalem. In August of that year she was conveyed to the Holy Land by a fleet of magnificent ships. The chroniclers relate that she brought with her not only many servants, horsemen, and soldiers but also treasures of jewels, precious stones, and rare fabrics. In the contemporary chronicles no mention is made of any sculptors whom Adelaide might have brought with her (neither can it be expected that they should be mentioned, considering the social status of the artist in that period). It is, however, tempting to assume that among the people who came with the queen were also some artists. One of them, trained in the workshops of southern Italy, may have carved the holy-water basin of Acre shortly after arriving there. It is evident that such a conjecture cannot be proved, but the chronology of events would conform with the results of a stylistic analysis. Be that as it may, the historical circumstances permit us to assume that the holy-water basin of Acre was carved by an Apulian artist in the early twelfth century.

133 Even Islamic motifs penetrated Crusader manuscripts of the twelfth century, not directly but rather via southern Italy; cf. Buchthal, *Miniature Painting*, p. 13.

THE
NAZARETH
CAPITALS

I

In November 1908, while excavating the old Church of the Annunciation in Nazareth, the French archaeologist Father Prosper Viaud discovered five Romanesque capitals of high artistic quality. Although frequently discussed in modern literature, these capitals still pose some serious problems as to sources, style, and iconography.[1] This study is a mere attempt to contribute a few additional observations, without claiming to bring any solutions.

The five capitals are carved in a very bright, yellowish stone commonly found in the surroundings of Nazareth. This stone combines qualities precious for the sculptor: on the one hand, its fine grain allows for the carving of minute details and incising of fine lines; on the other, its hardness guarantees good preservation. In fact, the Nazareth capitals surprise the beholder both by their delicacy of execution and their exceptionally good state of preservation. Thin, deep lines, carved close to each other, do not merge nor are they blurred; they give the reliefs a calligraphic quality which sometimes vividly suggests lines drawn on paper or parchment.

Four of the capitals are of equal size and structure. Each is 42 cm. (16.38 in.) high, 45 cm. (17.55 in.) wide at the top and 27 cm. (10.53 in.) at the base. Each of these four octagonal capitals has six historiated faces, while two faces are bare and were probably intended to be

1 Cf. P. Viaud, *Nazareth et ses deux églises* (Paris, 1910), pp. 149–163 (with an interesting letter by R. Lasteyrie on pp. 167–178); R. P. Germer-Durand, "La sculpture franque en Palestine," *Conférences de Saint-Etienne*, 1910–1911 (Paris, 1911), pp. 235–257, (does not add anything new to the descriptions of Viaud); P. Egidi, "I Capitelli Romanici di Nazareth," *Dedalo*, i (1921), pp. 761–776; C. Enlart, *Les Monuments des Croisés dans le Royaume de Jérusalem*, i (Paris, 1925), p. 126 ff., and ii (Paris, 1928), p. 305 ff.; A. Kingsley Porter, *Romanesque Sculpture of the Pilgrimage Roads*, (Boston, 1923), p. 167 ff.; P. Deschamps, "La sculpture française en Palestine et en Syrie à l'époque des Croisades," *Monuments et Mémoirs de Fondation Piot*, XXXI (1930), pp. 91–118; T. S. R. Boase, "The Arts of the Latin Kingdom of Jerusalem," *Journal of the Warburg Institute*, II (1938–1939), pp. 1–21 (the capitals are discussed on pp. 9–10).

engaged in the wall. The fifth capital (figs. 7–11) differs from the others both in size and structure. It is 65 cm. (25.35 in.) high; 76 cm. (29.64 in.) wide at the top and 36 cm. (14.04 in.) at the base. This capital is divided into three faces only.

For historical reasons the period in which these capitals were carved can easily be established. Their mature Romanesque style obviously points to the late twelfth century. The octagonally shaped capital appeared in France (Notre Dame de Melun, Apse of Dommartin in Ponthieu, inaugurated in 1163) and in Germany (Marburg) only in the second half of the twelfth century.[2] The Nazareth capitals, however, must have been carved before 1187. On July 4 the Crusaders were defeated by Saladin in the famous battle of the Horns of Khatin, and Nazareth was conquered by the Moslems. Although the Christian churches of Nazareth were not destroyed until 1263,[3] no building or decoration of a church could have been undertaken after Saladin's victory, hence our capitals must have been carved shortly before 1187. Additional considerations support this assumption. Viaud relates that the capitals were found near an unfinished doorway (the northern portal of the old basilica) and were most probably intended for its decoration.[4] It is obvious that they were made *avant la pose*,[5] and apparently had not yet been set in their appointed position when Saladin conquered Nazareth. Moreover, it seems that they were not just abandoned, but had been carefully hidden in a small cave by

2 Cf. Enlart, *Les Monuments des Croisés,* i, p. 119. However, this type of capital remained rather rare, even in the second half of the twelfth century. Enlart, *ibid,* i, p. 130, describes the shape of the Nazareth capitals as follows: "Leurs faces sont curieusement évidées, pour se raccorder aux futs octogones à faces concaves, disposition que je ne connais que dans cet exemple et au cloître de San Cugat de Valles, où son emploi est un peu different, mais systèmatique aussi." Interestingly enough, one finds octagonal capitals in several centers of Crusader art in the thirteenth century, in Acre (Enlart, fig. 66, pl. 50) and in Nicosia in Cyprus *(ibid.,* fig. 120, pl. 38).

3 The destruction of the venerated basilica evoked the letter *("Vocem terroris")* of Pope Urban IV to the King of France, in which the Pope wrote: "Venerandam ecclesiam Nazarenam totaliter destruens redegit ad solum." Quoted by Deschamps, "La sculpture française," p. 106.

4 Cf. Viaud, *Nazareth,* p. 55; Egidi, *I Capitelli Romanici* p. 767, believes that this was a side entrance, and that the position of the capitals was to be similar to that in Borgo San Donnino.

5 The rough side-faces (right and left) on both extremes of the four smaller capitals evidently were to have been engaged in the wall. Several times limbs or ends of drapery lap over these rough side-faces (figs. 28, 35, 36), which would have been impossible had the capitals been carved *in situ*. The large capital has no such bare side-faces.

Christians who appreciated their value.[6] All this strongly suggests that the capitals could not have been carved much earlier than 1187. Their style confirms that date.

6 All scholars seem to agree that the capitals were carefully hidden; they only disagree as to the time when this was done. Enlart, *Monuments,* ii, p. 295, believes that it was done after 1263 when Sultan Bibars gave orders to destroy the Christian church; but before the basilica of the Annunciation was actually destroyed, pious Christians saved the capitals by burying them in the ground. Deschamps. "La sculpture française," p. 107 ff., doubts it. He relates that Hugues Vincent, who was present at the excavation, reported that the capitals surprised by their "freshness" when they were discovered (as I have said, they are today still in an exceptionally good state), and concludes that they could not have looked so "fresh" had they been exposed to the open air for almost eighty years (from 1187 to 1263). Since the capitals certainly were never set in their proper place, the assumption that they were hidden in 1187 seems more likely.

II

I shall begin this study with a description and brief analysis of the most significant artistic features of the Nazareth capitals.

The Architectural Ornamentation. The upper part of the capitals consists of an elaborate representation of a building. This part is nearly identical in the five capitals. Obviously the same model was used for all of them, and the artist (or artists) followed a well-established pattern. However, the relationship between the architectural ornament and the rest of the capitals, particularly the figures, is rather complex. The architecture is both a milieu in which the figures are set and a frame to the scenes, but a closer investigation of the compositional pattern of the capitals reveals a certain underlying tension between these two functions.

The architectonic pattern consists of a few, well-defined elements, mainly a combination of wide and of slender arches. The wide, semi-circular arches are placed in the lower storey, forming the base of the edifice, also forming the basic milieu of the figures, and apportioning the space for each scene. The slender, stilted arches — varied in detail but uniform in structure — constitute the upper stories. This combination recalls, of course, a well-known type of Romanesque façade, one that found its most accomplished expression at Cluny. The corners of the capitals are tower-shaped, and again obviously stem from a single model. Their base describes a downward-pointing triangle, a feature that creates the impression that the towers are seen from above. At the top of the large capital is indicated a tile roof, clearly pointing to the Western origin of the model.[7] If the artist was indeed a

7 A fantastic conglomeration of towers, arches, gables and tile roofs occurs, of course, in Romanesque illuminations. Cf. Meyer Schapiro, *The Parma Ildefonsus; a Romanesque Illuminated Manuscript from Cluny and Related Works* (Monographs of the College Art Association of America, xi) (1964), p. 12 and figs. 1–6, 15, 20. It is interesting to notice that in a Spanish copy of this manuscript *(ibid.* figs. 71–72, 74–84) the tiles of the roofs have been consistently omitted.

Burgundian, he was inspired in his architectural imagery by the famous buildings of Cluny or elsewhere in Burgundy.

Representations of buildings are met frequently, and in various contexts, in Western sculpture of the twelfth century where architectural imagery also plays an important part in the decoration of capitals. There was, however, no uniformity in the employment of this imagery in the art of that period, which displayed a variety of types and patterns even in the limited realm of capital decoration. In some twelfth-century capitals a building is represented in a corner, in others the image of a façade (or even of a city) covers the whole surface and serves as a background to the figurative scenes. In such cases, the representation of buildings is usually determined by the story rendered on the capital.[8] In Nazareth the meaning of the buildings is not altogether clear, but the architectural decoration fulfills a more significant compositional function in the general layout of the capitals and in determining their specific character as works of art. This is achieved mainly by two means: 1. The architectonic forms and motifs decorate the upper, strongly projecting part of the capitals, thereby enhancing the impression of a deep recess in which the figures move and the scenes unfold. Needless

[8] Examples of the main types:

(a) Buildings in part of the capital: usually a tomb or a specific church, are meant. Cf. the capital at Mozat (Puy-de-Dôme) where the building, although consisting of arches, tileroofs, and a tower, represents the tomb of Christ visited by the three Marys (Kingsley Porter, ill. 1227). Another example is a capital in the Museum of Toulouse representing Holy Mary Egyptiaca chased from the church (cf. E. Mâle, *L'art religieux du XIIe siècle en France*, 6th ed. [Paris, 1953], fig. 163).

(b) Buildings covering the whole background of the capitals: cf. a capital in Avignon representing Delilah cutting Samson's hair (Kingsley Porter, ill. 1343). Here the architecture obviously represents a palace in which the event takes place; the interior space is indicated by a curtain. Somewhat similar in arrangement is a capital from the triforium of St. Benoit-sur-Loire (Kingsley Porter, ill. 1420), where arches and towers represent the exterior, and a draped curtain represents the interior of the building. In these examples the architecture forms the overall pattern of the capital, and although buildings are not represented on its faces, the whole capital is conceived as a building.

(c) Buildings covering the face of the capital and forming an actual "background" of the scene. Cf. the Zacharias capital in Clermont-Ferrand (Kingsley Porter, ills. 1175–1179); a capital from St. Nectaire (Puy-de-Dôme) (Kingsley Porter, ills. 1197–1198); the capital from Moutier-St. Jean (Côte d'Or) (Kingsley Porter, ill. 64). In these examples the buildings do not form the frame of the capital; they do not fulfill a function in the structure of the work, but they cover the whole face of the capital, or what is left of it behind the figures.

The Nazareth capitals come closest to those mentioned in type b since the architecture forms, in fact, their structure. They differ, however, from the examples mentioned in what may be termed the "meaning of the architectural frame." While in the capitals of Avignon and St. Benoit-sur-Loire the architectonic motifs are meant actually to represent a building (witness the curtain indicating the interior of the building, as opposed to the exterior suggested by arches and towers), the meaning of the architectonic motifs in Nazareth is not clear.

to say, deep undercutting is a common feature in French Romanesque sculpture. One is reminded, to mention but a few characteristic examples, of a tympanum of Avallon, where the figures (that differ in other respects from those of our capitals) are set in a deeply carved space, vaulted by wide, depressed arches.[9] A holy-water basin of Chamalières, adorned with the figures of prophets, also shows a certain similarity to the Nazareth capitals. The whole work is encompassed by a vaulted architectural frame which, as in our capitals, consists of a row of arched portals and towers. It is true that this work, although of monumental proportions, lacks the slanting sides of a capital and therefore has not that characteristic depth. Nevertheless, the figures are situated "within" an enclosed space.[10]

Deep undercutting is used, of course, in capitals of the period. A capital from St. Benoit-sur-Loire bears certain resemblances to the work of Nazareth both in the deep undercutting and in individual motifs (round arches meeting at little towers, the hands of the Saint and the Virgin extended across the limiting lines of the capital's faces). In spite of these similarities, however, the capital from St. Benoit-sur-Loire differs, both in spirit and in actual models, from those of Nazareth.[11] Several Provençal capitals show a combination of deep undercutting and architectural imagery in their upper parts. But these capitals are usually more "primitive" in style and execution, and of heavier proportions.[12]

9 Kingsley Porter, ill. 140. It is interesting to note another feature. On the tympanum three scenes are represented (Adoration of the Magi, Journey of the Magi, Magi before Herod). The arches and columns which belong to the relief itself form divisions between the individual scenes, and thus fulfill a function similar to that of the architectonic frame in the Nazareth capitals.

10 Kingsley Porter, ill. 1154; see also Michel's *Histoire de l'art*, i. 2, fig. 332. For the history of this holy-water basin cf. above, p. 21 ff. The famous jamb-sculptures from St. Etienne in the museum of Toulouse (Kingsley Porter, ills. 436–440) have a similar arrangement, but the space is shallower.

11 Kingsley Porter, ill. 1420. For the difference in style note, e.g., the lack of linear quality in the figures, and the fact that they do not recede in space, but have a more or less equal "mass" (for the Nazareth capitals in this respect cf. below, p. 83 ff.). The difference of actual models becomes obvious when comparing the towers. In the capital of St. Benoit-sur-Loire the towers are more primitive than those of Nazareth, they lack the geometrical basis, and so on.

12 See especially the capitals of La Daurade, now in the museum of Toulouse (Kingsley Porter, ills. 464–473). Some of these capitals (Kingsley Porter, ills. 466, 469, 471–73) are decorated by representations of walls and crenellations in their upper part. Especially in the last-mentioned capital, representing the Last Supper, the deep undercutting as well as the architectonic frame, or rather "roof," are very clear. These capitals differ, however, from those in Nazareth, both in the form of the individual motifs (e.g. the representation of huge, square ashlars instead of slender, elegant arches) and in the basic conception. The hanging arches of the La Daurade capitals remain isolated from the figures and scenes below them, thus betraying an approach to composition which is altogether different from that of the Nazareth capitals. We need not enter into a discussion of the history of the La Daurade capitals as it is generally accepted (cf. Kingsley Porter, p. 242 ff.) that they are roughly contemporary with the Nazareth capitals.

The deep undercutting combined with a projecting architectural frame, indeed call to mind the famous capitals of Chartres, but although there are some striking similarities between our capitals and those of Chartres, there are also significant differences to be discussed further.[13]

2. In the Nazareth capitals the architectural frame fulfills a fundamental function since it not only encompasses the entire upper side of the capital, but also forms the border between the separate faces upon which the various scenes unfold. We shall see that the artist, in composing the groups and in shaping the individual figures, objects, or even single limbs, conceived of the architectural frame as an organic part of the composition. In this respect, the Nazareth capitals differ fundamentally from those of Chartres, where the architectural frame forms a roof over the dynamic scenes, but does not in any way blend with them.

Most Crusader capitals that have been preserved show a basic pattern that differs from the architectonic frame of the Nazareth sculptures. Depressed arches occur in many of them, but the other elements are usually different. The decoration of Crusader capitals often consists of floral motifs,[14] which are altogether lacking in Nazareth. There are, however, a few capitals from the Latin Kingdom where we find an architectonic frame similar to that of the Nazareth capitals, both in its individual motifs and in the general function it fulfills. A capital found in Damascus and now at the Louvre[15] displays an elaborate architectonic frame forming divisions between the faces of the capital, which is

13 Viaud, *Nazareth.* p. 150, mentions Chartres, Bourges, and Carrières-Saint-Denis; Egidi, *I Capitelli Romanici*, pp. 770 ff., says that the baldachins over the western portal of Chartres are the only examples he knows of baldachins capping capitals in a similar manner. For Carrières-Saint-Denis, see the altar frontal, now in the Louvre (Kingsley Porter, ill. 1485). And see also the capital above the figure of a saint in St. Loup-de-Naud (Kingsley Porter, ill. 1494). The sometimes striking similarities between our capitals and those mentioned, especially those of Chartres, concern mainly the motifs of the architectonic frame. However, there are also significant differences. In Chartres the architectonic frame is interwoven with floral motifs, a feature not encountered in Nazareth. Moreover, at Chartres this frame forms a roof over dynamical scenes, but does not in any way encroach upon them, as is the case in Nazareth.

14 The tradition of floral motifs on capitals, apparently taken over from antique sculpture, continued in the Holy Land. Medieval capitals in Jerusalem have misled many an observer because of the classical features in their floral ornaments, and have been classified as late antique. Cf. R. Kautzsch, *Kapitell Studien: Beiträge zu einer Geschichte des spätantiken Kapitells* (Berlin, 1936), p. 98 ff. Good examples of capitals partly decorated with such ornaments are to be found in Crusader churches of Jerusalem and in the Cathedral of Tortosa in Syria. See also the capital mentioned in note 16.

15 Cf. C. Watzinger and K. Wulzinger, *Damaskus die antike Stadt* (Berlin, 1921), figs. 82–85, and p. 110 ff. Cf. also Enlart, *Monuments des Croisés*, ii, p. 101 ff., and Marcel Aubert, *Description raisonnée des sculptures du moyen âge, de la renaissance et du temps moderne*, I. *Moyen Age* (Paris, 1950), fig. 105b.

thus an important factor in the composition of the whole work. The architectonic motifs of another capital, in the Church of the Holy Sepulcher in Jerusalem,[16] also reveal a certain resemblance to the Nazareth sculptures, but as a whole the capital of Jerusalem is more archaic than those of Nazareth, and shows different characteristics. The figures are heavier in their proportions, and the decoration consists partly of floral forms. The architectonic frame of this capital shows, however, a certain resemblance to those of Nazareth.[17] Although this similarity does not permit speaking of a particular "School of Crusader Sculpture" in the Holy Land, it may suggest that the same models were to some extent used both in Jerusalem and in Nazareth.

The type of architectonic frame which we encounter in the Nazareth capitals is not unknown in French Romanesque sculpture. A twelfth century capital from Plaimpied (fig. 43) comes perhaps closest. Its projecting upper part is shaped in the form of large arches which meet at double-storied towers forming the corners of the capital. The towers themselves consist of rows of arches which, although less slender and elegant than in Nazareth, are reminiscent of them. The towers in the Plaimpied capital also display the tiled roofs known from our capitals. Different other similarities between the Plaimpied and the Nazareth capitals have been noticed. At Plaimpied the large arches are decorated with a pattern of diagonally crossed lines which also appears on an arch (fig. 43) and on the garments of the Nazareth figure (figs. 12, 17, 18).[18] It has further been observed that at Plaimpied one finds the large haloes which are a characteristic feature of the Nazareth capitals.[19]

Despite these similarities there are significant differences of which I shall mention here only those concerning the architectonic frame: in Plaimpied one finds a continuous row of arches in the towers only,

Fig. 43

Figs. 43, 12, 17, 18

16 Cf. Enlart, *Monuments des Croisés,* fig. 293, pl. 96. In 1810, this capital was badly damaged in a fire, so that its style cannot be determined conclusively. Enlart, *ibid.,* i. p. 129, relates it to San Cugat and the western portal of Chartres.

17 The similarity consists mainly in the fact that the arches capping the capital end in triple-storied towers. However, the towers (only one can be seen, the other must be inferred) and their arches are rather heavy, their proportions broad and low, and they differ in form and spirit from those of Nazareth. At the center of this capital is a very low tower with heavy crenellation (crenellation is also carved at the first story of the tower to the right of the capital), a motif well known from Aquitaine capitals (cf. above, note 12), but which does not appear in Nazareth.

18 Boase, *The Arts of the Latin Kingdom of Jerusalem,* p. 11, thinks that the hand of the Plaimpied Master "is all but unmistakable in work at Nazareth." W. Oakeshott, *Classical Inspiration in Medieval Art* (London, 1959), p. 82, also believes that the Nazareth capitals and the capitals of Plaimpied are the creations of the same master. Although a close relation between these works cannot be doubted, an identity of their masters is hard to accept.

19 Enlart, *Les Monuments des Croisés,* p. 131.

77

whereas in Nazareth they cap the entire capital; the towers themselves are not represented in the position peculiar to those in Nazareth, i.e. with their base forming a downward-pointing triangle, and finally at Plaimpied the architectonic frame is completely detached from the capital, and thus remains an external frame. A close relationship between the masters of Plaimpied and Nazareth seems probable, but we cannot be sure that the same artist carved the works in both places, neither that precisely the same models were used in them. Moreover, in Nazareth are discernible influences which cannot be traced to Plaimpied, but rather point to twelfth-century French sculpture from other regions.

After this brief comparison we may resume the discussion of our initial problem: the character of the architectonic frame and its artistic meaning in the Nazareth capitals. The observations I have made so far clearly suggest an intimate relationship between the architectonic frame and the figurative scenes. Considering the interplay between these elements we might say that in our capitals the architectural frame is the "medium" in which the figures are set. But this relationship also contains another, inharmonious quality; one might even say that there is a hidden contrast, or at least a tension, between the architecture and the scenes, a tension that tends to transform the architectural imagery into a mere neutral "frame." The figures have not the characteristic stiffness of the buildings, while the architectonic frame lacks the flexibility, the organic quality, and the intricate shapes of the figures.[20] While the figures show a great variety of postures, aspects, gestures, and proportions, in the arches on the upper part of the capitals the same uniform, rather limited, motifs are repeated; they are strictly vertical and angular in form. In comparison with the figures, the architectonic

[20] That this difference cannot be accounted for by the mere and apparently simple and convincing explanation that either an "organic" figure, or a "mechanical" building is being represented, is clearly shown by several works of art of the same period in which similar features are combined. See, for example, the capital of St. Benoit-sur-Loire (cf. above, note 11), in which the towers that form part of the architectonic frame have arches of irregular forms, corresponding to the shapes of the figures. In twelfth century art one often finds a marvelous correspondence of architectonic and figural motifs. See, e.g., the canopies of the famous figures of Etampes (Kingsley Porter, ills. 1463–1466) which, in their forms and position, echo the stiff and linear patterns of the figures. Or see the architectonic roof of a capital from Coulombs, now in the Louvre, representing the Sleep of the Magi (Kingsley Porter, ill. 1471; M. Aubert, fig. 72) where the slanting position of the towers is adapted to the position of the figures. A detailed discussion of that correspondence is, of course, beyond the scope of this study; we may, however, say that the difference in style between the architectonic frame and the figures on the Nazareth capitals betrays a different stylistic approach, and perhaps even a different hand. And see below, p. 159 ff.

decorations are highly polished, and attain a degree of "finish" absent in the scenes themselves. Looking carefully at the capitals one feels that the two basic elements, architectural motifs and figures, have different artistic orders and aesthetic norms. The ambivalent relationship between them — the architecture being both the "medium" and frame in which the figures and scenes are set — is an essential element in the artistic character of the Nazareth capitals.

Composition. The discussion of the architectonic frame, of its form and functions, raises the problem of composition. I refer here not to the composition of the individual scenes, but to the conception and structure of the capital as a whole. Each capital is, as mentioned, divided into several faces. By probing into the complex relationship between the capital as a whole and the separate faces one can perhaps clarify some basic features in the composition of these works. Which is here the more significant, the capital as a whole, or the individual face? Which of these two is here the primary unit?

The large capital (figs. 7–11) has only three faces which, although not separated by a frame, are clearly distinguishable both in contents and in style. On the central face (vaulted by two arches) a crowned figure, representing Faith or *Ecclesia*, leads by the hand another figure who probably represents the Faithful or an Apostle. On each of the two side-faces is carved a group of demons with wildly distorted, devilish physiognomies, who threaten the central group with brandished weapons. Here the content of the composition is clear: a "pure," holy middle section, flanked by two impure, demonic sides; the Church safely leading the believer through a demonic world.

This division between the central and the two side-faces can also be observed in style. The figures of the middle group are carved in a calligraphic manner, the lines are clear-cut and the surface highly polished. In this group there are no overlappings, as the figures are presented in undisturbed view, and they have ample space to move. In the two groups of devils the artist made use of different techniques. Here more emphasis is placed on jutting masses than on lines, and the lines, insofar as the artist used them at all, are less clear-cut, calligraphic, and mannered than in the central group. The figures of the demons are heavier and more material than the "holy" figures; their postures are twisted, spiralling, and they are compressed into a space which looks too narrow for them.

The structure of the four smaller capitals is more complicated. There

Figs. 7–11

is not so clear and symmetrical an organization of contents and style as observed in the large capital, but the faces are clearly separated from each other by a projecting, clean-cut, decorated frame. One can see how carefully the artist observed these delimitations in representing the scenes. The proportions and forms of the figures are adapted to the limits of the single face.[21] Iconographically, too, the unity of each single face is observed. It is true that the representation of each theme unfolds across several faces: on the other hand, however, each single face shows a certain self-contained phase, group, or figure of the story represented.[22] All this indicates that each face was conceived as a self-contained unit. In a few cases figures are represented on the separation line between two faces of a capital. Such figures, always of diminutive proportions,

Figs. 29, 38, 39

which actually straddle the borderline (figs. 29, 38, 39), do not establish a connection between the two faces. These figures look always in one direction only; they have, so to speak, a front, while they turn their backs to the other side, or to the other face of the capital. In a few cases a raised hand touches the frame without being projected beyond

Figs. 12, 13, 24

it (figs. 12, 13, 24); this gesture lends the limit of the face an expressive force, without actually connecting two fields. In all the five capitals we find only one gesture that actually reaches from one field into the other:

Figs. 21, 22

St. Peter resurrects Tabitha by grasping her hand (figs. 21, 22). This gesture is explicitly required by the text,[23] and without it the meaning of the scene would be incomprehensible. However, St. Peter's hand does not completely obliterate the character of the single face as an isolated field of composition; the link is reduced to a minimum, the hand of St. Peter, and even in this limited area one can still discern the

Fig. 7

21 Thus the arm of a demon (fig. 7) is too short because it is adapted to the form of the field. In view of the high quality of workmanship of this capital one cannot, I think, explain, this "fault of proportion" as simply showing a lack of knowledge or mastery. It is an aesthetic principle – the circumscription of the area – which determines the proportions. Even the form of a sword is adapted to the arch-shaped demarcation of the face. Two exceptions to this rule are the limbs and draperies that reach over to the bare faces that were intended to be engaged

Figs. 36, 37

into the wall (figs. 36, 37).

22 The "primitive continuity of narrative" in Romanesque capitals has been compared to the continuous illuminations of ancient parchment rolls or to the decorations of Roman triumphal columns (Meyer Schapiro, "The Romanesque Sculpture of Moissac," p. 283). The capital was fitted for such a method since its entire surface cannot be encompassed at one glance. Meyer Schapiro rightly stresses, however, that the demarcation of the individual faces, a characteristic feature of Romanesque capitals, even if often less pronounced than in Nazareth, tends to break up the continuous flow of narrative and to establish the individual face as a basic unit. In Nazareth the half capital (i.e. three adjoining faces) is sometimes conceived as a unit.

23 "and turning him [self] to the body [of Tabitha] said: Tabitha, arise. And she opened her eyes: and when she saw Peter, she sat up. And he gave her his hand and lifted her up" (*The Acts of the Apostles*, 9:40–41). The Nazareth capital represents the story quite literally.

boundary of the capital-face. The hand does not continue the movement of the outstretched arm in a natural manner, but, being adapted to the slanting position of the face into which it reaches, seems to be fractured.[24]

All these observations suggest that the individual face is the primary unit of artistic composition in the Nazareth capitals.

However, the capitals are not mere collections of individual faces; careful observation reveals many indications of a veiled but effective unity. We may begin with the simplest fact — the number of figures on each face. At first glance one notices the symmetrical arrangement of the figures on the large capital. The groups of demons on the side-faces are so similar that they seem to be reflections of each other. The figures on the central face, although different in expression, are also parallel in direction and movement. Two of the small capitals are completely symmetrical in the distribution and arrangement of the figures. On each of the four external faćes (two on the extreme right and two on the extreme left) there are two figures; on both central faces (i.e. third and fourth) there is but one figure. The single figures are the most significant in meaning, and they represent the climax of the action rendered on the capital.[25] This distribution points to a conception of the capital as a comprehensive unit.

Where there is no symmetrical number of figures on the corresponding faces of a capital, the artist has tried to re-establish the equilibrium by means of composition. In the Tabitha capital there is no numerical balance of figures in the two halves. On the central face of the left half (fig. 22, left) there are two figures, whereas on the corresponding face of the right half (fig. 25, left) is carved only St. Peter's figure. However, St. Peter's figure is of great mass (as opposed to the two slender figures on the opposite side), it fills the whole face, and the expressive movement of his arm reaches from one border of the field to the other. So here, too, we find an attempt to achieve symmetrical figuration of the whole capital.

In the last capital no symmetrical number and grouping of the figures

Fig. 22 left

Fig. 25 left

24 For a somewhat similar representation of a hand which seems "fractured" because its position is adapted to the face of the capital on which it is represented, cf. the capital from Clermont-Ferrand (Kingsley Porter, ill. 1177, and especially ill. 1178, the hand of Zacharias). The form of Tabitha's bare breasts on our capital reminds one of the form of Eve's bare breasts on another capital from Clermont-Ferrand (Kingsley Porter, ill. 1171), but this may be a widely diffused medieval tradition. And cf. below, p. 111 ff.

25 Cf. figs. 12, 13, 20.

Figs. 12, 13, 20

can be observed, but here, too, the attempt to establish a comprehensive unity of composition is obvious, an attempt based upon the postures and movements of the figures. In the Nazareth capitals, figures are rarely linked by a distant gesture or glance of the eye. The main connections are established by physical contact (and this is also the reason for the great significance of the hand, the principal organ of touch). Hence, despite the high skill and technical mastery of the Nazareth artist, the capitals betray an archaic principle of composition.[26] However, besides physical contact one finds here another manner of establishing relationships, though less evident: the movements of the figures create sometimes a closely knit pattern that encompasses the whole capital. Such a pattern is best visible in the capital of Tabitha and St. Peter. The capital is divided, both in content and composition, into two equal halves. Each half has its own center, and the figures represented on the three faces which form the respective half are grouped around it.[27] But on looking closer one notices that the movements of the figures connect the two halves. The diagonal position of Tabitha's bed on the left half (fig. 22) corresponds to the diagonal movement of St. Peter's arm on the right (fig. 24); the raised hand of Tabitha corresponds to the raised hand of St. Peter. There is a kind of invisible arch that holds together the two apparently self-contained halves of the capital and creates a comprehensive unity. As this unity contains many tensions, we may apply the term "discoordination" to describe it.[28]

Fig. 22

Fig. 24

Figs. 29–35
The two halves of the last capital (figs. 29–35) also show a "discoordinated" composition, each half having again its own center. The left half is centered around the figure of the possessed who is led by a demon; the right half is grouped around the figure of the executioner who beheads the Apostle. There may be a certain parallelism of opposites since the horribly expressive demon on the left half corresponds to the classically beautiful figure of the hangman on the right. There is also a certain consistent discoordination in the movement of these

26 For archaic qualities in Romanesque art, cf. Meyer Schapiro, *The Parma Ildefonsus*, p. 251 ff. and *idem*, "From Mozarabic to Romanesque in Silos," *Art Bulletin*, xxi (1939), pp. 313–374, especially p. 334 ff. For gestures in the Nazareth capitals see below, p. 111 ff.
27 See below, pp. 118 ff, 137 ff.
28 I use this term as defined by Meyer Schapiro, "The Sculptures of Souillac," *Medieval Studies in Memory of A. Kingsley Porter* (Harvard, 1939) p. 362: "By discoordination we mean a grouping or division such that corresponding sets of elements include parts, or properties which negate that correspondence."

figures; the demon turns to the left, the executioner to the right. However, the very motion of turning away from each other reveals a mutual relationship; this divergence also includes a convergence. The complicated overlappings of the legs of the possessed and the demon, and the spiralling twist of the possessed's body point not only to the left (i.e. the main, diverging direction) but also to the right, that is, to the other half of the capital. On the right half, the kneeling Apostle is definitely turned towards the left half of the capital, that is the direction he faces, as opposed to that of the executioner, thus bringing out the convergent movement. In this capital, which is so full of tension, the two sets of conflicting movements are clearly visible: the one set may be described as movements of divergence, tending to split the capital in two halves; the other, rather submerged set, consisting of converging movements, is important as an element of composition and tends to create a comprehensive unity of the capital as a whole.

Tension, necessarily emerging from this clash of directions, is made the basic principle of composition in the Nazareth capitals. Romanesque sculpture as an art of tension and twisted movement is clearly expressed in our works.

Line, Mass, and Texture. The mastery of the artist who carved the Nazareth capitals permits us to study in detail the means which he employed to achieve the various effects he aimed at. These techniques consist mainly in a highly refined connection of mass and line and sophisticated use of different stone textures.

The relationship between projecting, bulky mass and finely "drawn" line is of great significance in the Nazareth capitals, as it is in Romanesque sculpture in general. A glance at the drapery immediately points to the importance accorded to line, as a means of representation. Folds, hair, waves, and even physiognomic features are of a calligraphic quality. The admirably crisp cutting turns the faces of the capitals into dense fields of curved lines which remind us sometimes of pen drawings. Abstract patterns of rhythmically arranged lines often dominate the representation, obscuring the shape of the figures and objects.

But the calligraphic quality, although prominent, is by no means the single, or even dominant, stylistic feature of our capitals; it is intimately connected with mass. Some figures, or rather parts of figures, are bulky, and they so strongly project as to stand "in front" of the capital, or of the face from which they jut. It is possible that the plastic emergence of certain parts has also an expressive, or symbolic meaning, since

limbs of particular significance (the heads, Christ's blessing hand) project more than others.[29] Considering all this, one cannot say that the artist relied only, or mainly, on lines in carving the capitals. I shall attempt to show in some detail that the two means, line and mass, are not isolated from each other but that, on the contrary, they are closely interrelated.

When talking of projecting "mass" we must, of course, remember that the small size of the capitals gives a strong plastic effect to even slight differences of modeling. A figure of similar modeling would seem quite flat on a tympanum or a large pier, while in a small-size capital it might create the impression of being almost a statue in the round. We must therefore be careful in speaking about mass when we refer to the intention of the sculptor. It might be useful to recall that in some Romanesque reliefs, even in capitals, one finds projecting parts of figures or objects which are actually detached from the main block (see e.g. the ornaments on the capitals of Cluny, the head and the hands of Christ's figure on the capital of Plaimpied). In the Nazareth capitals there is no such total emergence of the figures, or parts, from the block; the projecting limbs (mainly the head of the *Ecclesia* on fig. 7, the head of the right figure on fig. 40, Christ's blessing hand on fig. 13) are not actually detached from the stone and have no "back-side" of their own. They only create the impression of being isolated. It is interesting to inquire into the means by which this impression is achieved.

It seems that the artist applied two means here. The one is simply the rendering of projecting parts in almost full mass, that is, the proper means of sculpture. Thus, to give but two examples, the heads of the Apostles in fig. 13 not only stand in front of their haloes, but actually jut further than any other parts of their own figures, similarly with the head of Christ in fig. 24.

However, the real plastic projection of these parts and limbs is further stressed by another means, namely, a sophisticated combination of textures. The capitals of Nazareth show three clearly distinguishable types of surface: (1) the smooth and highly polished surface of the figures (the smoothness enhancing the linear quality of the reliefs, because the deeply cut folds result in clean shadows and precise silhouettes); (2) the rugged surface of the backgrounds where the marks of the chisel, visible at more or less regular distances from each other (see figs. 14, 20) remained untouched; (3) the finely and regularly

Fig. 7
Figs. 40, 13

Fig. 13

Fig. 24

Figs. 14, 20
Figs. 13, 20, 23 29 See figs. 13, 20, 23.

84

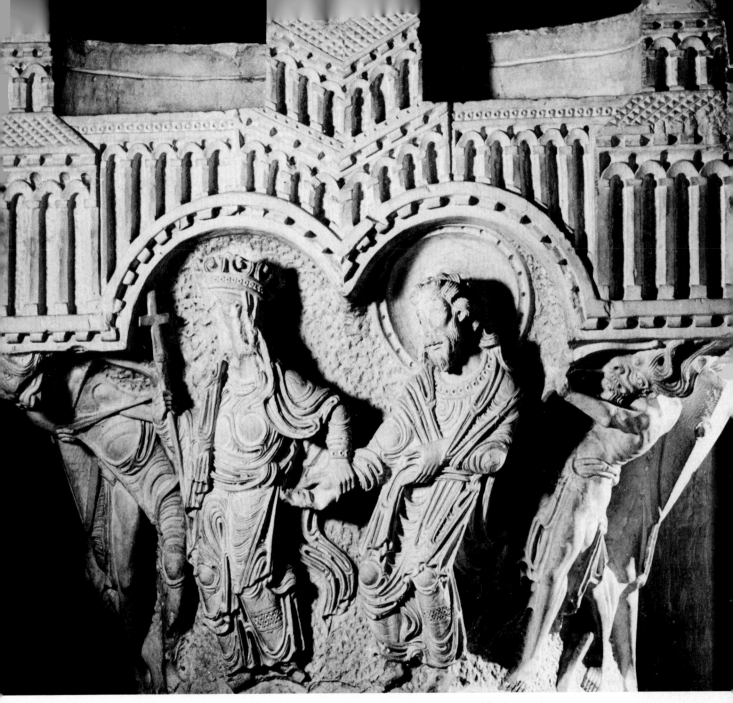

7 Capital: *Ecclesia* leads the believer, Church of the Annunciation, Nazareth.

85

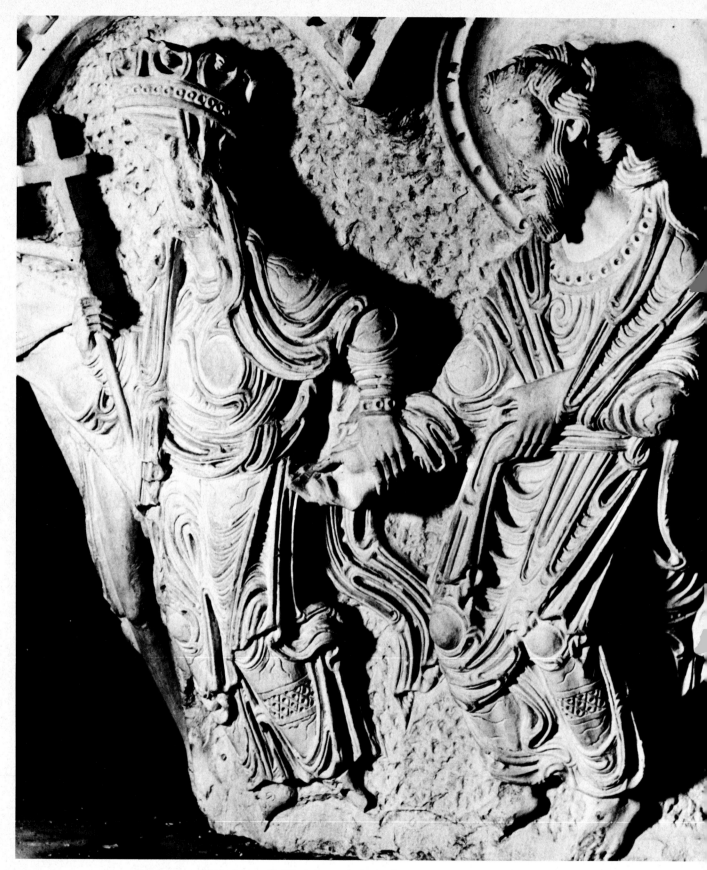

8 Above—Capital, detail (*Ecclesia* and the Believer).
9 Right—Capital, detail (the Believer).

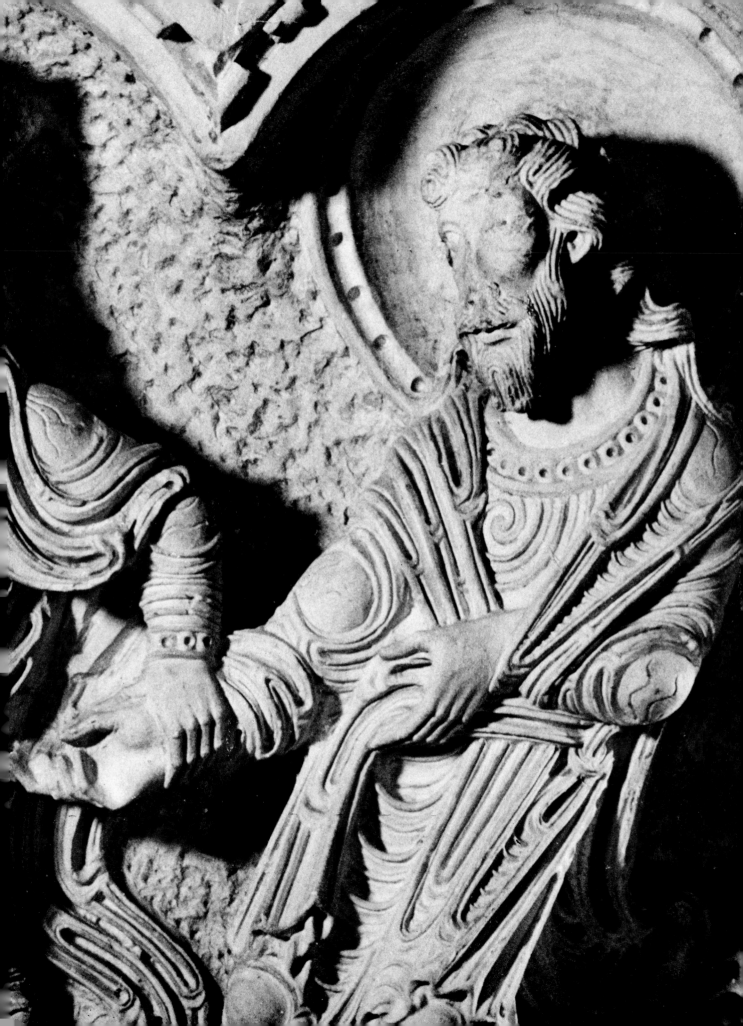

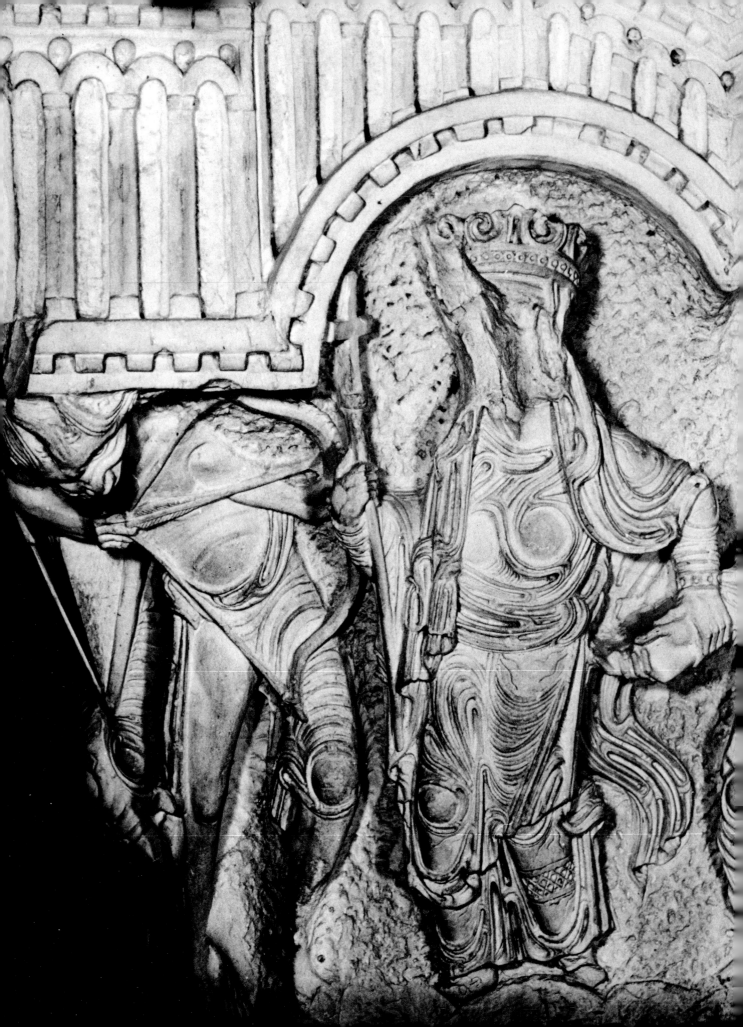

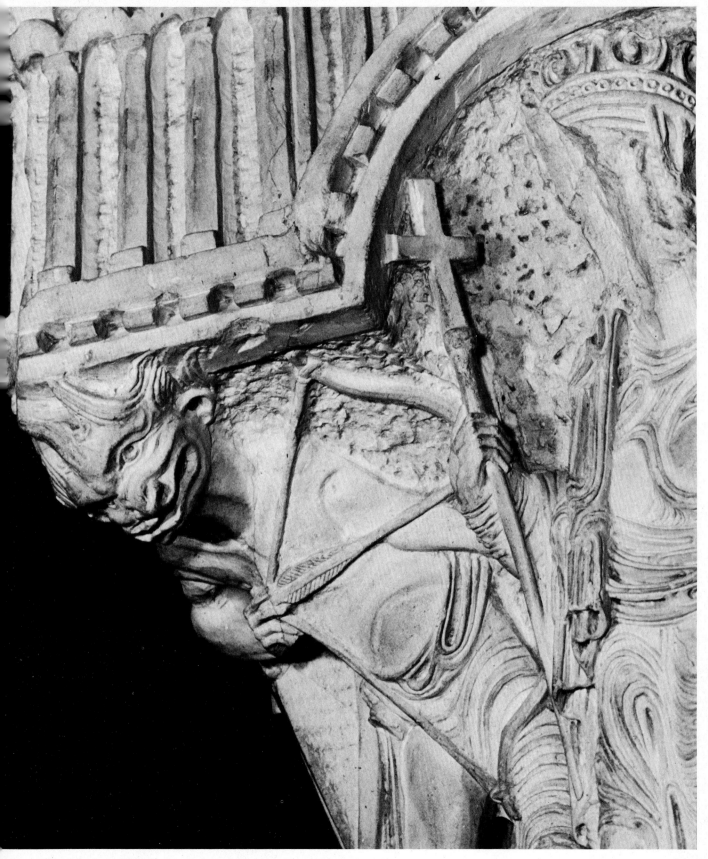

10 Left—Capital, detail (*Ecclesia* and a demon).
11 Above—Capital, detail (attacking demon).

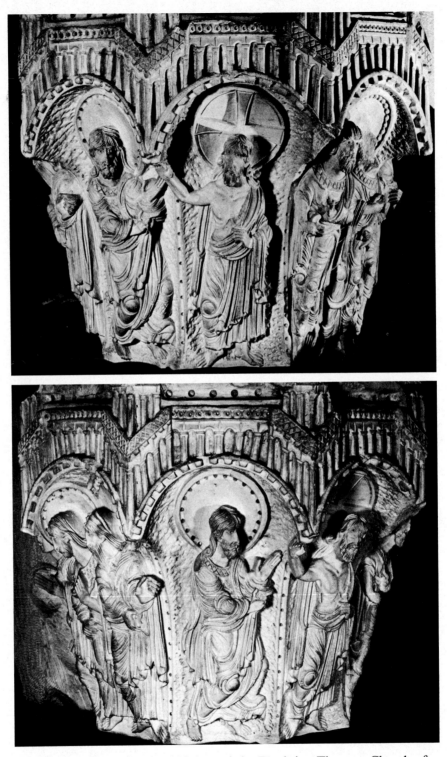

12 and **13** Above—Capital: Christ and the Doubting Thomas, Church of the Annunciation, Nazareth.
14 Right—Capital, detail (Christ and St. Thomas).

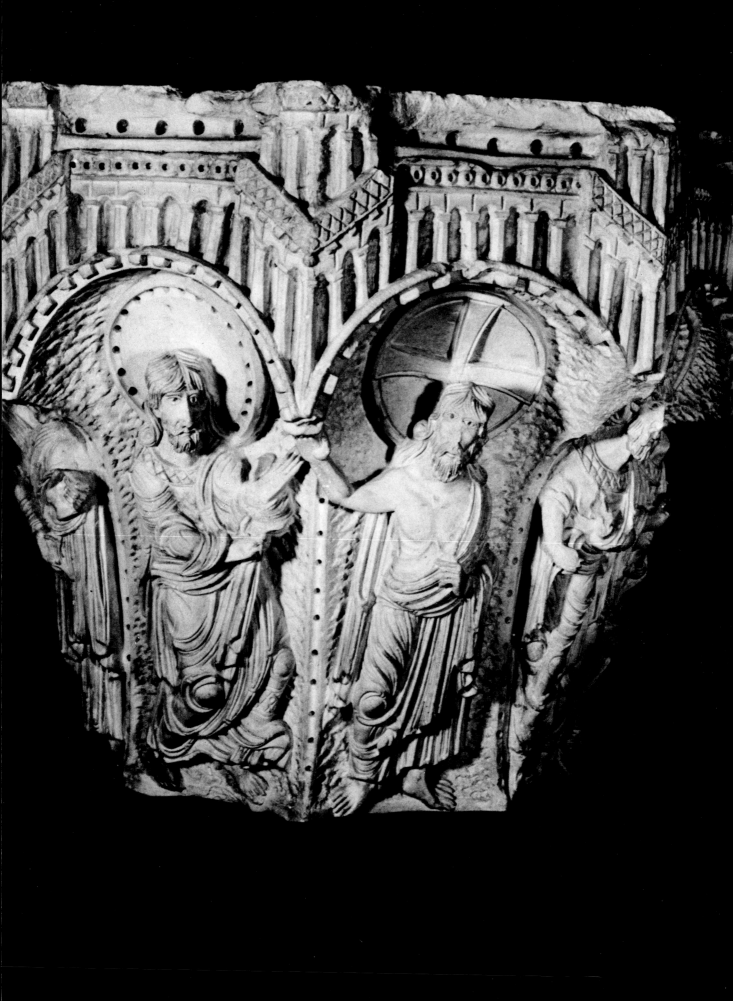

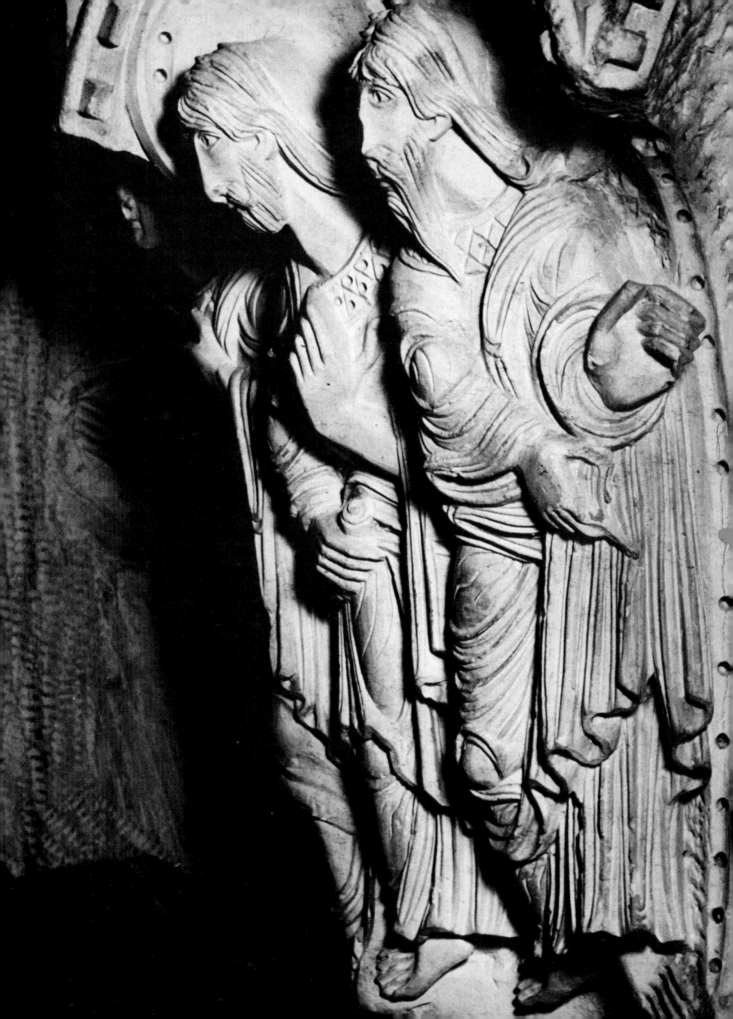

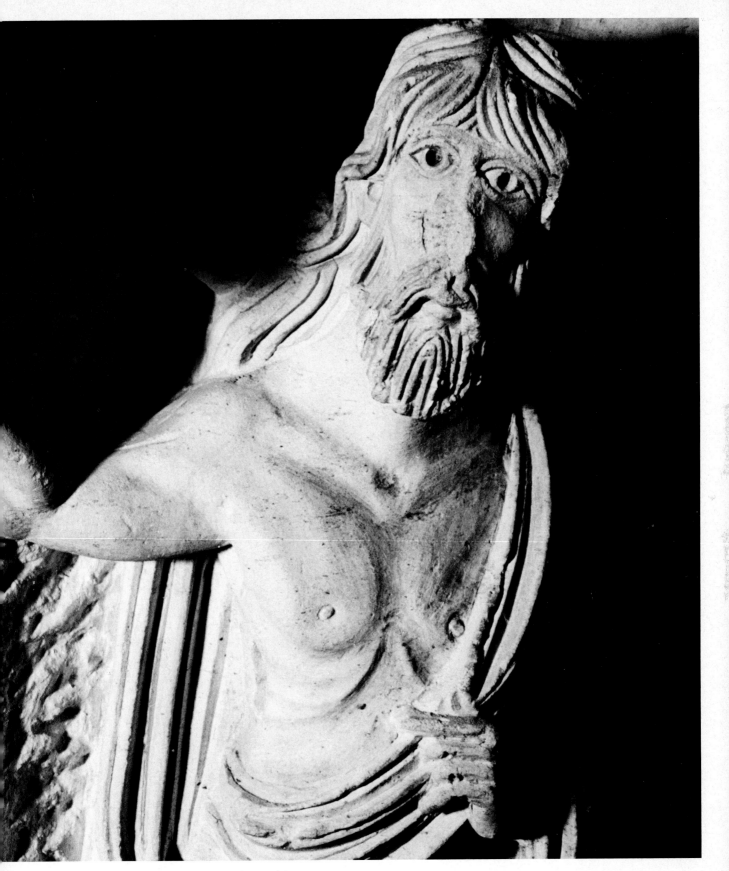

15 Left—Capital, detail (Apostles).
16 Above—Capital, detail (Christ pointing to his wound).

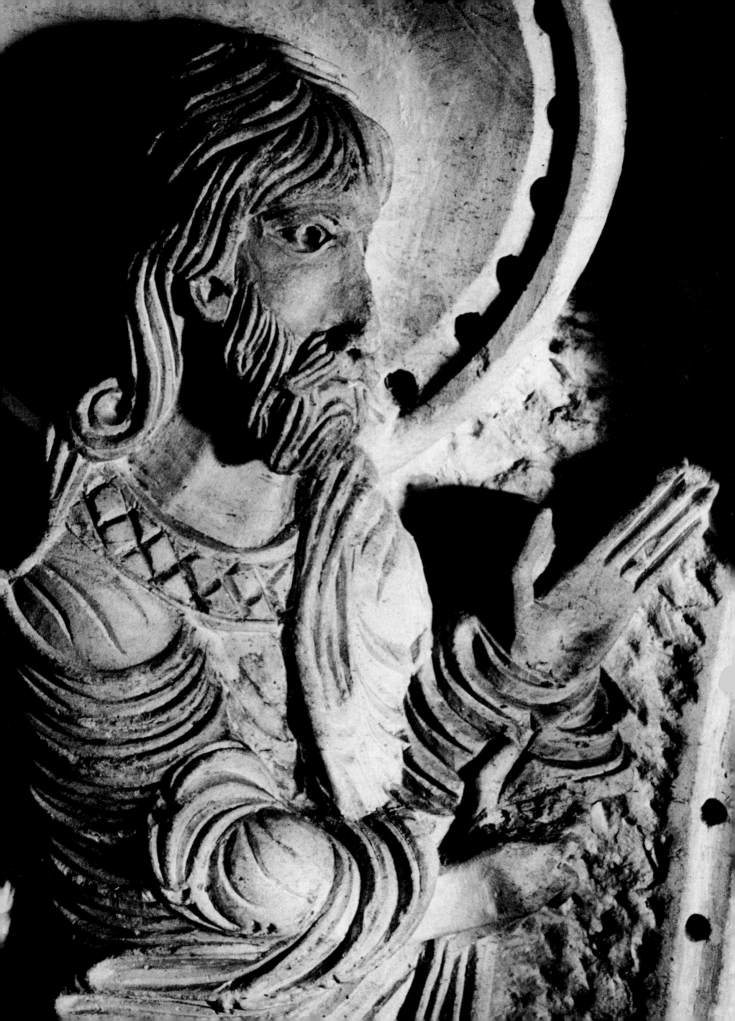

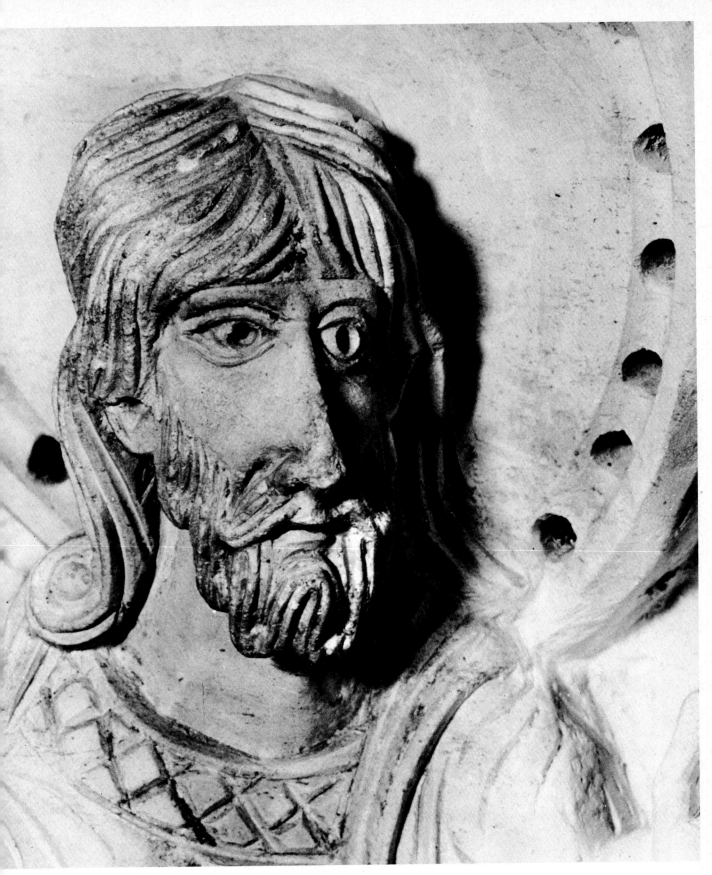

17 Left—Capital, detail (St. Thomas).
18 Above—Capital, detail (St. Thomas's head).

19 Left—Capital, detail (Christ's hand).
20 and **21** Capital: Story of St. Peter. Top—Christ and St. Peter;
Bottom—St. Peter raising Tabitha, Church of the Annunciation, Nazareth.

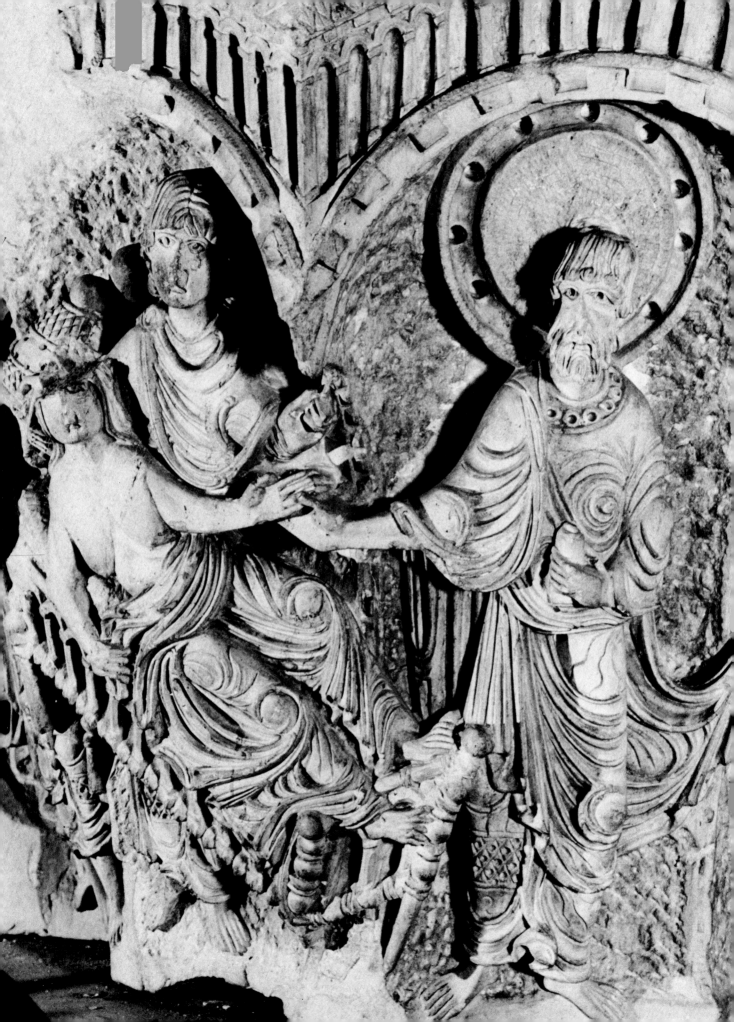

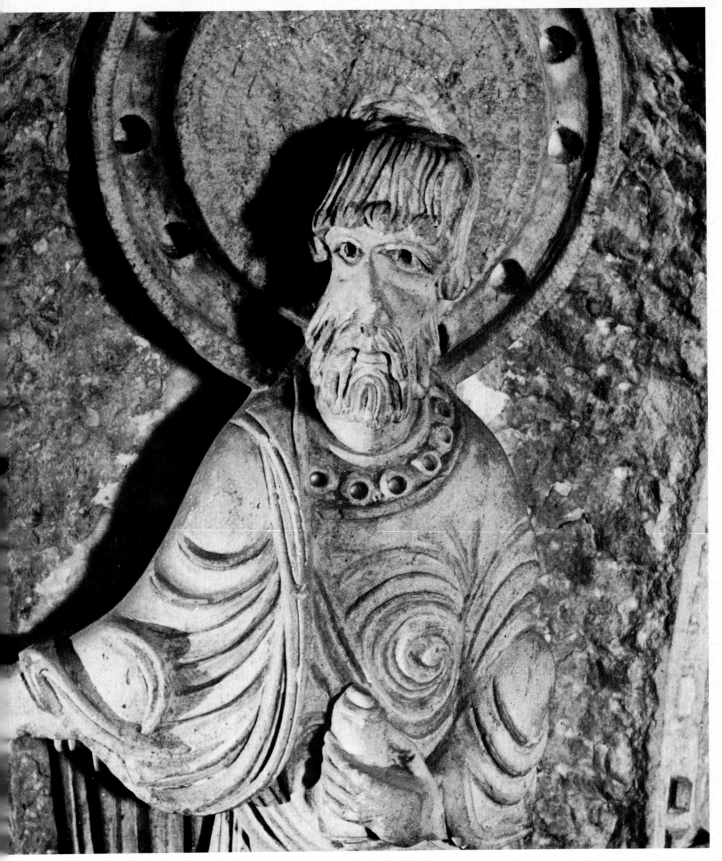

22 Left—Capital, detail (St. Peter raising Tabitha).
23 Above—Capital, detail (St. Peter).

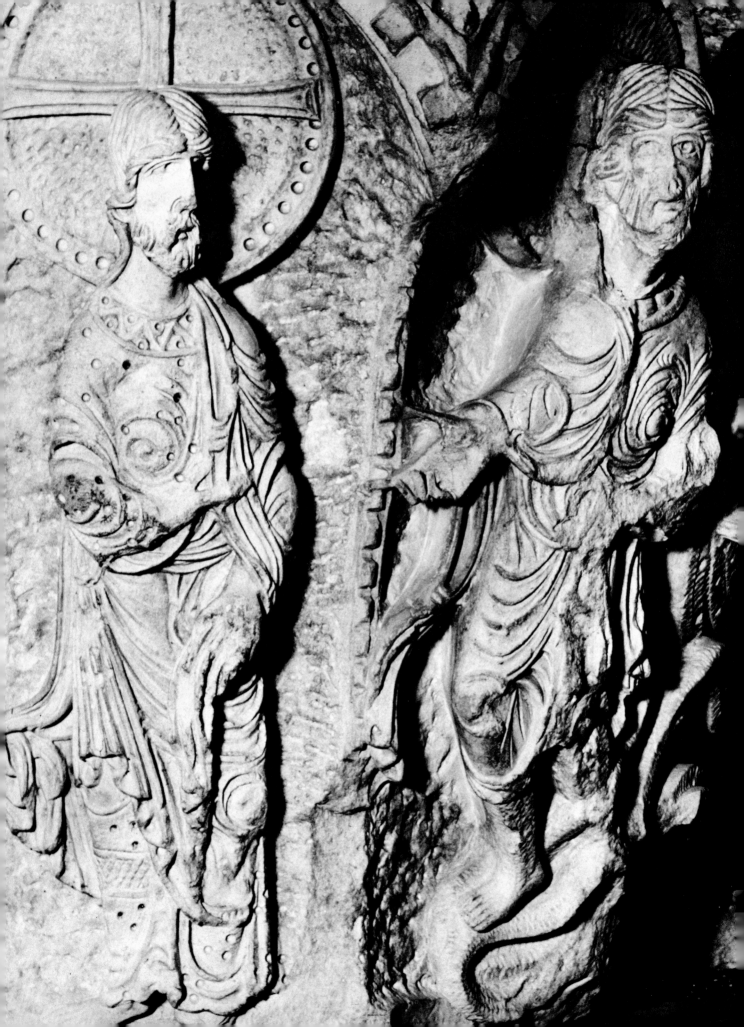

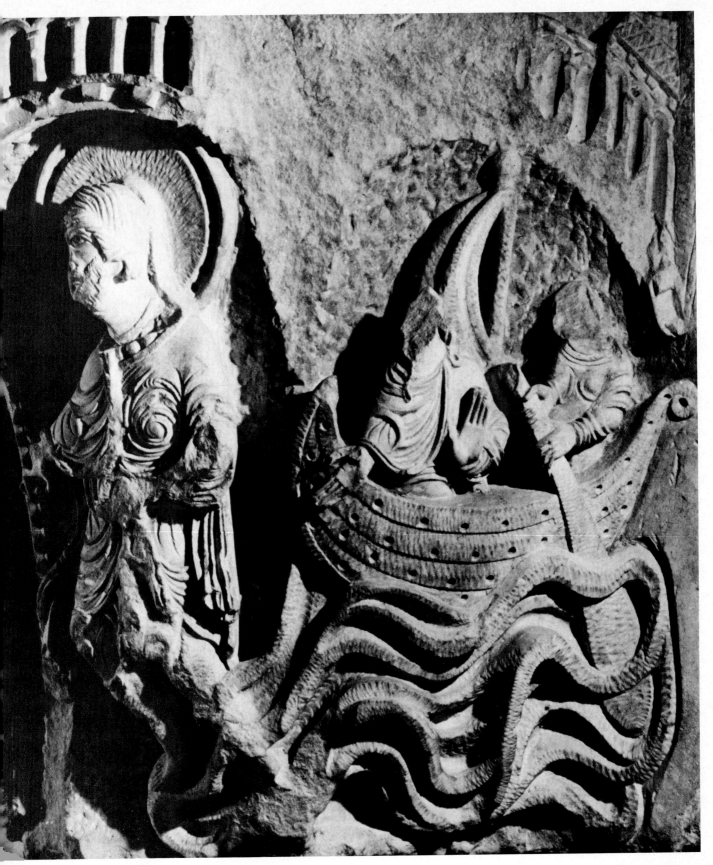

24 Left—Capital, detail (Christ and St. Peter).
25 Above—Capital, detail (St. Peter and Apostles in a boat).

26 and **27** Capital, detail (Head of Christ).

28 Capital, detail (Head of St. Peter).

grooved surface of some haloes (figs. 27, 33) that create concentric, or other patterns.[30] The consistent application of the various textures shows, I believe, that they were consciously used as an artistic means.[31] By this device the artist produced a difference of "value," the neighboring surface being of another grain and luminosity. Although the capitals do not seem to have been painted, the essentially pictorial quality of the difference in grain is of great significance in the style of these works. The difference of texture has been used consistently as a means of enhancing the impression of projecting mass. It will suffice to give one example here, a figure of Christ (fig. 26). Note here the scale of textures. The face is smooth, the contours of the eyes and the hole drilled for the pupil being the only sharp accent; the smoothness strongly reflects the light falling on the capital and brings out the face. The hair, a complex linear pattern, is mainly vertical in direction, emphasizing the vertical position of the figure. The large halo is covered by small, flat, round chisel marks, which emphasize both its roundness and lack of depth. In the background the chisel marks are long (obviously the artist used here another tool than in the halo) and mainly horizontal. The varying textures clearly differentiate between background, halo, and figure. Although in actual depth there is no significant difference between these elements, the combination of the different textures achieves the startling effect of a scale in depth, of layers, and makes the halo, and especially the face, stand out strongly. Here, then, we can clearly see that the plastic means of projecting mass is aided by the "pictorial" means of a texture scale.

However, the projection of limbs is not indicative of an organic concept

Fig. 26

30 In the carving of the haloes especially, the artist of Nazareth seems to have had a rich repertory of textures. For the finely grooved halo, consisting of concentric circles of a grain-like form, see fig. 25, In fig. 23 the halo is rough, and has probably not been finished. It is therefore interesting to observe that in the still rough field concentric lines are scratched rather casually, probably a "sketch" of the artist for his further work on this halo. Had it been finished, this halo would probably have looked like the one in fig. 33. A third type of texture is found in fig. 27, where the field of the halo is covered by small, flat, round knobs, which show no definite direction or pattern. Whether this type is derived from a dotted halo in an illuminated manuscript or a wall painting I am unable to say.

31 W. Oakeshott, *Classical Inspiration in Medieval Art*, p. 120, assumes that the different types of stone work indicate that the capitals of Nazareth have not been finished. Had they been completed, Oakeshott believes, the rough surface of the background would also have been polished, and it would have looked as in the Plaimpied capital. Here one should notice that in the Plaimpied capital the halo has the same degree of smoothness as the figures and the background. I find it difficult to believe that the careful grooving of the haloes on our figs. 25 and 33 is only a preparatory stage toward complete smoothing. See below for the consistency in the application of different types of stone work.

Fig. 25
Fig. 33

of the human body, since there is no full-length figure of nearly equally projecting dimensions.[32] A figure whose head stands out strongly has legs and feet barely outlined on the surface. Such a head is more of an outcrop of the stone, a *Teilmasse*[33] of the capital itself, than part of an organism. Neither have the linear patterns of the drapery a naturalistic meaning. Sometimes the folds are not felt as forms issuing from the natural relationship between garment and body; they have little to do with the weight and resistance of actual robes, but are as much a property of the subtle matter of the relief. The same may be said of the textures. In varying the stonework and texture of the surface the sculptor did not intend, as did later artists, to portray the material quality of different bodies and objects in nature. The distribution of the different textures follows only from the conception of the capital as a precious work of art. Therefore, the same texture is used for the representation of different objects. Hair and beards have the same texture

Figs 8, 13, 17
Figs. 34, 35

Figs. 39, 41

as the folds of a garment (figs. 8, 13, 17); the feathers of the demon are very much like the drapery (figs. 34, 35); the holes drilled for eye pupils are not distinguishable from those drilled for the decoration of the crowns (figs. 39, 41). The projection of certain parts of the figures which is achieved by the combination of textures also should not be understood as betraying a naturalistic intention.

It has already been mentioned that the different means are not used isolatedly. The connection between mass and line can be observed in some interesting details. The standing out parts are not rounded out, the sides (i.e. those which join the jutting parts to the background) are cut in a "cubistic" style and in straight forms (see especially the hands

Figs. 23, 34

in figs. 23, 34). This may, of course, be the result of the small size, which did not enable the artist to employ curved forms. Be that as it may, the result is that the plastic forms (the cutting and difference in bulk) contribute to the linear, graphic character of the reliefs.

The relationship between mass and line is not always consistent, and it does not give the impression that it was governed by clear rules. This is evident in another interesting example. On the large capital a helmeted

Fig. 10

demon, with a shield in front of him, is brandishing his lance (fig. 10 [Unfortunately our reproduction presents little of the helmeted demon, and more of another one, handling a bow and arrow.]). Since this

Figs. 13, 20, 30

32 Unfortunately this cannot be seen clearly enough in our plates. Cf. however, figs. 13, 20, 30.
33 I borrow this term ("partial mass") from the important discussion of the aesthetic principles in Romanesque sculpture by E. Panofsky, *Die deutsche Plastik des elften bis dreizehnten Jahrhunderts* (Munich, 1925), p. 17 ff.

figure actually holds the shield in front, there is a definite difference in depth between the shield and the figure behind it. The lance overlaps both. On a Roman sarcophagus or a Baroque relief the lance, a plastic object, would stand unbroken in front of both shield and figure. In the Nazareth capital the lance is not a plastic object, but a line which is carved across the varying depths of shield and figure. Here we have, then, both a drawing (the lance) and a high relief (figure and shield).

The Figures. The figures on our capitals are not of human quality, neither in their canon of proportions, nor in structure and specific forms. As one expects, they are not based on actual observation of nature but on established workshop traditions. As they differ from each other quite widely, they seem to be derived from several sources. I believe that in the Nazareth capitals one can distinguish two main types of figures.

The one type corresponds to the squat figure common in Romanesque sculpture of southern France. Several Crusader sculptures in the Holy Land bear a striking resemblance to the art of southern France. The capital which was found in Damascus shows a close similarity, both in the type of figure and in general criteria of style, to the capitals of St. Trophime.[34] The lintel of the eastern portal of the Holy Sepulcher Church in Jerusalem parallels very closely in composition, in ornament, and in the conception of the figures the capitals of La Daurade in Toulouse.[35] A direct influence of the art of that region on Crusader sculpture cannot be doubted. Hence, it is not surprising that there is also a close similarity in the type of figures.

In Nazareth there are no such extremely squat figures as on some well-known early Romanesque capitals,[36] perhaps the artist who carved our capitals was more modern and ambitious — yet a certain similarity in

34 Cf. Enlart, *Les Monuments des Croisés,* i. p. 127, who says: "La ressemblance de la sculpture [of the Damascus capital] avec celle des chapiteaux historiés du cloître de Saint-Trophime est absolue." Enlart does not discuss this similarity further.

35 Cf. Enlart, *ibid.,* i. p. 128; Boase, *The Arts of the Latin Kingdom,* p. 6. For a reproduction of the Jerusalem lintel, cf. Enlart, *Les Monuments,* fig. 304 (pl. 100); for the capitals of La Daurade cf. Kingsley Porter, ill. 462; for other capitals cf. Enlart, figs. 305–306 (pl. 100). In the Nazareth capitals one also finds individual motifs that point to an influence of the region of Toulouse. Compare, for example, the pose of the sitting figure of a king at Nazareth (our fig. 36) with the sitting Herode in a capital of Toulouse (cf. Michel, *Histoire de l'art,* i, 2, fig. 344). *Fig. 36* Note also the ornaments on the drapery borders in both works mentioned. The figures of the Nazareth capitals, however, are certainly more agitated than those in Toulouse.

36 It is sufficient to compare the seated figure of Daniel at Moissac (Kingsley Porter, ill. 278) which is of course earlier than our capitals, and that of the king in Nazareth (our fig. 36) to *Fig. 36* realize the difference between these two stages of Romanesque sculpture.

Figs. 8, 12, 38

Fig. 36

Figs. 14, 38

Figs. 8, 36, 38

Figs. 13, 17

Fig. 22

Figs. 22, 29

proportions to these early works cannot be overlooked. The figures of this type are hardly more than four to five heads high (figs. 8, 12, 38). The actual posture of the figures, whether sitting or standing, does not determine the proportions. In fig. 36 the sitting king on the left has the same proportions as the standing king on the right.

In the figures of this canon a disproportionate prominence is always accorded to the heads (figs. 14, 38). The artist obviously endeavored to represent all the essential structural features of the head. The torso and legs, covered by draperies, are defined by fewer details, usually ornamental. As I have already suggested with regard to the projection of the heads, their sometimes enormous proportions might be determined by motivations of meaning, the head being the most important and significant part of the human body. The heaviness of the heads is sometimes further emphasized by large beards and crowns (figs. 8, 36, 38). Sometimes the hands, if they perform a significant action, are also oversized. For instance, Thomas' hand, raised to touch Christ's wound, is larger than the arm from shoulder to elbow (figs. 13, 17).[37] St. Peter's hand, clasping that of the resurrected Tabitha, is also larger than the arm from shoulder to elbow (fig. 22). In all these cases, the meaning of the action, or gesture, performed by the hand seems to determine its proportions.

The characteristic features of the other type are slim, tall figures and small heads; the hands are either not shown at all, or insignificant and small.[38] These figures are at least seven to eight heads high, sometimes even more. See the woman behind Tabitha's bed, who is seven to eight heads tall (fig. 22), and the figure of the executioner (fig. 29) measuring eight heads. The latter, incidentally, betrays its classical origin by its rhythmic pose and the organic representation of the body. The elongated type is most clearly expressed in the figure of the possessed, which measures, despite the bent knees, eight heads. The artistic "weight" of the head is further minimized by the turned away face. In clear con-

37 The hand of Thomas, stretched out to touch Christ's wound, is sometimes enlarged in medieval art (see e.g. the representation on a capital of the cloister at Santillana del Mar – Kingsley Porter, ill. 866), but often it has normal proportions (see, for example, the representation in Silos – Kingsley Porter, ill. 67). My impression is that the proportions of Thomas' hand in Nazareth are particularly large.

Fig. 29
Fig. 35

38 The executioner's hand, although holding the fatal sword, is almost invisible and merges with the frame of the capital (fig. 29); the hands of the possessed, although in a clearly visible spot (fig. 35) are extremely small, merge with the demon's talon, and are hardly carved as separate limbs.

trast to the other type, the legs of this figure are disproportionately long. It is characteristic of the general tendency permeating these figures that the lower section of the possessed's legs (from ankle to knee) is longer than their upper section (from knee to hip), a device that further emphasizes the length of the figure.

Such slim and tall figures are, of course, well known from French Romanesque sculpture, mainly Burgundian.[39] Some of these French figures even display certain similarities to those in Nazareth, such as the twisted positions, the crossed legs,[40] and in the representation of the drapery to which I shall later return.

Not all the figures in the Nazareth capitals have extreme proportions as those mentioned above, but most of them can be related to one of the two types.

The figures, although of different types, have some common basic qualities. As already said, the figures lack the rigidity of the architectural frames; they are all permeated by movement, a quality displayed both in their postures and in the manner of representation. Even the standing figures are not conceived as upright columns. They either turn their heads (fig. 34), bend their knees (fig. 31), rest the weight of their body on one leg only (fig. 39), or are enlivened by the wind-blown hems of their drapery (fig. 29). Even the single limbs, often represented in a column-like pattern in Romanesque sculpture, are rendered in rhythmic motion in the Nazareth capitals. All this results in a strong organic effect.

Figs. 34, 31

Fig. 39

Fig. 29

However, this organic quality, although convincing, is rather abstract and has no naturalistic function. Thus it is sometimes difficult to distinguish between men and women as the folds modeling the feminine breast appear not only on the *Ecclesia* (fig. 10) — where a woman is actually represented — but also on St. Peter (figs. 23, 25) and the bearded king (fig. 36 left). Similar calligraphic patterns are used for elbows, shoulders, and knees; these being well known, common motifs

Fig. 10

Figs. 23, 25

Fig. 36 left

39 See, e.g., the slim figure of Judith on a capital of Vézelay (Kingsley Porter, ill. 44), an angel at Anzy-le-Duc *(ibid.,* ill. 97) and an Apostle at Charité-sur-Loire *(ibid.,* ill. 125). Needless to say, slim and tall figures appear also in other regions (cf. the sculptured column of Aix-en-Provence – Kingsley Porter, ills. 1407/8).

40 Cf. the Stoning of St. Stephen on a capital of Autun (Kingsley Porter, ill. 77) where one of the stone-throwing figures (to the left of St. Stephen) displays in posture and movement a remarkable resemblance to the executioner of Nazareth (fig. 29). For a Provençal example, cf. the *Flagellation* from the western façade of St. Gilles (Kingsley Porter, ill. 1321), the figure to the left of Christ. For the crossed legs see the St. Thomas from St. Gilles (Kingsley Porter, ill. 1304).

Fig. 29

in medieval art.[41] The specific character of the forms, which are organic but not naturalistic, is particularly clear in the figure of the possessed (fig. 35). The linear pattern of this figure consists of strong expressive sensuous forms, which are, however, so completely spiralled that they must be seen as a diagram rather than the representation of a real figure.

Fig. 35

Besides these figures one also finds on the Nazareth capitals some simpler and more naturalistic representations of the human body, mainly in the figures of demons. The realistic, concrete representations of hell in Romanesque art and the organic character of demonic figures in the art of that period — based probably on antique models and traditions — has been noticed in modern research.[42] The organic quality of Romanesque devils is more evident in sculpture than in the other arts.[43] These characteristics can also be observed in Nazareth. A naked figure with a demon's head (fig. 37 right) surprises by its classical beauty, convincing representation of movement, and soft modeling. The demons of the large capital (figs. 7, 10), that both in general character and in individual motifs remind one of Vézelay,[44] are to a lesser

Fig. 37 right

Figs. 7, 10

41 For a similar, though not identical, motif that may be considered as a hall-mark of Carolingian art (winding lines forming a "spiral circle" on the belly of Christ), cf. W. Koehler, *Die karolingischen Miniaturen, i: Die Schule von Tours* (Berlin, 1930), pl. 73 (Paris, Bibl. Nat., Ms. Lat. 1, fol. 330v). In the present context it is interesting to note that in eleventh-century art in the region of Clermont-Ferrand such motifs seem to appear more frequently, and are not restricted to belly or breast, but designate all convexities of the human body covered by drapery. Cf. the interesting discussion by Meyer Schapiro, "A Relief in Rodez and the Beginnings of Romanesque Sculpture in Southern France," *Studies in Western Art* (Acts of the Twentieth Congress of the History of Art) (New York, 1963), pp. 40–66, especially p. 53 ff. where many examples are supplied. For some examples in twelfth-century Burgundian sculpture, cf. Kingsley Porter, ills. 12, 37, 40, 44, 48–49, 81, 109. In none of these examples, however, does the motif seem to be so pronounced as it is in the Nazareth capitals, the only exception being the tympanum of Vézelay.
42 For the realism of Romanesque representations of hell, cf. Meyer Schapiro, "From Mozarabic to Romanesque in Silos," p. 327; note especially the convincing refutation of Miguel Asin Palacios' thesis *(Dante y el Islam* [Madrid, 1927]) that the new realism derives from a Moslem influence; for the organic representations of devils, and particularly for the relation of these representations to antique models, cf. O. Erich, *Die Darstellung des Teufels in der christlichen Kunst* (Berlin, 1931), *passim*, particularly p. 68 ff. (the Satan-Pan type), p. 77 ff. (the "pagan" as a prototype of the demon), p. 26 (the devil devouring souls of sinners, with a reference to Pausanias 10. 28, 7). Erich, p. 81, further observes that the horrible demon is characteristic of Western art, while in the Byzantine East even the devil "speaks like a theologian."
43 This has been noticed by Erich, *Die Darstellung des Teufels,* p. 78.
44 For individual motifs see the large heads which, although distorted, remain human, and the flame-like hair (Kingsley Porter, ills. 34a, 39) as well as crossed legs *(ibid.,* ill. 34a). In another capital of Vézelay (cf. M. Aubert, *La sculpture française du Moyen Age et de la Renaissance* [Paris and Bruxelles, 1926] pl. ix) a demon wielding a spear is represented. There is a striking resemblance in the representation of the bent posture, the back, the spine, and the legs (and to some extent also of the physiognomy) of this figure to the demon in our fig. 7.

Fig. 7

110

degree transformed into ornamental patterns than the other figures. Note especially the organic forms of the upper body, the muscles of the arms, and the convincing rendering of movement. Although in outline these figures, as all the others, are subordinated to the encompassing pattern of the capital (we have already had occasion to observe that the arm of one of the demons is too short because it is adapted to the frame), they betray a surprising knowledge of the human body. Even the demons' faces, although distorted to lend them a devilish look, have a strong organic flavor.

It is also interesting to notice that in the carving of the demons the artist relied to a larger extent on the expressive means inherent in "mass" as opposed to the means of "line." The surface of the demons' bodies, with their relative calmness, stand out in the proximity of the *Ecclesia* and the Apostle, whose bodies are covered by an intricate linear pattern (fig. 10).

The organic quality, however, is not restricted to demons, as proved by the figure of Tabitha. Her figure (figs. 20, 21) reveals the capabilities as well as the limitations of the sculptor of the Nazareth capitals. First one notices a shift in the point of observation. Tabitha's upper body is represented as if seen from above, the lower part of her body is, like all the other figures, represented in frontal view.[45] This corresponds to a shift in style. While the drapery covering the lower body is a calligraphic ornament, the naked upper body is surprisingly soft in modeling. This does not mean, of course, that the naked body is drawn from nature. Tabitha's flat, pointed breasts vividly remind one of Eve's breasts on a capital in Clermont-Ferrand.[46] But whatever the tradition from which the sculptor drew, he shows a feeling for the organic qualities of the body, as well as an affinity for the power of line and abstract ornament.

Gestures. As with most Romanesque sculpture, the gestures in the Nazareth capitals are one of the most important media of expression.

45 Such an arbitrary conception of space is, of course, not unknown in Romanesque sculpture; a shifting of the point of observation within *one* figure is perhaps more frequent in capitals, owing to their complex spatial structure. See e.g., a capital of Moissac where a prone figure is seen from above while the figures standing next to it are represented frontally (cf. Meyer Schapiro, "The Romanesque Sculpture of Moissac," p. 331 and fig. 54). Another example is provided by a capital from the cloister of St. Trophime (cf. J. Adhemar, *Influences antiques dans l'art du Moyen Age français* [London, 1939], fig. 39).
46 Cf. Kingsley Porter, ill. 1171. There are also some physiognomic resemblances between the face of this Eve and of Tabitha's figure. See the full, fleshy face, the extremely small but full mouth (especially the lower lip) and the somewhat oblique eyes.

111

However, despite the significance accorded to gesticulation, the artist is repetitive, as his repertory of specific gestures is rather limited. Most of them are typical, stereotyped movements of arm, hand, and head, well known from French art of the twelfth century. One finds but few individual or original gestures. Nevertheless, the gestures in the Nazareth capitals do possess evocative power, and reveal a perfect coordination between expressive movements and the meaning of figures and scenes.

The most important organ of expressive gesticulation in our capitals is, of course, the hand, mainly when represented with pointing index or open palm. Gestures of the hand create the principal form of relationship between figures, groups, and faces of the capital, a relationship which is clear without having to rest on actual contact. The figure *Fig. 22* behind Tabitha points to the Apostle who is set in the next field (fig. 22); some Apostles point upwards.[47]

A frequent gesture which has a wide range of meanings, is the open hand with outward turned palm. Despite its wide range, the specific meaning of this gesture is always clear in the scenes represented on the *Figs. 14, 17* Nazareth capitals. The open hand of Thomas (figs. 14, 17) expresses *Fig. 24* submission, weakness, and devotion. The gesture of St. Peter (fig. 24), somewhat similar to that rendered in the former scene — but combined with bent knees — suggests fear, the acceptance of a miracle, and devotion; the Apostle in the boat behind St. Peter expresses by this gesture, *Fig. 25* performed with both hands, awe aroused by the miracle (fig. 25). But the gesture may also be a symbol of agitated dialogue.

In spite of the emotional, dramatic character which permeates the capitals, as crystallized mainly in the gestures, in most cases the gesticulating hands are kept close to the body, preserving its compactness as a whole. Only in very significant scenes is the hand extended, and, so to speak, detached from the body.

Another gestural motif, of a very complex nature, is the open hand firmly clasped in the hand of another figure. Usually this motif expresses need of help as well as protection or consolation. This is the *Fig. 22* meaning of Tabitha's open hand held by St. Peter's hand (fig. 22, further emphasized by the hand of the figure behind Tabitha), as well as that of the open hand of princess Iphigenie (small figure), who seeks on bent knees St. Matthew's help. The protecting Apostle firmly *Fig. 39* clasps her hand (fig. 39). The same motif reappears in the center of the

47 The finger is broken here, but its original position and meaning are clear.

large capital: the *Ecclesia* holds the half open hand of the hesitating figure (again represented with bent knees) that she leads safely through a menacing world (fig. 8). In a certain sense this complicated gesture is the *Leitmotiv* and focus of all the meaningful gestures of the hand on the Nazareth capitals.

Fig. 8

Another significant realm of "gesticulation" is the position of the legs. I shall mention only two particularly striking postures: the crossed legs, and the bent knees. The crossed legs appear several times on our capitals, and apparently have in every instance the same meaning, as can best be seen in the figure of the possessed (fig. 35). Here the legs are doubly crossed: the legs of the possessed are crossed; in addition, they overlap the claw of the demon. The unstable, pirouetting posture lent to the possessed by the crossed legs corresponds to the energetically contrasted lines and the complicated involvement of surfaces that are characteristic of the figure. The possessed's movement seems disengaged from any external cause and is concentrated within the figure itself as an unstable, tense, and intricate play of crossed limbs and draperies. The artist emphasizes the posture of the legs by way of deep holes, heavy shadows,[48] and dramatic lines, thus showing that here it is employed as an expressive device. In medieval representations of the possessed we often encounter crossed legs, the chiastic pose being a powerful expression of ambivalence and inner conflict.[49]

Fig. 35

However, crossed legs are not restricted to the possessed; wherever demons or magicians are represented on the Nazareth capitals, the same characteristic feature appears. We may, therefore, assume that here the crossed legs are a formula for the demonic.[50]

Examples of the other characteristic posture of the legs, the bent knees, have already been mentioned several times. In all these examples the bent knees have the same emotional connotation, namely, weakness,

48 This is the more remarkable since on all the capitals the lower parts of the legs and the feet are in very flat relief only, closely approaching a mere linear drawing.

49 Cf. E. Panofsky, *Early Netherlandish Painting: Its Origin and Character* (Cambridge, Mass., 1953), p. 22, note 5 (on p. 365 ff.), for an interesting interpretation of such ambivalent situations and themes as those expressed by the crossed legs.

50 Cf. figs. 36, 37 (sorcerers: note that here the hands also overlap in a "crossed" pattern): fig. 35 (the possessed and the demon). In as antithetic an art as Romanesque sculpture, the pose of the crossed legs appears often and has different meanings. J. J. Tikkanen, *Die Beinstellung in der Kunstgeschichte: Ein Beitrag zur Geschichte der künstlerischen Motive* (Helsingfors, 1912), p. 122 ff., distinguishes between the antique motif of folded legs which expresses a posture of relaxation, and the Romanesque crossing of the legs that is full of tension. In the Nazareth capitals we encounter both types of crossed legs: the seated figure of the king (fig. 36) suggests a folding of the legs in relaxation, but the possessed figure crosses them in extreme tension (fig. 35).

Figs. 36, 37
Fig. 35

Fig. 36
Fig. 35

hesitation, and perhaps also humility. That it is so is clearly suggested by the context: Thomas approaches Christ on bent knees, St. Peter when walking on the water, the faltering figure on the large capital being led between the attacking demons.[51] That the artist was aware of the emotional meaning of this posture can be seen from the fact that the figure opposite the one with bent knees always has outstretched legs of a pronouncedly straight, vertical form. Comparing the postures of these figures, one realizes the high artistic quality of the Nazareth capitals, and the ability of the artist to express emotional situations by means of postures and gestures.

Speaking in broader terms, it is remarkable that only a few of the gestures represented on the Nazareth capitals are ritualistic and determined by the religious role of the figures (e.g., the gestures of benediction, and perhaps of preaching). Most of the gestures have an emotional motivation and fulfill an expressive function. The vividness of gesture in the Nazareth capitals recalls Burgundian art, although dramatic gesticulation is, of course, not restricted to the art of that region only.

Figs. 7, 13, 25 **51** See figs. 7, 13, 25.

III

The iconography of the Nazareth capitals is obscured by the fact that they carry no inscription, and that only a few of the figures can be clearly identified according to their attributes.

Although several studies have been devoted to these sculptures,[52] only limited attention has been paid to their iconography. The interpretation of the single scenes proposed by Viaud has been accepted by most other scholars who have dealt with the Nazareth capitals, but none of them seems to have inquired whether a comprehensive plan underlies the iconography of the five capitals.

It is not our purpose to trace the iconography of each of the scenes represented on our capitals to its ultimate source, We shall rather concentrate on two limited aspects: first, we shall try to establish the particular significance which the individual events and stories represented on the faces of the capitals might have had for the Crusaders in the late twelfth century; second, we shall ask whether these isolated scenes cohere in a comprehensive pattern.

On one capital (figs. 12, 13, 14) all the figures are nimbed and bare-footed, obviously representing Apostles. The individual figures cannot be identified,[53] but the scene is easily recognizable. Christ, appearing in the midst of his disciples, points to His wound, and the Apostle opposite Him sinks to his knees, raising his hands in astonishment and wonder. This can only refer to the Doubting of Thomas. The Thomas story must have presented a particular importance for the artists of Nazareth, or the people who determined the iconography of the capitals. One notices that in Nazareth this is the only case of a single scene encompassing a whole capital, the three other capitals carrying two or

Figs. 12, 13, 14

52 See the literature mentioned in note 1.
53 Except for the beardless figure that probably represents St. John. Cf. Viaud, *Nazareth,* p. 158, and Enlart, *Les Monuments des Croisés,* i, p. 306.

more scenes each. Considering these facts one is tempted to search for the reasons which lent that scene such exceptional significance.

Needless to say, the story of St. Thomas, particularly the scene of his incredulity, was well known throughout the Middle Ages. In the twelfth and thirteenth centuries, however, it seems to have enjoyed a particular popularity in western Europe. In the twelfth century Christ's apparition before the doubting Thomas already belonged to the repertoire of the theater.[54] It has, of course, frequently been represented in the visual arts, although no typical pattern of representation seems to have emerged.[55]

In the twelfth century the scene seems to have had several meanings, varying in the degree of distinctness and articulation. The most general, and therefore less well-defined, meaning of the Doubting of Thomas may be the superiority of Faith over scepticism that relies only on sensorial experience.[56] This meaning may have some relation to what seems to be the central theme of the Nazareth capitals, and is most clearly expressed on the large capital where Faith is represented as defeating all evil forces and protecting the faithful. Another meaning of the Doubting Thomas scene, implicitly suggested rather than explicitly stated, is of a more mystical nature. It has recently been said that this scene has influenced the emergence of the "Man of Sorrows"

54 Cf. M. Manitius, *Die Geschichte der lateinischen Literatur des Mittelalters*, iii (Munich, 1931), p. 1050.

55 Even if we look only at representations of the scene on capitals, we find a variety of types none of which closely resembles the composition of the Nazareth capital. See, e.g., the capital from La Daurade, now in the Museum of Toulouse (Kingsley Porter, ill. 469) where the architectonic frame is somewhat similar to that of the Nazareth capitals (see above, note 12), but Thomas is not sinking to his knees. No particular emphasis is placed here on Christ as opposed to Thomas. On an earlier and somewhat more archaic capital at Huesca, San Pedro el Vejo (Kingsley Porter, ill. 533), the figure of Christ is emphasized both by its central position and raised arm, but there is no difference in the height of the figures, and Thomas is standing upright. Interestingly enough, here too we see a beardless figure among the Apostles. In a capital of the cloister at Santillana del Mar (Kingsley Porter, ill. 866) only Christ and Thomas are seen, the latter again standing upright, although his posture may suggest the intention of kneeling in adoration. In sculpture, besides capitals, the scene of the Doubting Thomas has of course frequently been rendered; it is enough to mention the famous relief of Silos (Kingsley Porter, ill. 671) and the figure on a pier of the cloister of St. Trophime, Arles (Kingsley Porter, ill. 1351). The Doubting Thomas was also well known in Eastern art in the twelfth century. See the interesting description by Nicolaos Mesarites (cf. A. Heisenberg, *Grabeskirche und Apostelkirche*, ii, [Leipzig, 1908] p. 73 ff. and p. 264 ff. for other, mainly earlier, examples). Mesarites' lively description of the scene as rendered on a mosaic in a church of Constantinople does not suggest, I believe, a close similarity to the Nazareth capital. It also seems to differ both in general spirit and in details (the Apostles pushing Thomas towards Christ) from the other, Western, representations.

56 Cf. Meyer Schapiro, "From Mozarabic to Romanesque in Silos," p. 348, and note 122.

image, particularly because of the emphasis placed on the showing of the wounds.[57] The singling out of Christ on our capital,[58] with the index of one hand pointing at the wound (fig. 16) does indeed suggest the possibility of such an influence.

Fig. 16

For Christians living in the Latin Kingdom the scene of the Doubting Thomas may have had, in addition to the rather general meanings just mentioned, a more concrete significance. The legendary travels of St. Thomas to India, preaching the Gospel and converting the Infidel, must have held a particular appeal for the Crusaders. Episodes of the saint's journey to the eastern confines of the known world, to the kingdom of the mysterious Gondoforus, and the miracles he performed in India, were indeed frequently represented in twelfth century art.[59] In the Latin Kingdom St. Thomas was certainly popular. His tomb — venerated in the Church of the Virgin in Edessa (Urfa) — attracted many pilgrims.[60] In Jerusalem the place was shown where Christ appeared to the doubting Apostle.[61] On a liturgical vessel from the second half of the twelfth century found near Bethlehem, a sequence of scenes from Thomas' mission to India is represented.[62] Thomas' mission to the East may have been regarded by the Crusaders as a legitimation of their own enterprise.

In this broad context it is interesting to note that in the twelfth century the incredulity of Thomas and Christ's apparition to him were regarded as the act opening the Apostle's mission. During this apparition Christ

57 Cf. Wiltrud Mersmann, *Der Schmerzensmann* (Düsseldorf, 1952), p. x.

58 Mersmann, *ibid.*, stresses the fact that in the Nazareth capital Christ is singled out by having a special arch encompassing His figure. The author compares this representation with fourteenth century statues of the "Man of Sorrows."

59 Though the legend of Thomas' travel to India has been condemned by St. Augustine as Manichaeic story-telling *(Contra Faustum,* xxii, 79) it nevertheless struck the imagination of the Middle Ages and has frequently been recounted (cf., e.g. in the *Legenda aurea)* and represented (cf. E. Mâle, *L'art religieux du XIIIe siècle en France,* p. 305, note 2, mentioning some of the works of French art in which events of that journey are represented). For the historical foundation of the legend, cf. J. Dahlmann, *Die Thomas Legende* (Freiburg, 1912).

60 Cf. Enlart, *Les Monuments des Croisés,* ii, p. 335.

61 *Ibid.,* p. 253.

62 Enlart, *ibid.* 1, i, p. 189 ff. Similar vessels are also in the Louvre and in London. The Bethlehem vessel bears the following inscription:

Ad convertendos Thomas transmittitur Indos.

Cujus virtutes cupiunt si scire fideles

Hac perscrutentur quae coram sculpta videntur.

Enlart, *ibid.* p. 192, believes that the Bethlehem vessel was produced in Europe and chosen by the clergy of Bethlehem because of the subject matter of the scenes. For a representation of the scene in a manuscript of the Latin Kingdom, cf. H. Buchthal, *Miniature Painting in the Latin Kingdom of Jerusalem* (Oxford, 1957), pl. 10b.

sends the doubting Apostle to India. In the liturgical vessel of Bethlehem, as on its counterparts in London and Paris, the rendering of the Thomas story begins with a scene combining Christ's apparition with the start of the doubting Apostle upon his mission. Christ grasps the hand of the Apostle so as to make him touch His wound, and behind them can be seen the figure of Albanes, King Gondoforus' envoy, who had come to Caesarea seeking an architect.[63] The tympanum of the north porch of the church at Semur, where the mission of Thomas is represented in detail, also begins with the Saint feeling with his hand Christ's side.[64] Since the main theme of the capitals is the mission of the Apostles to the East, our scene appears as the opening of that mission. If our interpretation is correct, it may explain the significance accorded to the Doubting of Thomas in the Nazareth capitals.

Figs. 20–25
On each of the other three small capitals more than one scene is represented. One of the capitals (figs. 20–25) is devoted to St. Peter. Both in content and in form it is composed of two halves, each half consisting of three adjacent faces. As I have already said, each half, although constituting a self-contained composition, is nevertheless linked with the other half, thus creating an inner unity of the capital as a whole. This complex relationship seems also to prevail in the scenes represented.

Figs. 24, 25
The identification of the event represented on the right half of this capital (figs. 24, 25) is not as simple as it might appear at first glance. The gesture of Christ, who is represented on the left, standing on the sea shore, might be interpreted as a benediction or as a summons. Since the hand is badly mutilated, nothing definite can be said of the meaning *Fig. 24* of this gesture (fig. 24). On the next face, the central field of this half of the capital, we see St. Peter with his feet in the water, knees flexed, and his arm extended in a sweeping movement expressing either despair or *Fig. 24* an appeal for help (fig. 24). On the last face two Apostles in a boat[65] are sailing a stormy sea. One of the figures in the boat firmly grasps the shaft of a large oar, while the other spreads his hands in a movement of astonishment and adoration.

Viaud, de Lasteyrie, and Deschamps[66] believed that the events related in

63 Cf. Enlart, *Les Monuments des Croisés,* i, p. 189 ff.

64 E. Mâle, *The Gothic Image* (Harper Torchbook ed.), New York, 1958, p. 304.

65 Although the figures have no haloes there cannot be any doubt that they represent Apostles. Since the faces are mutilated nothing can be said of their identity.

66 Viaud, *Nazareth,* p. 158; (the latter for de Lasteyrie's view), p. 172; Deschamps, "La sculpture française," p. 103 ff.

John 21:1–7 are represented here. There are, however, several difficulties in accepting this interpretation. The text (John 21:7) expressly says: "Therefore that disciple whom Jesus loved saith unto Peter, It is the Lord. Now when Simon Peter heard that it was the Lord, he girt his fisher's coat unto him (for he was naked) and did cast himself into the sea." As one knows, the particular detail of the naked Peter, girded only in his fisher's coat, recurs in visual representations of that scene.[67] On our capital, however, Peter's figure is completely clad in a richly ornamented garment which cannot be mistaken for a fisher's coat; moreover, the folds clothing the upper body are particularly emphasized. This would speak against the assumption that the event related in John 21 is represented in our capital. Neither is there any suggestion of the fisher's net which one would expect in this scene. Finally, in most representations of the scene the full muster of eleven disciples is shown in the boat, while on the Nazareth capital the boat contains only two figures.

Another possible interpretation of our scene would be the Miraculous Fishing (Luke 5:10–11). Since it is in this story that Christ says to Peter, who sinks unto his knees, "Fear not; from henceforth thou shalt catch men" it would have been particularly fitting for our capitals, the general theme of which is the mission of the Apostles. The representation of only two Apostles in the boat would also fit the text (Luke 5:10). However, some details seem to speak against this interpretation: Christ stands on the shore instead of being in the boat, and Peter is clearly sinking in the water.

Finally, it could be assumed that the scene here represented is that which is usually described as the "Sinking Peter" (Matthew, 14:24 ff.), but this interpretation also raises several difficulties. Christ is not walking on the water, as he should be according to the text of the Gospel, but seems to stand on the shore. This particular detail could be explained by a contemporary Byzantine text.[68] More important is that a crucial motif, Christ grasping Peter's hand (a motif that recurs in all visual representations and literary descriptions of the scene and

67 See e.g., the mosaic in Monreale. It should be noted that in renderings of this scene Peter is often represented as swimming in the sea. Mesarites, p. 52 (cf. note 68) describes Peter as actually swimming.

68 See the description of Mesarites, a twelfth century Byzantine author, of a cycle of mosaics in Constantinople. Cf. August Heisenberg, *Grabeskirche und Apostelkirche,* ii (Leipzig, 1908), pp. 10–96; the description of the Sinking Peter, pp. 49–52. In his description (p. 50) of the stormy sea Mesarites says: "Look at this rioting sea, look at the waves rising to the height of mountains, others quietly gliding, lingering at the shore, as if collapsing in awe before the Lord who stands on it [the shore]."

has acquired a symbolic value),[69] is missing in Nazareth. On the other hand, there are several reasons that would suggest that the scene was of particular significance for the Church in Nazareth. The basic meaning of the scene — weakness because of lack of faith, and the conquering power of faith — would certainly fit the broad theme that seems to run through all the capitals, and which is focussed, and represented in allegorical form, on the large capital. It might be said that the motif of the clasping hand, which is missing in our scene, is given prominence on the large capital. Here the hand of a hesitating Apostle, who reminds one of Peter in posture (flexed knees), drapery, and even physiognomic motifs, (short beard) is being led by the hand of conquering Faith. In its broad meaning the Sinking Peter should probably also be linked with the Incredulity of Thomas, as the scene shows both faltering faith (as does the Thomas story) and the divine or spiritual force that overcomes such weakness.

The theme of the Sinking Peter was well known both in the West and in the East. Crusader artists could also have found earlier representations of it in the Holy Land.[70] In the twelfth century such representations seem to have held a large appeal, stirring emotions and imagination, as can be seen from Mesarites' lengthy and lively description of a mosaic rendering.

Crusader artists would certainly have remembered the theme as represented in the West. In this connection it is interesting to note that, while in Byzantine art all the eleven Apostles are usually in the boat, in Western art of the tenth and eleventh centuries one finds examples where their number is considerably reduced.[71] In the Latin world there

69 Christ's gesture of pulling Peter by the hand becomes an image of the Saviour pulling the second Adam from the depth of Hades. Cf. Mesarites, p. 52.

70 For an interesting investigation of this motif, cf. Wilhelm Paeseler, "Giottos Navicella und ihr spätantikes Vorbild," *Römisches Jahrbuch für Kunstgeschichte*, v (Vienna, 1941), pp. 51–162, especially pp. 142–150. The church of St. Sergios in Gaza was decorated, *inter alia*, by a representation of the Sinking Peter, according to the description by Chorikios of Gaza (cf. Ch. Bayet, "Recherches pour servir à l'histoire de la peinture et de la sculpture chrétienne en Orient, avant la querelle des iconoclastes," *Bibliothèque des écoles françaises d'Athènes et de Rome*, fasc. 10 [Paris, 1879], p. 61). Another famous representation of the scene, probably produced in the Holy Land, is on the Ampulla of Bobbio (cf. Paeseler, "Giottos Navicella," p. 146 and fig. 125, and Carlo Cecchelli, "Note iconografiche su alcune ampolle bobbiesi," *Rivista di archeologia cristiana*, iv [1927], p. 115 ff.).

71 See e.g., the representation in the *Codex Egberti* (cf. F. X. Kraus, *Die Miniaturen des Codex Egberti in der Stadtbibliothek zu Trier*, [Freiburg, i. Br., 1884] fig. 22) with three Apostles in the boat; the somewhat later Golden Evangeliary of Henry III (cf. A. Boeckler, *Das Goldene Evangelienbuch Heinrich III* [Berlin, 1933] pl. 20) has five Apostles in the boat. Similarly the so-called Alexander-gem that has disappeared (cf. P. R. Garrucci, *Storia dell'arte cristiana*, vi [1880], pl. 478, 13; further literature in Paeseler, "Giottos Navicella," p. 146, note 361) had three figures in a definitely allegorical representation.

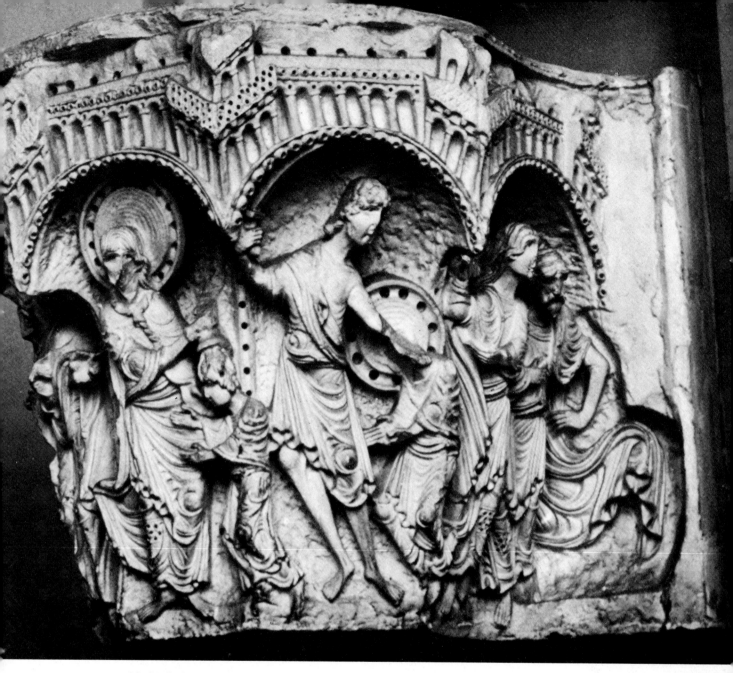

29 Capital: Story of St. James, Church of the Annunciation, Nazareth.

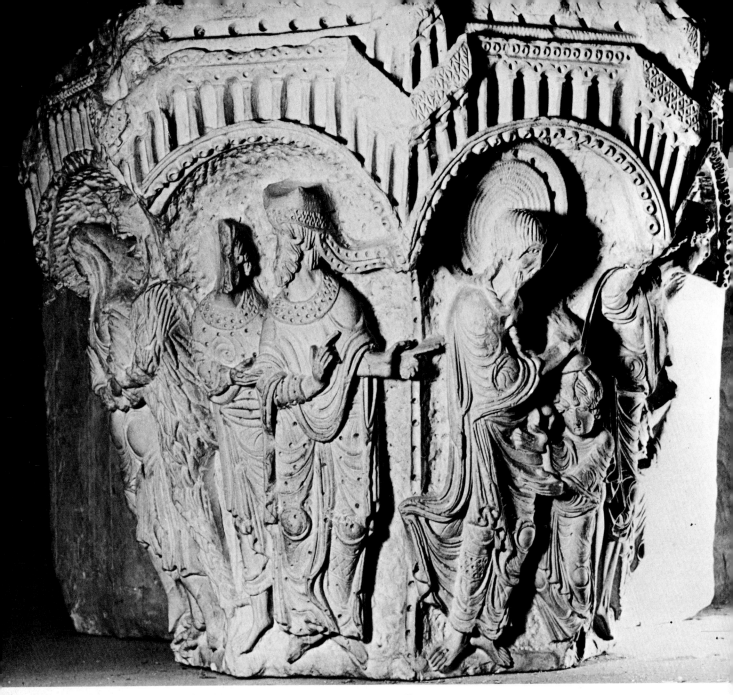

30 Above—Capital: St. James and the scribe.
31 Right—Capital, detail (St. James baptizing the scribe).

122

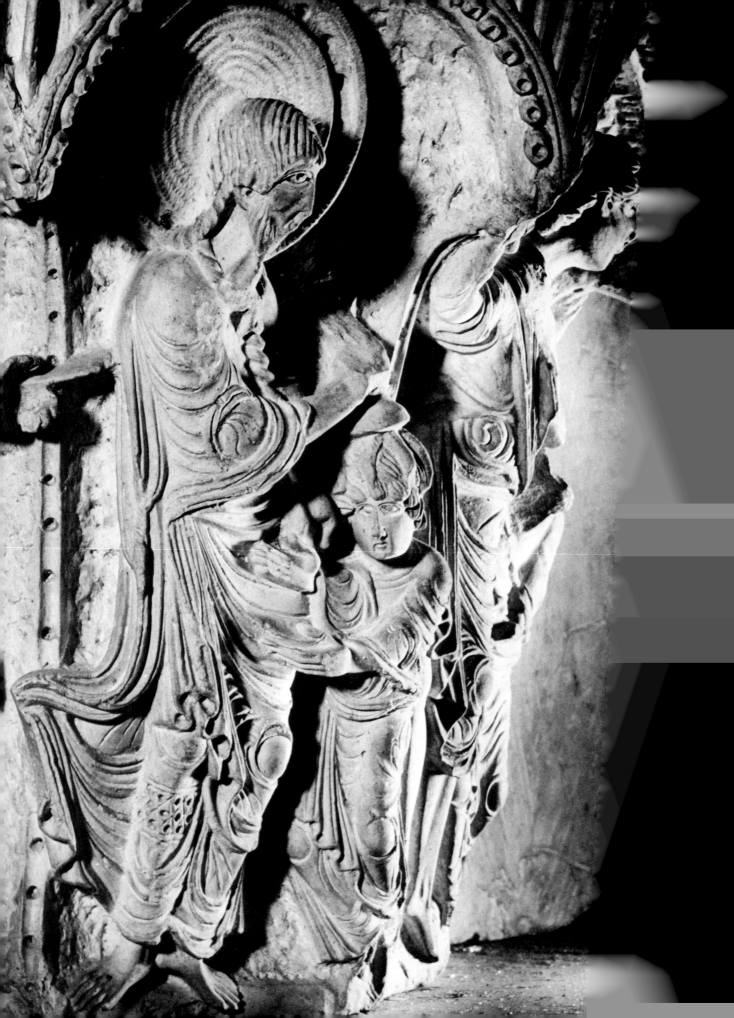

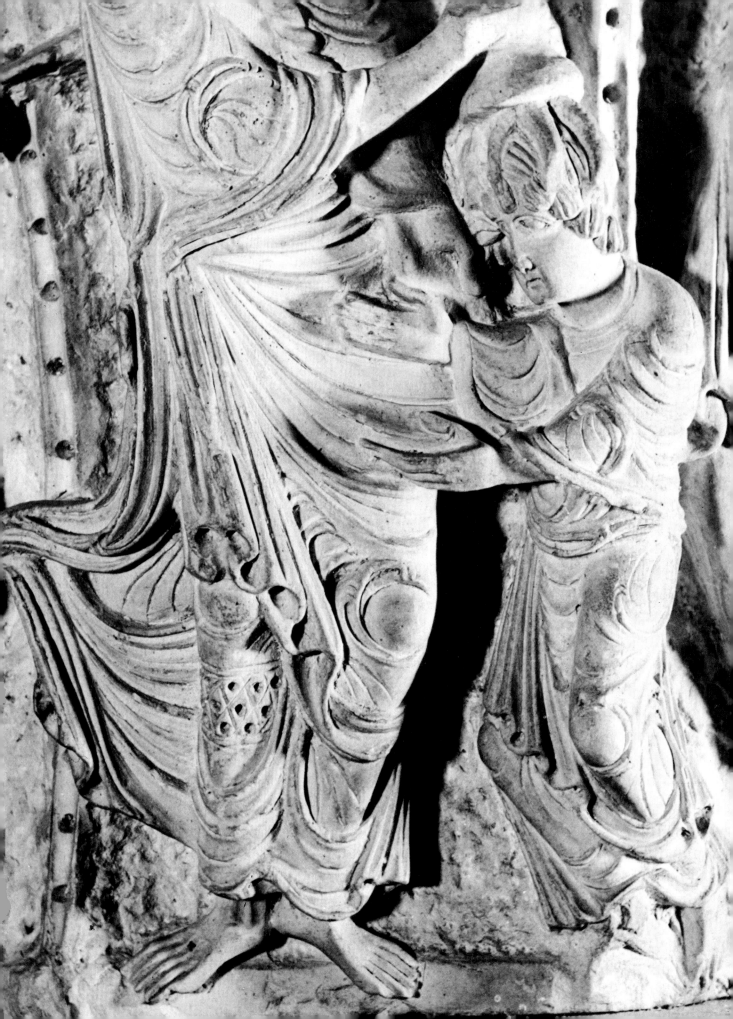

34 Left—detail (two figures).
35 Right—Capital, detail (demon and possessed).
36 Next two pages—Capital: Story of St. Matthew, Church of the Annunciation, Nazareth.

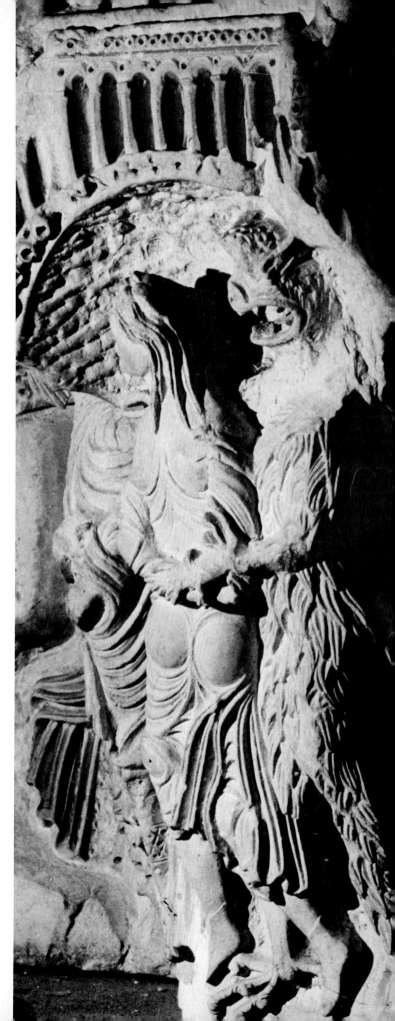

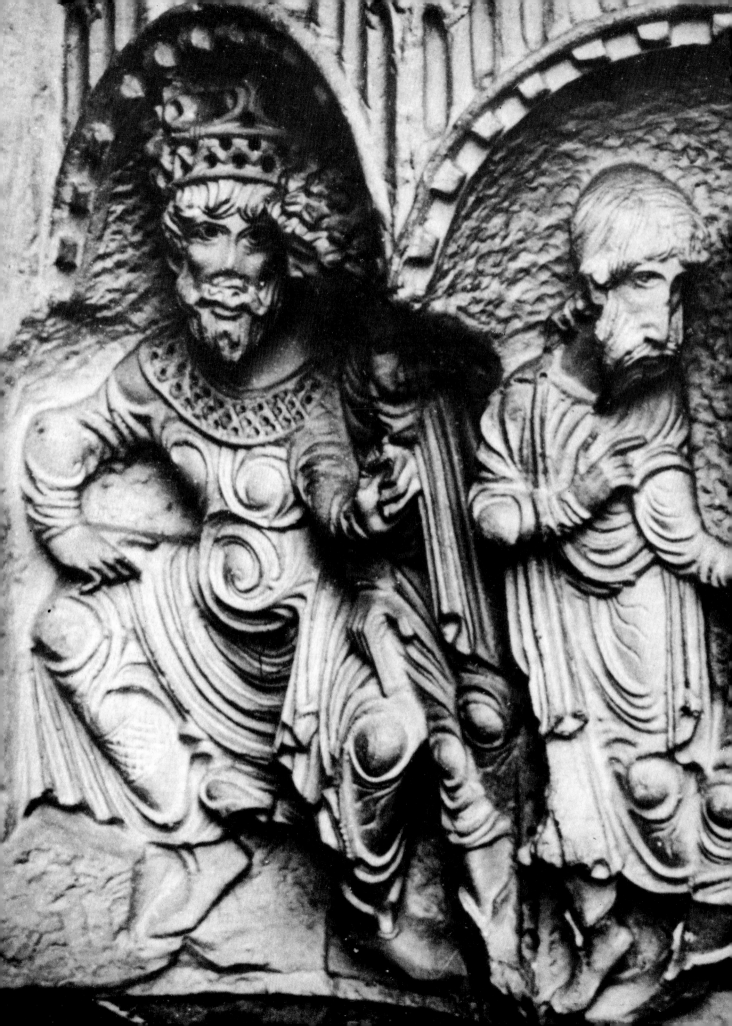

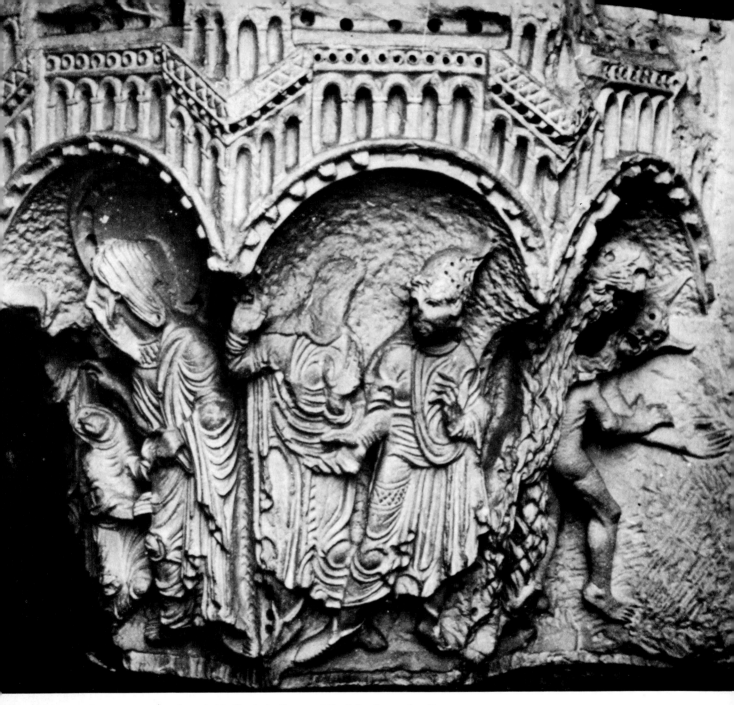

37 and **38** Capital: Story of St. Matthew, details.

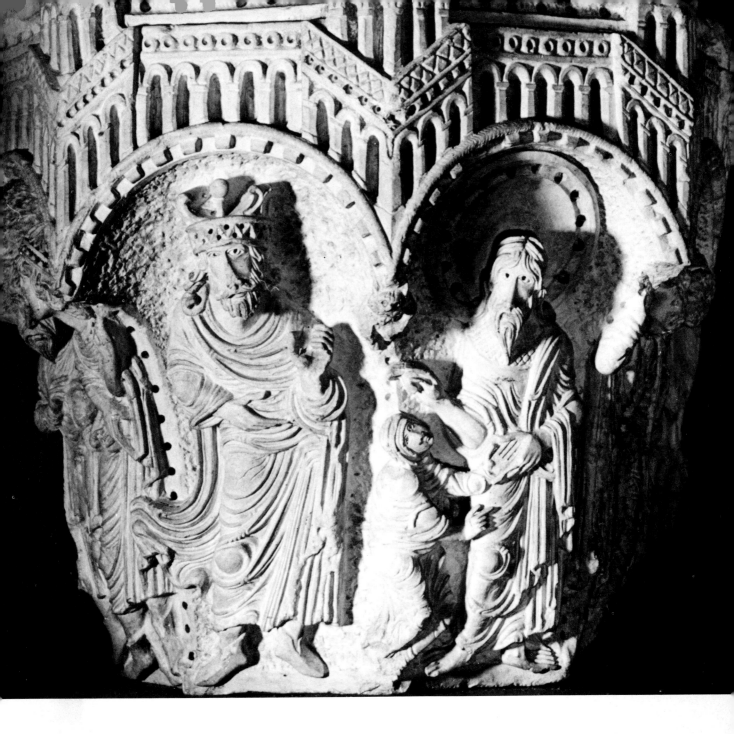

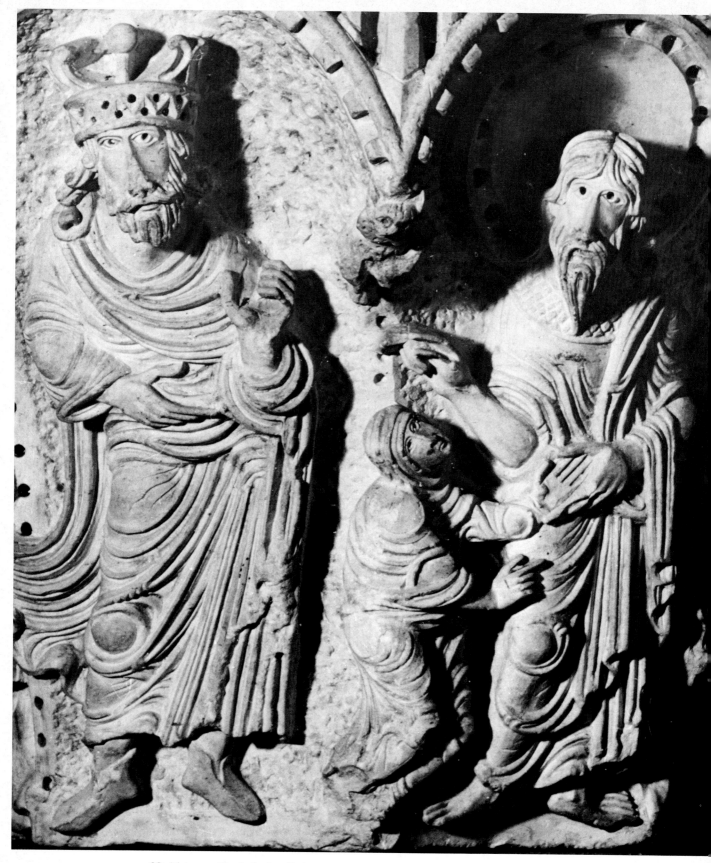

39 Above—Capital, detail (Hyrtacus, St. Matthew and Iphigenie).
40 Right—Capital, detail (two figures).

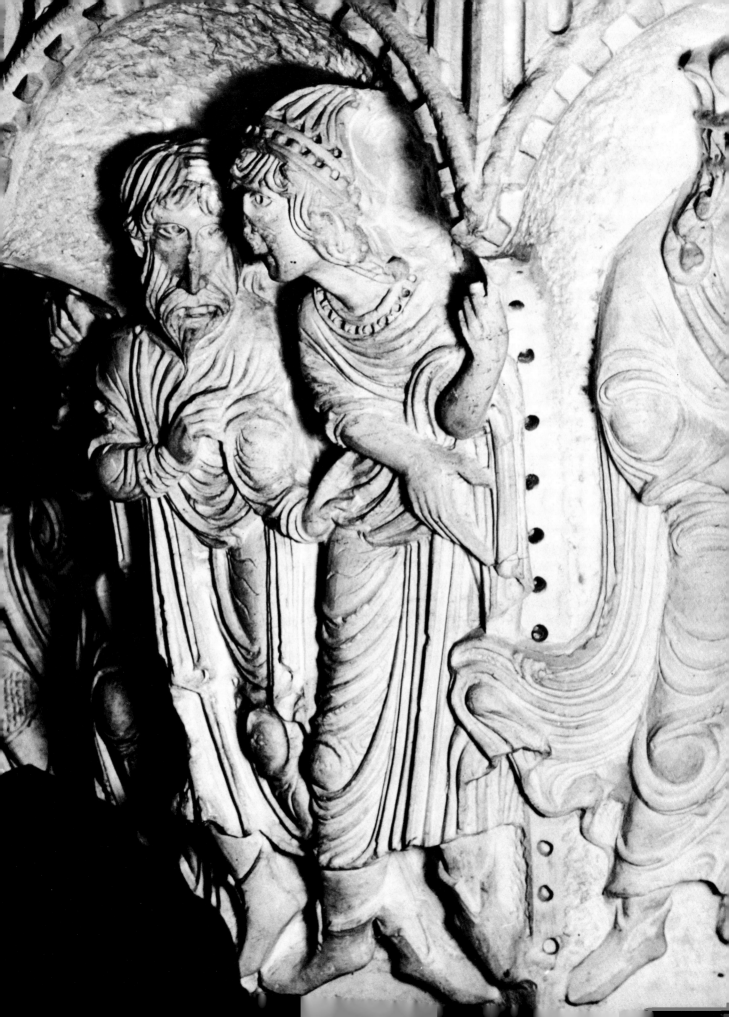

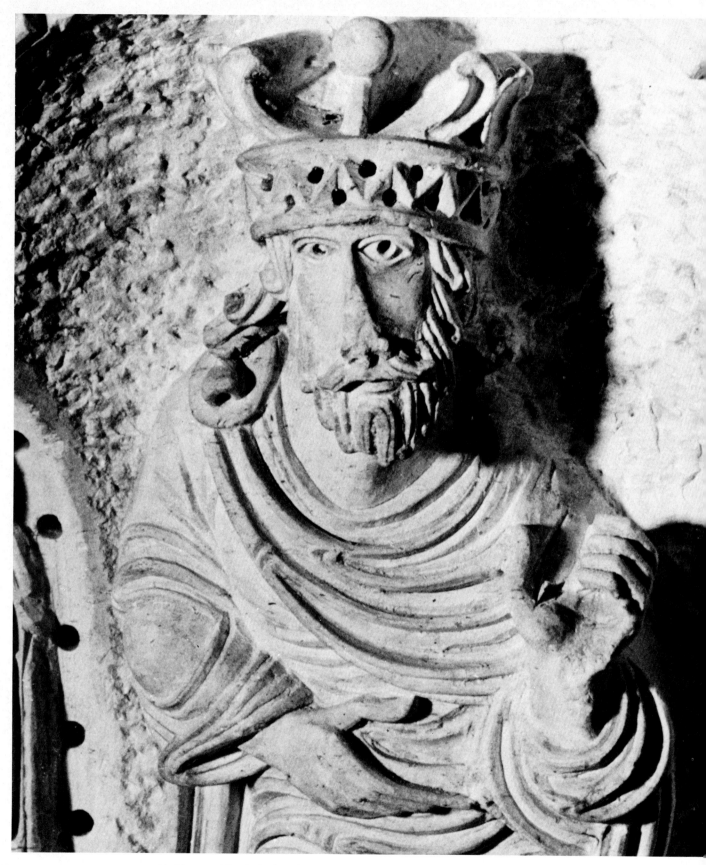

41 Above—Capital, detail (head of Hyrtacus).
42 Right—Capital, detail (St. Matthew and Iphigenie).

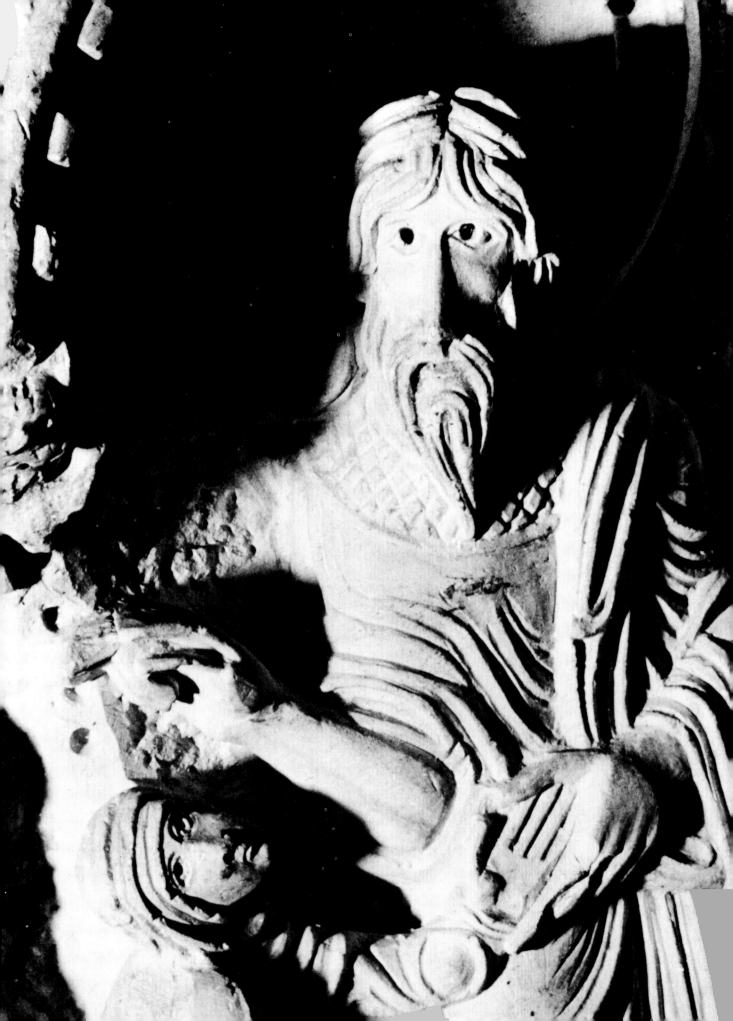

43 Capital, Plaimpied (Cher), Church of St. Martin.

seems to have existed also a literary tradition that could explain the fact that on our capital Christ does not grasp Peter's hand. Prudentius, in his poetical description of the Sinking Peter, gives the event a new turn. While the Peter of the Gospel asks to walk on the sea toward the Lord, in Prudentius' description Peter only asks for help during a storm, and it is Christ who urges him to leave the boat. Peter, the poet says, stretches out imploring hands, and Christ invites him "by a sign" to leave the ship.[72] This passage from *Contra Symmachum* (a work that exerted a wide influence) almost reads like a description of the scene of the Sinking Peter on our capital.

The other half of the Peter capital (figs. 21, 22) poses no difficult problems as to interpretation: it is clear that there the Resurrection of Tabitha is represented. Enlart has pointed out that in iconography the artist clung to the Western tradition: Tabitha is lying on a bed, and her upper body is nude.[73] The artist has departed from the text in several details. Peter is not kneeling, as suggested in *The Acts of the Apostles*, 9:40, but standing; in his left hand he holds a scroll (of which nothing is mentioned in the *Acts)* while with his right he holds Tabitha's hand, as required by the text. The emphasis placed on the drapery, blown by a wind over to the field in which the Apostle is represented, may suggest that this drapery motif is an expression of the divine spirit pervading the Saint as he is performing the miracle.

The only detail that has given place to some discussion is the identity of the figure standing behind Tabitha and helping her to rise (figs. 21, 22), and of the figures on the last face of the capital. Viaud believed[74] that these three figures represent the widows mentioned in the text (9:39),

Figs. 21, 22

Figs. 21, 22

72 *Contra Symmachum*, ii, 28–32 *(Migne, P. L., LX,* 175 f.). The text reads as follows:
>"Tendit suppliciter manus,
>Notum subsidium rogat.
>Ast ille placide adnuens
>Puppi ut desiliat iubet."

It is interesting that this passage occurs in a poem devoted to the preaching of Christianity to the heathen. Christ, who saved Peter struggling in the waves, is called upon to aid Prudentius against Symmachus, the defender of paganism, whose eloquence is like the stormy sea. This agrees with the other scenes of the Nazareth capitals in which the struggle of the Apostles against the heathen demons occupies an important place. While I do not want to suggest any direct relationship between Prudentius' poem and the program of the Nazareth capitals, this parallelism throws an interesting light on the meaning which the Sinking Peter could acquire in the context of the battle against the Infidel. This particular meaning must have certainly appealed to the Crusader community.

73 Cf. Enlart, *Les Monuments des Croisés,* ii, p. 306.

74 *Nazareth,* p. 159.

but de Lasteyrie has convincingly argued[75] that the figure helping Tabitha is too richly clad to represent a widow and should therefore be understood as somebody belonging to her family, while the two additional figures obviously represent men (the one young and the other old) who should be considered as some of the Apostle's helpers. Finally, Enlart believed that the figure behind Tabitha, which is beardless and barefoot, represents St. John, while the two additional men are other Apostles.[76] For the interpretation of the scene, in general, and for the definition of its place in the overall scheme of the capitals (if there is such a scheme) the exact identity of these figures is of rather marginal significance.

The iconography of the two other capitals is more obscure, but certainly no less illustrative of the Crusaders' beliefs and imagination. The events represented on them are drawn from later stages in the development of Christian imagery.

Figs. 29, 30

Fig. 29

Fig. 31

As mentioned above, the composition of the capital reproduced on figs. 29, 30 is divided in two symmetrical halves. Does the iconography exactly correspond to the composition? This is not so evident as in the former capitals. The right half of the capital (fig. 29) represents the martyrdom of St. James. On the left side of this half (fig. 31) we see the Saint wearing on his neck a rope which hangs down on his breast, and pouring the contents of a vessel over the head of a small figure that kneels in front of him. This group clearly represents the events preceding St. James' decapitation. As it is known, St. James was led to his execution by a scribe called Josias, who had fastened a rope around the Saint's neck. On the way to the place of torture the Saint healed a cripple, a miracle which brought about Josias' conversion. The *Legenda aurea* expressly states that the scribe fell on his knees and was baptised by the Saint.[77] The small figure in our group, then, represents the scribe, and the vessel in James' hands is the instrument of baptism. Viaud mistakenly affirms that the Saint holds the vessel in his "chained hands."[78] In fact, on our capital the hands of James are mutilated and nothing of a rope can be seen on them. However, the general interpretation of the scene, which was originally proposed by Viaud, is certainly

75 In Viaud, *ibid.,* p. 172 ff.
76 *Les Monuments des Croisés,* ii, p. 306.
77 Cf. *Legenda aurea,* ed. Graesse, p. 424, which reads: "Scriba autem, qui funem in collo suo miserat et trahebat, nomine Josias, hoc videns ad pedes ejus se projecit et veniam petens se christianum fieri postulavit."
78 *Nazareth,* p. 160.

138

correct. The next face (fig. 29) shows the Saint's decapitation. James *Fig. 29*
extends his hands in a gesture which means both acception of mar-
tyrdom and of the martyr's crown. On the last face appear two figures
which do not perform any specific action. The figure standing closer to
the Saint raises a hand in a dramàtic speaking-gesture; the other figure
is characterized by a strongly billowing drapery which extends into
the next (bare) face. De Lasteyrie has suggested that these two figures
represent the faithful who came to carry off the Saint's body.[79] This
interpretation can, in fact, be supported by the text of the *Legenda
aurea* which relates that believers carried off the martyr's body.[80] The
significance accorded to the removal of St. James' body (which was
brought to Spain where he became the patron of the Crusaders) cer-
tainly justifies the presence of these figures on our capital.

Does the other (left) half of the capital represent further scenes in the
life of James, and is therefore the entire capital devoted to him, as the
one is to Thomas and the other to Peter? Or is the left half devoted to
another Saint? This has been a matter of some dispute. Most scholars
have assumed that the left half of our capital is devoted to St. Barthol-
omew.[81] The well known legend has it that St. Bartholomew travelled
to India, where he cured the possessed, healed the lunatic daughter of
king Polymnius, and resurrected his son. Convinced by these miracles,
the king was converted to Christianity, renounced his throne, and
eventually became a bishop.[82] How, then, could the scenes represented
on the left half of our capital be related to the events of Bartholomew's
story? On the extreme left face of the capital we see the Apostle talking
to a young, beardless, worldly figure; the Saint extends his hand to the
young man (fig. 30). If it is indeed the story of Bartholomew that is *Fig. 30*
rendered here, this group could represent, as Viaud proposed,[83] either
the Saint with one of the possessed he cured, or with the resurrected
son of the king. De Lasteyrie doubts the first interpretation since the
well-dressed and well-groomed worldly figure shows no signs of posses-
sion,[84] but he does not mention the other interpretation. Another pos-

79 In Viaud, *ibid.*, p. 173.

80 *Legenda aurea*, p. 424.

81 Viaud, *Nazareth*, p. 160 ff.; Deschamps, "La sculpture française," p. 104 (but without going
into details); Enlart, *Les Monuments des Croisés*, ii, p. 306. As far as I can see, only de Lasteyrie
questioned this interpretation. Cf. below, p. 140 ff.

82 *Legenda aurea*, p. 540 ff.; *Passio Sancti Bartholomaei Apostoli (Acta Apostolorum Apocrypha*,
ed. M. Bonnet, ii [Leipzig, 1898]), p. 128 ff.

83 *Nazareth*, p. 161.

84 In Viaud, *ibid.*, p. 174.

sibility, based on the story of St. Bartholomew, would be to connect this group with the scene on the second face, representing a demon leading a possessed in chains. The literary formulations of Bartholomew's story relate that the Saint ordered one of the king's servants to approach the possessed daughter of Polymnius: the servant hesitates, although the Saint tells him that he has already exorcised the demon.[85] The eloquent gesture of the Apostle as well as the hesitating pose of the secular figure might vaguely support this explanation. However, the rich garments of the young man seem to argue against his being a servant.

On the next face we see the powerful group of the possessed with hands chained at the back, being led or pushed leftwards by a demon, that is, in the direction of the Saint in the group just discussed. The former group, of a high expressive quality, poses a rather difficult problem of identification. As we have already mentioned the story relates that St. Bartholomew healed the possessed daughter of King Polymnius. The literary traditions mention the detail of the king's daughter being chained, that the Apostle asked she should be brought to him, and that she would then already be healed and freed of the demon.[86] But on our capital the demon is interlocked with her, and she herself is represented in that chiastic, spiral-like movement which is a strong expression of *Fig. 35* lunacy, and she shows no signs of being healed (fig. 35). Moreover, the demon looms so large in the composition that it is difficult to assume that he was represented without any basis in the narrative. It was mainly this problem that made de Lasteyrie doubt the assumption that the left half of our capital is devoted to Bartholomew,[87] a question to which I shall presently return.

If it is indeed the story of Bartholomew that is represented here, then *Fig. 34* the last face (fig. 34) would represent King Polymnius, after he had renounced his throne and become a bishop. His headgear clearly differs from all the crowns represented on the capitals, and does indeed suggest a bishop's mitre. The figure beside him, to which the king-bishop turns in a lively speaking-movement, could be his resurrected son[88] or simply another follower.

De Lasteyrie, at the suggestion of Emile Mâle, believed that the whole

85 Cf. *Passio Sancti Bartholomaei Apostoli*, p. 133 ff.; "Dicit eis apostolus: Iam ego uinctum teneo inimicum in ipsa erat, et uos adhuc timetis eam?"
86 Cf. *Passio Sancti Bartholomaei Apostoli*, p. 134.
87 Viaud, *Nazareth*, p. 174.
88 As was proposed by Viaud, *ibid.*, p. 161.

capital was devoted to St. James. The left half, which the other scholars believed to be based on the story of St. Bartholomew, would in that case represent St. James's struggle with the sorcerer Hermogenes.[89] Old and widespread legends told of that struggle: while preaching in Judea, St. James encountered two sorcerers, Philetus and Hermogenes, the latter acting in accord with the Pharisees. Philetus is converted by the Saint, but he is paralyzed by Hermogenes; James sends his *suarium,* by a messenger to the converted sorcerer Philetus, and relieves him. Hermogenes dispatches demons to harry the Saint, but they are defeated and sent back with the order to bring Hermogenes to James. They do so, carrying Hermogenes "with his hands tied at his back."[90]

If the whole group is indeed devoted to James, then the group on the face to the extreme left probably represents the Saint with Philetus, who has given up sorcery. It could also be read as a representation of sending the *suarium,* as is perhaps suggested by the gesture of the Apostle. The second face (fig. 35) would represent Hermogenes whom the demons lead to St. James. In that case the largely looming figure of the demon, as well as his action of pushing the possessed figure towards the Saint, would perfectly agree with the narrative. Moreover, the possessed figure has the hands "tied at the back," as required by the story.

Fig. 35

The only difficulty is that the possessed figure seems to be that of a woman. The details of the possessed person's face cannot be seen,[91] but the feminine character is suggested both by the anatomical details (breast and buttocks) and by the long hair, falling in disorder on the figure's shoulders. As we have already pointed out,[92] on the Nazareth capitals the form characteristic of the feminine breast occurs on figures that are clearly those of men; hence, this particular feature cannot be considered as sufficient to identify the figure as that of a woman. Moreover, in medieval art one often finds the "inorganic" combination of sexes, and of different types of beings, as a characteristic of the demonic.[93] Taking these elements into consideration, I think, this scene can be interpreted as that of Hermogenes pushed by demons toward St. James.

89 Viaud, *ibid.,* p. 174.

90 *Legenda aurea,* p. 423, reads as follows: "Qui cum abiissent, apprehendentes Hermogenem manus ei a tergo ligaverunt et ipsum sic vinctum ad Jacobum adduxerunt."

91 The only feature that can be clearly established is that the face is beardless, but other sorcerers are also beardless.

92 See above, p. 109 ff.

93 See, e.g., the central porch of Notre Dame in Paris where Satan, who is a male figure, has female breasts (cf. Erich, *Die Darstellung des Teufels,* p. 78). Another form of representing inorganic combinations as a Satanic feature may be the depiction of faces as breasts or genitals (*ibid.,* p. 80).

Figs. 36, 37 The fourth of the small capitals (figs. 36, 37), conceived in the form of a continuous narrative, is devoted to Matthew. The events represented on it are again derived from later stages of medieval imagery, and can be explained by the apocryphal writings and particularly by the *Legenda aurea.* The interpretation of the scenes, originally proposed by Viaud,[94] has been accepted, though with some modifications, by all subsequent scholars. It is based on texts only; the scenes represented on this capital seem to have been rarely treated in the arts (particularly in sculpture), and none of the scholars who have investigated the capitals have adduced any former visual representations of the story of Matthew.

The literary sources tell of Matthew preaching to the Ethiopians, fighting two sorcerers, Zaroes and Arfaxat, and resurrecting the son of the Ethiopian king.[95] Some of these events seem to be represented on
Fig. 36 the left half of the capital. The first face, on the left (fig. 36), shows a sitting king (probably Eglypus, King of Ethiopia) who wears a large crown; against him leans a smaller and slenderer figure characterized by youthful appearance and elaborate headgear. As the sex of the youthful figure cannot be established, it may represent either the king's resurrected son, now happily restored to his father,[96] or the king's wife, or daughter.[97] It has been pointed out by some scholars that this group recalls the representation of Herod and Salome on a famous capital of Toulouse.[98] While there are indeed some obvious formal similarities (see the posture of the king, especially the hand resting on the knee, the richly adorned garment, and perhaps also the crossed legs of the smaller figure) they don't help in establishing the meaning of the scene, since our capital obviously has nothing to do with the story of Herod and Salome. The meaning of the scene is to be understood in the context of the whole capital.

Fig. 36 center The group on the next face (fig. 36 center), consisting of a young and an old man engaged in animated conversation, has been interpreted in different ways. Viaud believed that the young man represents the resurrected son of the Ethiopian king, while the old one represents the eunuch who, according to the legend, was favourably inclined towards

94 *Nazareth,* p. 161 ff.
95 See *Legenda aurea,* p. 623 f., and M. R. James, *The Apocryphal New Testament* (Oxford, 1926), p. 467.
96 As proposed by Deschamps, "La sculpture française," p. 105.
97 As proposed by Viaud, *Nazareth,* p. 162, and by Enlart, *Les monuments des Croisés,* ii, p. 307.
98 See Deschamps, "La sculpture française," p. 105. For the Toulouse capital, cf. Kingsley Porter, ill. 446.

the Saint.[99] Most other scholars, however, see in this group the two sorcerers, Zaroes and Arfaxat, who had been unable to resurrect the king's son, and were discomfited by the miracle worked by the Saint.[100] Although there are no signs that would definitely establish the identity of the two figures, the second interpretation seems more plausible, and can probably be supported by some details of the work itself. The two figures are interlocked, their knees meet and their legs overlap, creating the X-shaped pattern, already discussed as a feature connected with the demonic.[101] It is also interesting to note that the younger figure wears a conic hat, or helmet, which closely resembles the form of the helmets worn by the demons on the large capital, to which we shall shortly return. Hence it seems likely that this group represents the two magicians. On the other hand, the dragons that play a conspicuous part in the legend, being always connected with the two magicians, do not figure on the capital.

On the third face (fig. 39 left) we see the standing figure of another king, probably representing Hyrtacus who ascended the throne after Eglypus, his brother, was converted to Christianity and became a bishop. The gloomy expression and rigid stance of the standing king (clearly opposed to the relaxed, seated position of the king on the first face) is perhaps meant to indicate the evil character of Hyrtacus, who was to end his life by committing suicide.

Fig. 39 left

Continuing the narrative, the following face of the capital depicts the next major event. The legend relates that Hyrtacus, after ascending the throne, wished to marry his niece Iphigenie, who had taken the vow of chastity. In desperation she turned to Matthew for help, and, as the *Legenda aurea* has it, she fell on her knees before him.[102] This scene appears on the fourth face (fig. 39 right). The diminutive figure of Iphigenie (who, interestingly enough, is the only figure of the Nazareth capitals to wear a nun's veil) sinks to her knees; in one of his hands the Apostle holds Iphigenie's hand in a protective gesture, and with the other he blesses her.

Fig. 39 right

The last two scenes of this capital are even more obscure and allow for

99 Viaud, *Nazareth*, p. 162.
100 De Lasteyrie in Viaud, p. 176; Deschamps, "La sculpture française," p. 105; Enlart, *Les Monuments*, ii, p. 307.
101 Cf. above, p. 113, and notes 49, 50. An X-shaped pattern is also created by the hands of the two figures – continue the line from the hand of the older figure, touching the younger, into the younger's arm – a line which is crossed by the other arm.
102 *Legenda Aurea*, p. 624.

Fig. 37 center

differing interpretations. On the fifth face (fig. 37 center) are represented two figures practically identical with the two sorcerers on the second face.[103] Are they again Zaroes and Arfaxat? In the legend, the two sorcerers appear several times, at different stages of the narrative.[104] A second representation of them is, therefore, justified by the texts (although nothing significant is said of them after their first encounter with the Saint). Another explanation of this group would be to see in the two figures some of the sorcerer-messengers whom, according to the legend, Hyrtacus dispatched to Iphigenie to convince her to agree to the proposed marriage. Although this would fit the sequence of events as related in the texts, the interpretation is difficult to accept. Since the messengers sent by Hyrtacus do not fulfill any significant function in the story, one can hardly see any reason for representing them. Moreover, among the messengers were also women who are not represented on the capital. The striking similarity of this group to that on the second face speaks, I think, for the assumption that here we see again the same sorcerers. Did the artist conceive of such a group of two intertwined figures as a typical image of sorcery, an image that could be applied to Zaroes and Arfaxat as well as to the sorcerer-messengers? Although no detail enables us to reach a definite conclusion, it seems likely that we see here again Zaroes and Arfaxat who, as I have already remarked, are said to have always gone before the Apostle.[105]

Fig. 37 right
Fig. 35

The meaning of the last group (fig. 37 right) is no less obscure. A hairy demon (recalling the demon in the group of the possessed, see fig. 35) seizes, or pushes, a beautiful naked figure that bears a grotesque head endowed with what seem to be asses' ears. The shape of the only visible hand of the demon recalls that of a bird's claw. Viaud assumed that the group represents Hyrtacus' soul as it is seized by a demon.[106]

103 Not only in composition, but also in specific motifs. Cf. the overlapping of the legs of two figures, and the conic cap of the younger man. Since the face of the one figure is mutilated, one cannot compare it with the corresponding face in the former scene.

104 In the *Apostolic History of Abdias* (cf. James, *Apocryphal New Testament*, p. 467) it is told that Zaroes and Arfaxat "fled the country" after the Apostle baptized the "King, Prince and Princess Ephigenie, who vowed chastity"—which would correspond to the sequence on our capital. In another place (James, *ibid.*, p. 465) it is said that "Zaroes and Arfaxat always went before the Apostles and warned the people against them, but were as regularly defeated."

105 Viaud, *Nazareth*, p. 162, believes that this group "might represent King Hyrtacus with his son," an interpretation which is difficult to accept. Where the artist wanted to represent a king, *Fig. 36* he clearly identified him as such by a crown (cf. fig. 36), but in this particular scene nothing indicates that a king is meant. On the other hand, there is the close similarity to the group of the sorcerers on face 2 which can hardly be mere chance.

106 *Nazareth*, p. 162.

144

The difficulty about this explanation is that, according to the literary traditions, it was not Hyrtacus himself but rather his son who was seized by a demon, and confessed his father's sins at the Apostle's grave. Of Hyrtacus himself it is said that he stabbed himself when attacked by leprosy.[107] The deformation of the figure's head could perhaps be interpreted as indicating the ravages of that disease.

Representations of devils seizing a naked figure that stands for the soul of a sinner are, of course, well known in medieval art. There are also some examples which have certain formal elements in common with our group. In an English illumination of the eleventh century, for instance, two devils carry off the naked soul of a sinner; one of the devils hooks it, as in Nazareth, with a claw issuing from the region of the belly.[108] These are, however, rather vague similarities which are not sufficient to identify our scene.

Another interpretation, briefly suggested by Enlart,[109] would explain this group as representing two devils. The literary traditions of the legend intimately connect the Saint's defeat of the two sorcerers with his victory over two demons. These, as already mentioned, are not represented on the former faces of the capital, and their escape may perhaps be seen on the last face. Misled by the beautiful, almost classical nude, Viaud probably tried to find an appropriate human being in the legend. However, such a figure may also represent a demon. In medieval art, especially of western Europe, there were two major types of demons, a bestial and a classically human one.[110] In the twelfth century one frequently finds a beautiful Satan, inspired from classical sculpture.[111] There are also devils in the shape of beautiful naked figures wearing grotesque animal heads. I shall quote only two distant examples. In English twelfth-century sculpture one finds such a type of devil supporting the hell in *The Doom* of York Minster.[112] Some interesting Italian examples are to be found in the mosaics of the Baptistery in

107 *Legenda aurea,* p. 625.

108 Vatican, *Regina lat.,* 12, f. 62 v (cf. Meyer Schapiro, "From Mozarabic to Romanesque in Silos," p. 331, note). The motif of a devil seizing a figure by the throat also occurs on a capital of Vézelay (cf. Kingsley Porter, ill. 42). However, here the figure seized is that of a saint who wears a heavy robe. The nudity of the figure on our capital may be an indication of sinfulness. Cf. Erwin Panofsky, *Studies in Iconology* (New York, 1939), p. 156 ff.

109 *Les Monuments des Croisés,* ii, p. 307.

110 Cf. above, note 42.

111 Cf. e.g., Erich, *Die Darstellung des Teufels,* p. 68, referring to a capital from St. Sernin in Toulouse.

112 Cf. F. Saxl, *English Sculpture of the Twelfth Century* (London, 1954), pls. xciii, xcv.

Florence.[113] These devils are not only represented by — more or less — beautiful, naked bodies wearing bestial heads, they also bear the distinctive mark of long ears that is so prominent in the Nazareth capital. Hence, it can be safely affirmed that the specific combination of a naked figure with a bestial head was one of the formulae for representing the devil, encountered mainly in renderings of the Last Judgement. Our group may have been derived from such a representation. Even the position of the arms and hands of the nude figure of Nazareth, a position difficult to explain, may point to the fact that the figure is derived from the representation of a demon in a Last Judgement grasping the soul of a sinner. Such a derivation, although not conclusive in itself as far as meaning is concerned, would lend further support to what is suggested by an investigation of the other aspects. In sum, seen in the context of the whole capital, it is quite plausible that the discussed group represents two fleeing demons. This would bring the story of the Apostle's defeat of the heathen magicians and demons to a natural conclusion.

Does the large capital represent a further episode drawn from medieval legends, or does it sum up in *one* image the themes of all the other capitals? In other words, is the large capital of a narrative or of an allegorical character? As I have already mentioned, the central face of that capital shows a group of two figures; a crowned female figure — with a long veil falling from head to shoulders, and carrying in one of her hands a long staff mounted by a cross — leads by the hand another figure. The second figure, nimbed, bearded and barefoot, is obviously

Fig. 8 frightened, and hesitates to proceed (fig. 8). This central face is flanked on both sides by faces on which are represented groups of two demon-warriors attacking the central group.

Who are the figures on the central face and what is the meaning of the scene? De Lasteyrie was the only scholar who considered the possibility of the scene being of a narrative character. He believed that the bearded figure, with nimbed head, and bare feet again represents an Apostle. Following a suggestion by Mâle, he tentatively identified the figure as St. Matthew.[114] As mentioned above, an obvious omission on the Matthew capital is the Apostle's encounter with the two dragons. The legend has it that these two fire breathing dragons that accompanied

113 Often reproduced. Cf. Ferdinando Bologna, *Early Italian Painting* (London, 1963), pl. 66. See especially the devil to the left, stepping over a sinner enveloped in flames, and grasping a figure. In the Florence mosaic the nude devil has a short tail. The naked figure on our capital is partly covered by the hairy demon and therefore one cannot say whether it has a tail.
114 Viaud, *Nazareth,* p. 177 ff.

the sorcerers Zaroes and Arfaxat were defeated by the Saint making the sign of the cross. De Lasteyrie suggests this scene might be represented here. The dragons, he says, became devils; the two other figures, whose faces are partly hidden by strands of hair (fig. 7), are the two sorcerers. Although De Lasteyrie expressed this suggestion reluctantly because, as he himself admitted, it left many questions open, it should be briefly examined. There are several considerations which make it difficult to accept De Lasteyrie's suggestion. First, there is the fact that we see no dragons but demons and warriors. The image of the dragon, so common in Romanesque art, was certainly not unknown to the Nazareth artist;[115] if he did not represent it, one can safely assume that he did not intend to. Second, it is not the Apostle who makes the sign of the cross, but the allegorical queen who carries the cross in her hand. Third, the legend stresses that St. Matthew boldly strode against the dragons, rejecting advice to hide in the house.[116] The figure on our capital, however, clearly suggests fear and hesitation.

Fig. 7

For all these reasons, the identification of the figure as Matthew, and of the scene as the episode of the encounter with the sorcerers and dragons must be rejected.

De Lasteyrie's assumption that an Apostle is represented here is based on the fact that the figure is nimbed, and barefoot.[117] In medieval art, however, one often finds allegorical figures, and even secular personifications, adorned with a halo.[118] Neither are the bare feet sufficient to denote an apostolic figure, as the feature occurs in figures that certainly

Fig. 43

115 On the Nazareth capitals no dragons are represented, but on that of Plaimpied (fig. 43), whose relationship to our capitals is significant in style as well as in motifs (cf. above, p. 77 and below, p. 156 ff.), a dragonlike creature does appear.

116 *The Apostolic History of Abdias,* vii (James, *Apocryphal New Testament,* p. 446) relates the event in the following words: "One came and announced that the magicians were coming with two crested dragons breathing fire and brimstone. Matthew crossed himself and rose to meet them. 'Speak from the window,' said Candacis. 'You can be at the window; I will go out' [replied the Apostle]." The formulation of the *Legenda aurea,* p. 623, is just as clear.

117 Viaud, *Nazareth,* p. 177.

118 For early Christian art, cf. Adolf Krücke, *Der Nimbus und verwandte Attribute in der frühchristlichen Kunst* (Zur Kunstgeschichte des Auslandes, xxxv) (Strasbourg, 1905), p. 65 ff. In Byzantine art the halo is frequently employed as a sign not only of holiness but also of importance and power. Cf. M. Didron, *Iconographie Chrétienne: Histoire de Dieu* (Paris, 1843), p. 157 f. Personifications of towns and virtues may also have a halo. For well-known examples, cf. the personifications of towns (Ain, Gibeon) in the Joshua Roll (cf. K. Weitzmann, *The Joshua Roll — A Work of the Macedonian Renaissance* [Princeton, 1948], figs. 19, 37, 65, 73) and the personification of Penitence in a Crusader manuscript of the twelfth century (cf. Buchthal, *Miniature Painting in the Latin Kingdom,* pl. 149e and p. 62). For Satan adorned with a halo in Byzantine art, cf. Didron, *Iconographie Chrétienne,* p. 162. Even in Western art, where the halo is used to designate saints, there are exceptions. Cf. Nik. Müller in *Realenzyklopädie für protestantische Theologie und Kirche,* vii (Leipzig, 1899), pp. 559–566.

do not represent Apostles.[119] Hence, the hesitating figure with the halo must not necessarily represent an Apostle, and the assumption that the large capital represents a narrative scene may be dismissed.

Most other scholars who investigated the Nazareth capitals believed that the female figure on the large capital was an allegorical representation of Faith or *Ecclesia*. The representation of *Ecclesia* as a noble, sumptuously clad, and crowned female figure is famous of course. As one knows, she often carries in her hand a long-shafted cross, or a *sceptrum regale* ending in a cross.[120] But similar attributes sometimes occur in representations of *Fides* as well.[121] The long veil, falling from the head of the figure, may also sometimes characterize *Fides*.[122] In the Nazareth capital it is, in fact, of little importance whether the female figure is a representation of "Faith" or "The Church," since in our scene the meanings of these figures actually overlap; in both cases it is the True Belief (i.e. the belief in the Christian Church) that leads the other figure through an ominous world.

But who is the other figure? In this respect scholarly opinions differ widely. Viaud believed[123] that it is "The Just" who is here led away from the demons. To strengthen his interpretation, Viaud adduced several interpretations from Scripture. He quotes a sentence from *The Wisdom of Solomon* (10:10), but the whole passage, from which he takes a single sentence, is even more suggestive, and deserves quotation *in extenso*:

An upright man, who was a fugitive from a brother's wrath,
She guided in straight paths;
She showed him God's kingdom,
And gave him knowledge of holy things;
She made him prosper in his toils

Figs. 29, 22 **119** On the Nazareth capitals, the executioner (fig. 29), and the figure behind Tabitha (fig. 22).
120 Cf. J. Sauer, *Symbolik des Kirchengebäudes und seiner Ausstattung in der Auffassung des Mittelalters* (Freiburg, 1902).
121 For *Fides* with a crown, cf., e.g., the *arbor bona* in the *Liber floridus Alberti* (Ghent, Bibliothèque de l'Université et de la Ville, MS 16, fol. 231 – reproduced in Adolf Katzenellenbogen, *Allegories of the Virtues and Vices in Medieval Art* [1964], fig. 64; cf. also p. 65). For the cross as a symbol of "Faith," cf. J. Sauer, *Symbolik des Kirchengebäudes*, p. 240. In a lost mosaic of Reims, *Fides* carried a blossoming sceptre (cf. Katzenellenbogen, *Allegories*, p. 53). In the *Hortus deliciarum*, *Fides*, represented as a knight, carries a cross as a weapon, whereas the other virtues, which are also represented in the guise of knights, carry conventional weapons (see Katzenellenbogen, *Allegories*, fig. 8b).
122 Cf. Germer-Durand, "La sculpture franque en Palestine," p. 244. For examples of *Fides* with a veil, cf. Katzenellenbogen, *Allegories*, figs. 64 (see preceding note), 67, 72b.
123 *Nazareth*, p. 156.

And increased the fruits of his labors;
When those who oppressed him were covetous, she stood by him,
And made him rich.
She protected him from his enemies,
And kept him safe from those who lay in wait for him,
And decided his hard contest in his favor,
So that he should know that godliness is stronger than anything.
When an upright man was sold, she did not abandon him,
But delivered him from sin;
She went down into the pit with him,
And she did not leave him in prison,
Until she brought him the scepter of a kingdom,
And power over those who lorded it over him. (10:10–14).

Viaud also quotes the Epistle to the Philippians, 2:12, which says: "work out your own salvation with fear and trembling,"[124] and Psalm 73:23, that reads: "Nevertheless, I am continually with Thee: Thou hast holden me by my right hand."

These quotations are certainly convincing, since they fit so well the central group on our capital, both in general expressive mood and in specific motifs. This correspondence, however, should not induce us to assume that the texts cited by Viaud may have served as a direct source of the representation. In spite of the fact that the apocryphal writings exerted a considerable influence on the medieval mind, one finds it difficult to believe that the crowned female figure on our capital represents "Wisdom," and not "The Church" or Faith. Nor can I see any convincing reason for assuming that the hesitating figure represents in a precise way "The Just." The parallelism between the texts (particularly that from *The Wisdom of Solomon*) and the group on the large capital only shows that such images, in visual and in literary form, had a long history in medieval culture.

A somewhat different interpretation of the group is given by Germer-Durand.[125] He adduces another quotation from Scripture that evokes the image of victory (First Epistle of John 5:4: "And this is the victory that overcometh the world, even our faith"), a victory that is not related to any specific figure or event. He believes, however, that the hesitant figure represents an individual Apostle, namely, Peter. Germer-

124 However, the sentences that precede and follow the words quoted give them a meaning that, in my opinion, does not agree with that intended by Viaud.
125 "La sculpture franque," p. 245.

149

Durand claims that one finds "some resemblances" when comparing the hesitant figure on the large capital with the figures that undoubtedly represent Peter. But in following his advice we do not reach the same conclusion. It is true that the draperies are sometimes similar (cf. the ornamented neck-line of the garment covering the figure on the large capital and of Peter resurrecting Tabitha, figs, 9, 23), but so they are in other figures that certainly do not portray Peter (fig. 40).

Figs. 9, 23

Fig. 40

Another common element, the posture of the body and particularly the flexed knees which occurs in Peter on the waves (fig. 25) and in our figure, is an expressive formula of weakness and uncertainty that may be observed also in the figure of Thomas (fig. 14). Specific physiognomic elements show, I think, different characteristics. In both representations of Peter, the Apostle wears a short, round beard, while the beard of the hesitant figure in the large capital is somewhat longer and pointed.

Fig. 25

Fig. 14

Reviewing these considerations, it seems fairly certain that the group on the large capital does not represent a narrative scene, but rather has an allegorical meaning. Several closely interrelated themes suggest themselves. If the hesitant figure is indeed intended as an Apostle, it does not represent any individual Apostle, but is rather a symbolic image of the Apostles' mission of preaching Christianity to the heathen, the dangers besetting that mission, and the mysterious help extended to them (and by implication to the Crusaders) by the Church or by Faith. One wonders, however, whether this figure has not a more secular and, at the same time, a more precise meaning, related to the historic events of the years preceding the fall of Nazareth. Since the early 1180s the Christian community in the Latin Kingdom had felt seriously threatened by the gathering forces of Saladin. In 1183–1184 Moslem warriors invaded the northern part of the Latin Kingdom, besieged Mount Tabor, and almost reached the outskirts of Nazareth.[126] The rescue of the city and the entire Galilee, achieved by a general mobilization of the Crusader forces and the presence of the True Cross, must have been understood as a miracle. If the Nazareth capitals were indeed executed shortly before 1187, as seems probable, might they not have referred to these events? Should not the hesitant figure be understood as a representation of the frightened Christian community being led safely by the Church, under the sign of the cross, through the menacing forces of the devil-like heathen?

126 Cf. S. Runciman, *A History of the Crusades II* (Cambridge, 1952), p. 436 ff.

150

Such an interpretation cannot be proved conclusively, but additional observations suggest, I think, the same reasoning. If we consider the capital as a whole, the attacking figures are remarkable in number and grouping. The idea of four demons in hell (and four archangels in heaven) is common to Jewish, Christian, and Islamic belief. The isolation of four demons is typical of late antique and medieval magic and of exorcism formulae, and is met in Romanesque illuminated manuscripts.[127] Also, the conception of unleashed demons with open mouth and bared teeth, attacking their victims with pointed and sharp weapons, is typical of late antique and medieval magical practices and exorcism.[128] We are thus confronted with an influence of popular demonic imagery. But are these four figures demons? As opposed to the demons on the other capitals (figs. 35, 37), these figures have human bodies, only their faces bear a devilish expression. The human form of the demon was, of course, common in Byzantine culture,[129] but the shape of the figures does not show deep Byzantine influence. The appearance of devils in the guise of soldiers is also known from apocryphal writings,[130] but there the disguise is, so to speak, complete, and nothing points to the demonic character of the figures. Keeping all this in mind one asks whether the devilish figures attacking the central group might not stand for the Islamic forces (in the representation of which a demonic note would certainly seem justified to Crusaders) then advancing upon the Christian settlements. Some of the weapons, and other objects, would seem to point to contemporary usage. The conic

Figs. 35, 37

127 Cf. Meyer Schapiro, "From Mozarabic to Romanesque in Silos," p. 333. In exorcism formulae against the demons the four cardinal points are often mentioned, Cf. F. Pradel, *Griechische und süditalienische Gebete, Beschwörungsformeln und Rezepte des Mittelalters (Religionsgeschichtliche Versuche und Vorarbeiten*, iii, Heft 3) (Giessen, 1907), p. 352 f.

128 Cf. Meyer Schapiro, "From Mozarabic to Romanesque in Silos," p. 333. There are some interesting oriental texts of exorcism which read almost as a description of the large capital of Nazareth. An exorcism for "binding the arrows, daggers, swords, and all implements of war" says: "by that great and terrible name and that exalted arm, I bind, anathemize, and expel from off him who beareth these writs all arrows, bows, swords and knives – all of the implements of war belonging to wicked men. I bind their arrows, in fine, all the war implements of enemies. And thou shalt not be afraid of the terror of the night; nor for the arrow that flieth by day." Cf. H. Gollancz, *The Book of Protection Being a Collection of Charms* (London, 1912), xxx-xxxi, lxxxvi-lxxxvii. For the significance of sharp instruments in sorcery, cf. Kuhnert's article *Defixio* in Pauly-Wissowa, *Realenzyklopädie der klassischen Altertumswissenschaft*.

129 See above, note 42. For devils with human form in Crusader manuscripts, cf. Buchthal, *Miniature Painting*, pl. 4a; for such devils (less beautiful than in the first example) bearing grotesque heads, cf. *ibid.*, pls. 59 f. For the bestial devils, cf. the description: black, sharp-faced, with long beard, hair to the feet, fiery eyes," in James, *Apocryphal New Testament*, p. 468.

130 Cf. James, *ibid.*, p. 461.

helmets worn by the warriors on the large capital especially recall the Saracenic helmets in use from the eighth to the fourteenth century. A similar form of helmet appears in illuminated manuscripts of the Latin Kingdom, where it denotes Saracen soldiers.[131]

Looking at the central group on our capital one further notices the emphasis placed on the cross which the crowned female figure carries in front of her. A cross-carrying *Ecclesia* or Faith is, of course, quite common. Nevertheless, one cannot help remembering that in the Crusader Kingdom the True Cross played an overwhelming part. Not only was it carefully guarded as a precious relic, but it was also shown to the Crusader warriors wherever they were about to engage the Saracen forces. On the eve of battle the Crusader knights were blessed with the True Cross, the relic being often carried by priests who appeared in full ornate regalia before the warriors. The True Cross, as a source of inspiration, became a central symbol of the war waged by the Crusaders against the infidels.[132] Returning to our capital, the question arises whether it is not the True Cross that is here represented? Although this assumption cannot be proved, one suggestive detail is remarkable: *Ecclesia* uses the cross she carries to strike and push away the demonic warrior's bow and arrow, thus providing a visual metaphor of the

protective virtue the Crusaders attributed to the True Cross (fig. 11). Be that as it may, to the minds of Crusaders of the late 1180s the emphatic form of the cross and its being wielded against the weapons of the attacking demons is likely to have evoked the image of the True Cross and the role it played in the battle against Saladin's forces.

All this is admittedly conjecture. However, when all the suggestions contained in our work are pieced together, one feels that the scene represented on the large capital was meant to refer to recent events, or else must have been understood as such by Christians living in Nazareth shortly before 1187; it constitutes a visual affirmation of their hopes and beliefs in the conquering power of the Church and the True Cross, that were to protect the Christian community.

If our interpretation is correct, it is certainly not mere chance that the

131 Cf. Buchthal, *Miniature Painting*, pls. 65a, 75a, interpreted by the author (p. 65) as indicating the helmets of Saracen soldiers. For the form, cf. L. A. Mayer, "Saracenic Arms and Armour," *Ars Islamica*, x (1943), p. 1 ff., and fig. 1. The representation of objects on our capitals closely

follows conventional forms. Cf. e.g., Tabitha's bed (figs. 21, 22) and the bed on a sculpture of Moissac (cf. M. Schapiro, "The Romanesque Sculpture of Moissac," fig. 116).

132 Cf. Runciman, *A History of the Crusades*, index. s. v. "True Cross."

central group on our capital closely follows, in composition and form, the traditional scene of the "Harrowing of Hell," as presented in an illumination from the scriptorium of Jerusalem in the Latin Kingdom.[133] The "Harrowing of Hell" provided not only a basic formal pattern, which could serve as the starting point for variations, it also infused into it a meaning that was intimately related to the scene represented on the large capital.

After the discussion of the individual scenes represented on the Nazareth capitals, we shall now briefly turn to the question of whether they have a comprehensive underlying program. This question cannot be conclusively solved. To give a definite answer, one would have to know what the decoration of the whole church looked like (the capitals being intended only for a side portal), and of this we know nothing. However, on careful consideration of the themes represented on our capitals alone, some comprehensive tendencies grow apparent.

The narrative character of the scenes on our capitals makes it unlikely from the outset that their iconography constitutes a theological "system," as encountered in some French cathedrals. Consequently, what one tries to find is not a closely-knit, transparent system of allegories, but rather the somewhat looser criteria that determined the selection of the stories and scenes represented.

Looking at the capitals, one is struck by the fact that the Church of the Annunciation, erected on the very spot where that memorable event took place, should be decorated with scenes from the lives of the Apostles. The type of the *Apostelkirche* was, of course, well known in the twelfth century, and had particularly deep roots in Eastern soil.[134] The clergy of Nazareth, living in *Outre-mer*, would have known such churches, and the artists may have come in contact with the Byzantine traditions prevalent in the decoration of these buildings. However, a Byzantine influence, if it existed at all, should not be overestimated. The selection of the Apostles represented on the Nazareth capitals deviates from Byzantine practice. We don't know, of course, whether there were any additional scenes — actually executed or intended — illustrating events from the lives of other Apostles. But the grouping of these particular four Apostles (Thomas, Peter, Matthew, James) does

133 Cf. Buchthal, *Miniature Painting*, pl. 9b. One of the main differences between the "Harrowing of Hell" and the central group of the large capital is the terrified, hesitant attitude of the bearded figure, a detail that clearly attests both to the high skill of our artist and to his intention.
134 Cf. Heisenberg, *Grabeskirche und Apostelkirche*, ii, *passim*.

not reflect Byzantine usage.[135] On the other hand, we know that the mission of the Apostles played a significant part in Western thought and imagery of the early twelfth century, and was granted an important place on the portals of Vézelay and Angoulême.[136] The main source of inspiration, in form as well as in themes, is then Western.

Although the central theme is derived from French art, the iconography of the Nazareth capitals does not completely correspond to that of its sources, but has distinctive features. In Vézelay we see Christ sending out the Apostles on their mission, in Angoulême we see them setting out. In Nazareth is represented the peak of that mission, crystallized in its most dramatic events, the Apostles preach in the Eastern lands (Judea, India, Ethiopia), they fight demons, and they perform miracles. In the selection of scenes, then, the Nazareth capitals hold a specific position.[137]

From the stories represented there emerge a few, closely interconnected themes. Of the seven scenes that cover the small capitals, two represent the Calling of Apostles (Thomas, Peter); in three additional scenes, faith in, and the redeeming power of that mission are visualized (James baptizes Josias, Matthew protects Iphigenie, Peter resurrects Tabitha); in the two remaining scenes the struggle with demons is the central event (Matthew contends with magicians). Christians living in the Latin Kingdom in the troubled years before 1187 must have conceived of these stories as reassuring messages from the past, giving both a legitimation of the Crusader settlement in the Holy Land, and hope for final victory.[138]

Seen from this point of view, it is perhaps not so surprising that the Church of the Annunciation should be decorated with scenes from the lives of the Apostles. While one cannot discern in our capitals an iconographic "system," one easily finds in them a unity of theme and emotion, reflecting the beliefs and hopes of the Christians in *Outre-mer*.

135 This grouping also does not agree with Western representations that show Byzantine influence, as, for example, the mosaics of Monreale, and San Marco in Venice.

136 For Vézelay, cf. Jean Adhémar, *La Madeleine de Vézelay* (Melun, 1948), p. 116 ff., with a brief summary of research on the exact theme represented on that famous tympanum, a problem which, as one knows, has caused much argument. Cf. also A. Katzenellenbogen, "The Central Tympanum at Vezélay: Its Encyclopedic Meaning and its Relation to the First Crusade," *Art Bulletin*, XXVI (1944) pp. 141–151.

137 Cf. Deschamps, "La sculpture française," p. 102, who claims that some of the scenes represented on the Nazareth capitals have no exact counterpart in France. He therefore believes that the iconography of our capitals is "très particulière."

138 The subdued but nevertheless existing elements of exorcism which we have stressed (cf. above, p. 151 ff.) may have something to do with these hopes.

IV

Who created the Nazareth capitals? Are all the five capitals the work of the same master, or did several artists cooperate in producing them? And where did he, or did they, come from? What are the artistic traditions to which our capitals belong?

As far as I can see, the question of "hands" has been raised only once,[139] and even then incidentally; it was not given any further attention in research, probably because most scholars have assumed — though without stating so — that the capitals are the work of the same master. But the broader problem of the artistic origins of our capitals, i.e. the traditions in which the Nazareth artists were raised, and the models which they used in their work, has come up more often. Although neither the question of origin has been treated systematically, comments consisting mainly of references to scattered examples in western Europe, the brief discussions devoted to it, have revealed the main problems involved. A brief summary of the research may therefore prove useful. The first author to raise the question of origin was De Lasteyrie. Following a suggestion by Mâle, who found the crown of Hyrtacus (fig. 41) and the conic helmets of the warriors on the large capital similar to forms current in German art in the Ottonian and Romanesque periods, De Lasteyrie asked whether in the twelfth century there were any German masters in the Holy Land.[140] In the subsequent literature, however, the hypothesis of a German school was dismissed. All scholars now agree that the Nazareth capitals are derived from French art. The question now arises: to which specific tradition of French art should the capitals of Nazareth be related? Another question, never clearly stated, but vaguely suggested in some of the studies, is whether our

Fig. 41

139 Cf. Egidi, *I Capitelli Romanici di Nazareth*, p. 773.
140 In Viaud, *Nazareth*, p. 171 ff.

capitals and some other fragments of similar style reflect a local school of sculpture.[141]

What does seem to be accepted by most scholars is that the influences and models which may be detected in our capitals cannot be traced to a single twelfth-century school of French sculpture. In the studies dealing with our capitals the reader is constantly referred to Burgundian sculpture, but also to the art of Ile-de-France and Provence. The architectonic frames of the Nazareth capitals recalled to most scholars the Portail Royal of Chartres, and the sculptures decorating the portal of Étampes. But one may also notice that the shape of the capitals and the patterns of the faces at Nazareth are different from what we see in these places.[142] Enlart stressed that a distinctive structural feature of the latter capitals — the lack of astragals — is particularly frequent in twelfth-century sculpture of the Rhône valley, though it also occurs in other regions.[143] As we have already seen, our capitals have many distinctive features in common with the Plaimpied capital, and one scholar has even reached the conclusion that they were actually executed by the "Plaimpied Master."[144] All this indicates that the Nazareth capitals cannot be considered as being entirely the product of one specific school of French sculpture; rather, they reveal a complex convergence of elements originating in different local traditions and regional schools.

One is, of course, tempted to ask how this convergence, or fusion, of different traditions came about. Had it been achieved in France, and brought over to the Latin Kingdom as an eclectic, more or less complete system? Or should we rather assume the existence of a local school, formed by several masters who came from different regions of the metropolis? In the present state of our knowledge, it is, I think, impossible to reach a definite conclusion. Apart from the capitals, only few

141 Cf. Germer-Durand, *La sculpture franque*, p. 238, saying that there were workshops and "une véritable école de sculpture chrétienne en Palestine." Enlart, *Les Monuments des Croisés*, i, p. 129, says that Germer-Durand "avait raison de considerer qu'ils [the capitals of Nazareth and of Mount Tabor] sont le produit d'une école locale." On p. 131, however, he says that since the monastery of Mount Tabor belonged to Cluny "il est probable qu'un ou plusieurs artistes bourguignons amenés par l'Ordre de Cluny ont travaillé pour les sanctuaires voisins du Tabor et de Nazareth." The possibility of native artists working in a "school" founded by sculptors who came from France has not been considered, and does indeed not seem probable.
142 For the comparison with Étampes, cf. Enlart, *Les Monuments des Croisés*, i, p. 130, who says that he found a similar shape of capital faces only in San Cugat de Valles "où son emploi est un peu different, mais systematique aussi," See also above, note 16.
143 Cf. Enlart, *Les Monuments*, i, p. 118.
144 Cf. Oakeshott, *Classical Inspiration in Medieval Art*, p. 120, and see above, notes 18, 19.

156

fragments of Crusader sculpture of the second half of the twelfth century have come down to us, a fact which does not enable us to generalize. Hence, the following brief considerations are only a very tentative attempt at answering the above questions, or, at least, at defining the problems with a somewhat greater degree of clarity than has been done up to present.

One author who (in a single sentence) proposed a solution to the problem of origin was Kingsley Porter. He relates the Nazareth artist to an interesting school of sculpture that flourished in Vienne about the middle of the twelfth century. Among the key monuments of this school are two capitals of St. André-le-Bas which, according to an inscription, were produced by "Guillaume the son of Martin" in 1152. The capitals of Vienne (and the other works related to them)[145] do indeed show an interrelation of Burgundian, northern and Provençal elements, and it is a similar affinity that Kingsley Porter finds in the Nazareth capitals. He mentions in particular "the same spiral folds, the same heaviness, the same admixture of Provençal elements." In addition one could mention some motifs in our capitals that are very similar to those in Vienne. See, for instance, the specific form of a widely billowing drapery in our fig. 29 and Guillaume's Samson.[146] If we accept Kingsley Porter's theory, we shall have to assume that the fusion of elements from different schools took place in France and was brought as a whole to the Latin Kingdom.

Fig. 29

But are the similarities mentioned above sufficient to establish a direct and close contact of the Nazareth artist with the school of Guillaume, or even a dependence of the former on the latter? Does one not find features that speak against such a relationship? Kingsley Porter recognized that the Nazareth artist is "a little finer, a little more Burgundian than Guillaume." Even if we allow for certain variations of influence, natural in a school that was the meeting ground of different traditions, there still remain, I believe, some rather significant differences. Thus, Guillaume himself does not apply architectonic imagery, although the heavy upper part of his capitals would allow for canopies. The canopies of Étampes, which Kingsley Porter connects with the Vienne school, certainly belong to the broad trend of canopy representation in twelfth century art to which our capitals also belong, but in design and details

145 Cf. Kingsley Porter, p. 165 ff.
146 Kingsley Porter, ill. 1219.

they differ from the Nazareth canopies. The haloes at Vienne and in all ramifications of its school are unlike those at Nazareth.[147] As to the physiognomic type, it is altogether different. In the art of the Vienne school I could not find that long, slim, and sharply cut face that is so characteristic of the figures in Nazareth, that has led several scholars to the conclusion that the Nazareth artist portrayed a "Semitic type" that could be seen in the Holy Land.[148]

We also find slight, but significant, differences in the details. In Nazareth, for instance, the beards are carved in straight strands, in Vienne the strands end in a curl; in Nazareth they are narrow, in Vienne they are heavy; in Nazareth hair and beards are flat, in Vienne they are deeply undercut. Or compare the modeling of the bare feet of Job in St. André-le-Bas with the modeling of the feet in Nazareth. As compared to the feet of the Vienne Job, most feet on the Nazareth

Figs. 12, 20, 29 capitals (see figs. 12, 20, 29) are edged and angular, and lack the organic feeling that is so pervasive in the French figure.

There are also some more general qualities and patterns that are characteristic of the works at St. André-le-Bas (and to a lesser extent of the other works of that school) that are not to be found in Nazareth. Guillaume himself must have had a deep affinity and direct access to classical art, which cannot be said of the Nazareth artists. Although we have several times indicated classical qualities in our capitals, we cannot find in Nazareth such classical facial types and gestures as in the Job capital of Vienne. Another basic difference is that in Vienne the posture of figures, and especially of limbs, is not adapted to the slanting position of the capital faces, as it is in Nazareth.

To sum up, although a similarity of spirit and of individual motifs in the art of both places cannot be denied, it is difficult to see the works under discussion as products of the same "school," in the precise meaning of the word.

May we then venture to assume that different traditions converged in a local school? Such an assumption arouses serious misgivings. The high artistic quality of our capitals, the skill displayed in the use of tools

147 The two capitals attributed to Guillaume have no haloes, but another figure in the Cathedral of Vienne (Kingsley Porter, ill. 1217), which Kingsley Porter, p. 166, attributed to the same school, has a small halo decorated with a pattern that is altogether different from those we see in Nazareth.

148 De Lasteyrie, in Viaud, *Nazareth,* p. 172, believes that the models were Jews. Deschamps, "La sculpture française," p. 102 (and p. 97, on the two heads of Nazareth for which see below, p. 167 ff.), speaks only of a clearly Semitic type. Egidi, *I Capitelli Romanici,* p. 775 speaks of "Semiti" and "Turanici." For a discussion of this problem, see below, p. 171 ff.

and in the application of sophisticated methods of carving to achieve aesthetic effects, the lack of any primitivism (as compared to contemporary sculpture in France), make it difficult to accept such a hypothesis. One would expect a local school that could not have had much time to crystallize to be less skilled, and not so well acquainted with contemporary metropolitan models. In the field of book-illumination, however, Buchthal has shown that local schools did reach very high standards, and could rapidly assimilate different models.[149] One cannot exclude the same eventuality in sculpture, although in our specific case it does not seem likely.

Another consideration that makes one hesitate is that a local school, if we are to assume its existence at all, would have restricted its activities to the region of Nazareth only and left behind so few remnants. Except for one interesting but unfinished work (the Nazareth heads),[150] no fragments of any significance can be associated with such a school. The other "major" works of Crusader sculpture, which were created in other regions of the kingdom, belong to different traditions of French art (see the lintel of the Holy Sepulcher Church).[151] Can one really believe that a highly complex synthesis of different French traditions took place in a short-lived local school active in the region of Nazareth?

Wherever the convergence of the different traditions took place, be it in France or in the Latin Kingdom itself, we can assume that the Nazareth capitals were executed in a workshop headed by a Burgundian artist, but influenced by trends from other regions and schools of French sculpture. In the discussion of the artists who worked at the capitals I shall attempt to show this in somewhat greater detail.

Turning to the question of "hands" one is confronted with problems which seem difficult to solve. I consider that in the Nazareth capitals one can vaguely distinguish between different approaches to sculpture. The question is: do these differences reflect the work of different sculptors, or do they only show that different models were used?

Examination of the capitals reveals a rather consistent difference of character between the architectonic frames and the figures. The canopies of all five capitals are obviously based on the same model which,

149 *Miniature Painting in the Latin Kingdom, passim,* especially pp. 35 ff., 93 ff.
150 See below, Chapter Three.
151 For the lintel of the Holy Sepulcher Church, cf. Enlart, *Les Monuments,* ii, p. 166, and figs. 305–307. Enlart ascribes it, though somewhat hesitantly, to a Tolosan workshop.

although clearly derived from the art of northern France, is more complex than almost anything of this kind we know. The canopies of the Nazareth capitals are executed with extraordinary skill, betraying the sculptor's supreme mastery and subtlety of technique. In artistic quality, however, they are rather monotonous, displaying a certain lack of imagination. One notices further, as already mentioned at the beginning of this chapter,[152] that despite the important part the general pattern of the frame plays in the composition, the frames of the individual capitals are not adapted to the scenes they delimit. Necessarily, one asks, if the stiff, mechanical, and repetitive forms of the canopies could have been carved by the same hand that created the flexible, animated, and highly imaginative figures and draperies. That this is not a question of naturalism (that is, the mechanical forms of lifeless architecture versus the organic forms of bodies and the draperies covering them) can be seen by comparing an inanimate object within the scene (e.g. Hyrtacus's crown, fig. 38) with the canopies. The crown, or any other object within a scene,[153] has the same animated, irregular, plastic character as the figures themselves, while the canopy is of a rigid quality that makes it alien to the figures and scenes.

Fig. 38

Such a relationship between canopy and scene is not common, though it is probably not unique. There are many works of sculpture in northern France, as well as in other regions, in which canopies and figures present a remarkable unity. At Étampes, for instance, the canopies are more elastic, though simpler in form, than in Nazareth, while the draperies of the figures are more schematic, the result being that both have a common character. The same is true, I think, for St. Denis, St. Loup-de-Naud, and other places.[154] The capital of Plaimpied (fig. 43) displays perhaps a treatment similar to that of the Nazareth capitals, but the difference between the elaborate canopy and the figures is not so pronounced, since the draperies are not so dynamic and intricate in form as they are in Nazareth.

Fig. 43

Does the treatment of the canopies and the figures — different in spirit as well as in technical execution — follow from the use of different

152 See above, p. 77 ff.

Fig. 22

153 See Tabitha's bed, fig. 22. That this is not a representation from nature but an application of conventional forms, which are to be found in other Romanesque works, can be seen from a comparison of Tabitha's bed with the bed in a relief of Moissac (cf. Meyer Schapiro, "Romanesque Sculpture of Moissac" fig. 116).

154 Cf. Kingsley Porter, ills. 1141–42 (St. Denis), 1485–86 (altar frontal from St. Denis, now in the Louvre), 1494 (St. Loup-de-Naud). See also the sculptured column from Coulombs (Eure-et-Loire), now in the Louvre (Kingsley Porter, ill. 1471).

models, or is it the work of a different hand? It is difficult to give a definite answer, but there is much that seems to speak for the latter alternative. For reasons already outlined I believe that all five canopies were executed by the same craftsman, but he did not carve any of the scenes.

Within the figures and scenes themselves, differences of touch are not obvious, but upon more attentive observation and comparison they may perhaps be disclosed. The scenes of the Matthew capital (figs. 36, 37) seem to be by a different hand than the others.[155] As already mentioned at the beginning of this study, the figures of this capital follow a different canon of proportions; they are shorter and heavier, and the heads are larger in comparison to the bodies. However, the differences between this capital and the others are not restricted to objective conventions of proportion, but are also felt in general spirit and in the carving manner. The modeling of the Matthew capital is softer, the figures are rounder and have more weight. The calligraphic quality, although certainly present, is less pronounced than in the other capitals. The folds of the draperies are less deeply carved, and, so to speak, do not cut into the body. They also follow more closely the organic shape of the figure, and are less autonomous in their patterns. It is instructive to compare the draperies of this capital with those of the Thomas capital (figs. 13, 14), where they reach an almost complete autonomy, or with the *Ecclesia* (figs. 8, 10) where the rich arrangement of the folds obscures the organic structure of the body. It is also interesting to notice that the widely billowing drapery, a motif that shows an independent form of the folds, detached from the figure, is encountered in all the other small capitals[156] but is absent in the Matthew capital. The soft carving of the draperies fits in with the more organic representation of the figures themselves. Particularly interesting is the nude figure to the extreme right of the Matthew capital (fig. 37) displaying a roundness and softness of modeling that is not met with in any of the other Nazareth capitals. Again this is not a matter of naturalism. Tabitha's bare breasts (fig. 22) seem flat and almost angular when compared with the round, muscular leg of the nude figure on the Matthew capital.

The gestures and postures of this capital are more relaxed, natural and convincing than in the other capitals; they are less tense and dramatic, although the events represented are certainly not. One of the motifs

Figs. 36, 37

Figs. 13, 14
Figs. 8, 10

Fig. 37

Fig. 22

155 The only author to suggest this was Egidi, *I Capitelli Romanici*, p. 775.
156 See figs. 20, 29.

Figs. 20, 29

161

specific of the Matthew capital is the broad, relaxed, seated posture of
Fig. 36 the king on fig. 36, with another figure comfortably leaning against
him. Another motif is the rhythmic posture of the standing Hyrtacus
Fig. 39 (fig. 39), one leg supporting the weight of the body, the other held in a
free, light movement. Although there are many standing figures on
the other capitals, we do not find such a relaxed pose in them.

The natural gesticulation goes together with the softly modeled heads
that reveal a surprising variety of facial expression. This is the only
capital where one finds faces that suggest smiling. The diversity of
facial expression can be observed in fig. 39, where the hard, somewhat
distorted face of the impenitent Hyrtacus is seen together with the
soft, supplicant face of Iphigenie, and St. Matthew's spiritual, monastic
countenance.

Some of the qualities and motifs characteristic of this capital recall the
art of southern France. For the sitting king we have already mentioned
a parallel example in a capital from Toulouse.[157] For the relaxed
standing pose one finds almost parallel examples on the west portal of
St. Trophime at Arles, in the western façade of St. Gilles at Beaucaire,
and in Avignon.[158] Some facial types of the Matthew capital recall
famous images from the region of Toulouse.[159] In the sculpture of
southern France one also finds more frequently the round modeling
and the carving of folds which, although linear, are not deeply cut.

On the other hand, some features and elements of this capital point,
perhaps, to a Burgundian influence. The spiral folds on knee, belly,
Figs. 36, 40 and breast (figs. 36, 40), so prominent in some figures of this capital,
are less common and less pronounced in the fully developed art of
southern France than they are in Burgundian sculpture (although these
are, of course, widely diffused motifs). Attention has also been drawn
Fig. 39 to the fact that the group of Matthew blessing Iphigenie (fig. 39) recalls
the famous *Noli me tangere* of Autun.[160]

Considering these features one may assume that the Matthew capital

157 Cf. above, note 35. For the figure leaning against the king (especially the posture of
comfortably crossed legs), cf. also the David of St. Gilles (Kingsley Porter, ill. 1327, at top).
The full, round, and curled head of hair of the leaning figure also recalls famous figures from
Toulouse.
158 Cf. Kingsley Porter, ills. 1370 (Arles), 1392 (St. Gilles), 1296 (Beaucaire), 1341 (Avignon).
159 Compare, for instance, the head of the young magician on our capital with the famous
head of the angel Gabriel in the *Annunciation,* now in the Museum of Toulouse (see Kingsley
Porter, ill. 482); and cf. also the head leaning on the king on our capital with the angel's head
in the Annunciation of Moissac (see Kingsley Porter, ill. 376).
160 Cf. Enlart, *Les Monuments,* i, p. 130.

162

was carved by an artist who was raised in the tradition of southern France, but who was later (perhaps in the Nazareth workshop itself) influenced by typical Burgundian motifs. But all this is admittedly conjecture.

In most figures and scenes of the other capitals a predominant Burgundian influence is clearly discernible, and it is for this reason that one assumes the Nazareth workshop was headed by a Burgundian artist. In the following observations I shall limit myself to a few suggestions.

The Burgundian spirit is crystallized in our capitals in several characteristic features. See, for instance, the deep undercutting that leaves angular edges (a feature which produces an effect of flatness in the draperies) coupled with an extraordinary vivacity of elaborately spun fold-forms that recall the web of lines characteristic of the famous Romanesque works of that region. These features are particularly clear in the Thomas capital (figs. 13, 19) and in the central group of the large capital (figs. 7, 9) although they may also be observed in the other capitals. See further the vividness of the gestures, a feature typical of Burgundian art of the twelfth century which determines, perhaps more than any other specific element, the character and spirit of our capitals. The twisting movements of the figures, the bent knees, the zigzag of the whole body, of which we find many examples in Nazareth, belong to a common Burgundian type, met with at Vézelay, Autun, and Montceaux-l'Étoile.[161] The concentric folds, to be seen on almost all of the capitals, may be found not only on the great tympana of Vézelay, but throughout Burgundian sculpture. Widely billowing draperies, detached from the body and ending in a zigzag of opulent pleated hems, a pattern much favored in twelfth-century Burgundian art, are prominent on our capitals. (Figs. 10, 20, 29).

Even the details and specific motifs in our capitals point to Burgundy. The concentric folds on the back and legs of the possessed, leaving free, or emphasizing, the lower part of the figure (fig. 35), can be found at Vézelay, Montceaux-l'Étoile, and Autun.[162] The Nazareth capitals' close relationship to Burgundian art can also be seen from the ornamental patterns. Paul Deschamps has drawn attention to the fact that the patterns decorating the garments of some of the figures in

Figs. 13, 19
Figs. 7, 9

Figs. 10, 20, 29

Fig. 35

161 Cf. Kingsley Porter, ills. 34a, 35, 46 (Vézelay), 55 (Saulieu), 77, 78 (Autun), 105 (Montceaux l'Étoile), 115 (La Charité, Transfiguration).
162 Cf. Kingsley Porter, ills. 37, 40 (capitals in Vézelay), 105 (Montceaux l'Étoile, tympanum of western portal). Cf. also Grivot-Zarnecki, *Gislebertus*, pl. 22a.

Nazareth have their exact counterpart in the sculptures of Charité-sur-Loire,[163] a place located, in the twelfth century, on the border between the Duchy of Burgundy, and the Royal Domaine, but which in its art belonged to the former. As discussed in the first part of this chapter, these ornaments frequently occur in the sculpture of other Burgundian churches.[164] In this context it is also interesting to note that the haloes of Charité-sur-Loire, although smaller than those of Nazareth, are adorned with round holes drilled along their borders,[165] a feature which occurs several times in our capitals (figs. 9,

Figs. 9, 17, 18

17, 18). The large size of the haloes, so characteristic of our capitals, is also well known from some of the main centers of Burgundian sculpture.[166] The varying textures of the haloes, however, seem to be a specific element of the Nazareth artists.

There are also complex motifs, sometimes involving physiognomic imagery, relationship of the figure to the frame, and carving patterns, that suggest a close relation of the Nazareth capitals to the main trends of Burgundian sculpture. Images of demons such as these found on our large capital — characterized by oversized, bestial heads and twisted movements — are well known from Vézelay and Autun. But it is illuminating to see that the specific motif of such a demon, placed at the corner of the capital, bowed down as if oppressed by the weight of the stone he supports with his head while attacking a central group, also occurs in Burgundian art. Even the carving of such a group at Autun[167] displays a similarity to our large capital. In Autun the legs of the demon are carved in flat stripes which follow the form of the leg,

Fig. 10

edges clearly dividing one stripe from the other. In Nazareth (fig. 10) the stripes take on the more naturalistic form of a leg's muscles, but the edges between the stripes can still be discerned.

In sum, the general spirit as well as the details described (which could be multiplied) show that the head artist of Nazareth came from Burgundy, and brought with him the great tradition of that region's art.

163 "La sculpture française," p. 101.
164 See above, pp. 79 ff., 111 ff.
165 Kingsley Porter, ills. 115–118, 120–122.
166 See Kingsley Porter, ills. 11, 109 (Charlieu), 119, 121 (La Charité-sur-Loire), 114 (Donzy-

Fig. 43

le-Pres); and cf., of course, the capital of Plaimpied (our fig. 43).
167 Grivot-Zarnecki, *Gislebertus,* pl. iii.

THE
NAZARETH
HEADS

I

One of the most interesting pieces of Crusader sculpture known to us is the large capital, now preserved at the Greek Patriarchate of Jerusalem, on which are carved two heads. This work was discovered in 1867, during an early campaign of excavations at the site of the Church of the Annunciation in Nazareth. Unfortunately, nothing is known of the precise conditions under which it was found. The capital has been published several times, and it has also been mentioned in the literature dealing with Crusader art.[1] But so far as I know, no detailed study has been undertaken.

The two impressive heads that constitute this unfinished work are carved out of a single large block of stone. The stone is identical with that of the Nazareth capitals, and the artist who carved the heads was clearly able to make full use of its properties.[2] The block itself, in the fragmentary form in which it has come down to us, is 50 cm. (19.5 in.) high, 43 cm. (16.77 in.) wide and 31 cm. (12.09 in.) deep. The heads take up almost the whole height of the stone, and are thus much over life size. The head with the long beard (henceforth the right head) (fig. 45) is 47 cm. (18.33 in.) high, the other (henceforth the left head) is 41 cm. (15.99 in.) (fig. 44). It is obvious that the capital is unfinished. Since it clearly displays various stages of carving, it provides an instructive specimen for the study of sculptural techniques in the twelfth century. The work poses many questions. What is its date and artistic provenance and to what "school" does it belong? The two heads represent a peculiar physiognomic type that has aroused the curiosity of several

Fig. 45

Fig. 44

1 Cf. Germer-Durand, "La sculpture franque en Palestine," *Conférences de Saint Etienne*, 1910–1911 (Paris, 1911), pp. 247–248; C. Enlart, *Les Monuments des Croisés dans le Royaume de Jérusalem* (Paris, 1925–1928), i, p. 131, ii. pp. 303 ff., 307 ff.; W. Oakeshott, *Classical Inspiration in Medieval Art*, (London, 1959), pp. 82 ff., 106, 118 ff.; T. S. R. Boase, "The Arts of the Latin Kingdom of Jerusalem," *Journal of the Warburg Institute*, ii (1938–1939), p. 10.
2 See above, p. 69.

scholars and prompted them to propose rather bold hypotheses. It is therefore of interest to ask whether this type can be derived from the European sculpture of the period, or whether it was an invention of the artist working in Nazareth. One also wonders as to the purpose of this work, and how it would have been placed had it been finished. Finally, one asks: what is the meaning of the work and whom do the heads represent? Before attempting to answer some of these questions a brief description is necessary.

In looking at the two heads one is first struck by their similarity. Although the artist has obviously tried to differentiate them by depicting different physiognomic features — the most obvious being the long and straight beard of one figure, and the short and curled beard of the other — there can be no doubt that he used the same model for both faces. Both heads have enormous skulls and luxuriant long hair, parted in the middle. The hair, carved in long, regular strands, covers the upper part of the ears. The overall modeling of the strands (which creates a strong linear effect) emphasizes the shape of the skull. The forehead is very low, the hair covering it carved in a simple, wave-like, geometrical pattern. The faces are long, narrow, and of an accentuated flatness. (The impression of flatness is at present further strengthened by the fact that the tips of the noses have been broken off, but there is no doubt that the same effect of flatness characterized the intact faces as well.) The cheek bones hardly protrude and the cheeks themselves do not recess, as one would expect in such lean faces.

The eyes are very interesting and, in spite of slight differences in the two faces, follow the same pattern. They are not situated in deep hollows, nor do the eyeballs protrude — both features contributing to the effect of flatness. In the middle of the eyeballs a deeply drilled hole represents the pupil, an important element in the expression of visionary spirituality that is so characteristic of the two faces. In the left face the eyes slant down toward the nose; in the right face their position is almost horizontal. In the left face especially, the upper lid is almost straight while the lower one is downwards curved, a feature found in Crusader sculpture belonging to a different school.[3] The linear character of the eye is stressed by the fact that, in both faces, the upper lid merges with the arc of the eyebrows.

The long and straight nose is an important feature in creating the definite, sharp-cut physiognomic type presented by the faces. The form

3 See above, p. 16 ff.

168

of the nose emphasizes the character of flatness as well as the spiritual expression. As far as can be determined from their damaged state, the nostrils were flat and wide. In both faces the moustache which, like the hair, has deeply carved strands, plays an important part in the linear pattern of the heads. In the right face the moustache merges with the beard, in the left it is turned up and, balancing the movement of the beard tufts, creates a tense linear ornament. In the right face the lower lip is accentuated, drooping somewhat. The carving of the beards shows the artist's full mastery. The long, pointed beard of the right head brings out better the vertical axis of the face. The beard of the left head curls only at the tips. This beard, although curled at the sides and end, does not diminish but rather increases the impression of leanness and verticality of the face.

It is difficult to define exactly the powerful expression of the faces — especially of the left one — but there is little doubt, I think, that this expression was exploited by the artist as a visual presentation of a "type." The sculptor made masterful use of sophisticated means to achieve his end. The large skulls and the beards, with the deeply carved parallel strands of hair, emphasize the flatness of the almost dematerialized faces, the smoothness of which is undisturbed by any details (e.g. modeling of bones, or wrinkle lines) that would distract the spectator's attention. The large and flat eyes, with the holes of the pupils drilled exactly at the center, do not gaze in any specific direction. This "gaze into the void" is a symbol of numinosity of an intensity not often encountered even in medieval art. These physiognomic features characterize the figures as those of ecstatic visionaries.

II

I have elaborated on this description because it leads, I believe, to a problem of some significance, in connection with the attempts to interpret this work. The few scholars who have commented on the two heads have noted the historical significance of the unusual physiognomy. They have also noticed that the heads are related to the Nazareth capitals, one of them even offering the thesis that both the capitals and the heads were produced by the same hand.[4] The distinctive physiognomy of the heads has led these scholars to assume that the sculptor did not take over this type of face from the artistic tradition in which he was raised, from the stock of visual formulae inherited from European art, but from nature. Since the faces are reminiscent of a certain Semitic type — characteristic of the people living in the Holy Land, — they believed that the sculptor living in the East, was impressed by it, and reproduced it in his work.[5] As a similar hypothesis has been advanced, though rather incidentally, concerning the facial types carved on the capitals as well,[6] the assumption deserves a brief examination.

From the outset it seems unlikely that an artist working in the third quarter of the twelfth century should have portrayed physiognomic

4 Germer-Durand, "La sculpture franque," p. 247, suggests this by saying that the capitals provide the key to the understanding of the two heads. Enlart, *Les Monuments des Croisés,* ii, p. 307, only says that the style of the capital and of the two heads is identical, but does not discuss the question of hands. Oakeshott, *Classical Inspiration in Medieval Art,* p. 118 (note to pl. 23b) ascribes both the capitals and the heads to the "Master of the Plaimpied Capital." And see above, p. 158.

5 Deschamps, "La sculpture française en Palestine et en Syrie à l'époque des Croisades," *Monuments et Mémoirs de Fondation Piot,* xxxi (1930), p. 87, says: "On remarquera le type sémite frappant, preuve que l'artiste, français nous sommes persuadés, s'est inspiré de modèles indigènes."

6 See above, p. 158.

types from nature,[7] a practice that fits only much later periods. It is true that even in Crusader art (in a Sinai icon of the twelfth century) one finds a face that is based on a careful observation of racial characteristics — a Mongol is represented as one of the three Magi adoring the infant Christ. But Weitzmann, who published this icon, had to argue most persuasively — and did so convincingly — that in fact this deviation from the established norm was due to almost unique historical reasons.[8] For the twelfth century, however, and without any specific reasons, the representation of a native type seems highly unlikely. One should also add that the Magi, coming from far lands, are almost by definition, and following popular imagery, exotic types, and were often represented as such. On the other hand, prophets, or other saintly figures that may have been represented on the discussed capital, are not exotic but rather hieratic figures, and their representation in the guise of "natives" cannot be accepted without very specific reasons.

In this context one also recalls the Crusader artists' reluctance to assimilate local, i.e. non-Christian, motifs and elements into their work. As we know, Islamic motifs occurrent in the art of the Latin Kingdom were not the result of a direct influence, i.e. through the imitation by the artists of what they saw in their surroundings, but were imported from Europe, and could therefore be seen as belonging to the true metropolitan tradition.[9] Could the case be different where physiognomic types are concerned?

The style and execution of the two heads do not suggest such an unusual procedure. A twelfth-century artist, representing a type for which he had no ready-made formula, might be expected to be uncertain of his form, hesitant, tending toward different solutions in the various parts of his work, and bringing frequent corrections. This would be especially obvious in an unfinished work such as our capital. However, we have seen that, quite to the contrary, the artist who carved the work under discussion never seemed to have been in doubt as to the form of

7 Postures copied from nature do occasionally appear in Crusader manuscripts. Cf., e.g. H. Buchthal, *Miniature Painting in the Latin Kingdom of Jerusalem* (Oxford, 1957), pl. 79 and p. 65, for a figure in the Arsenal-Bible, sitting in an oriental posture with crossed legs (incidentally, the pose of this figure does not exactly correspond to the attitude usual in the East). It is, however, much easier to understand the copying of a general bodily posture from nature than the observation, and formulation, of a physiognomic type. Besides, for iconographic reasons the representation of a figure of marginal significance in oriental garb, or posture, is more easily acceptable than the portrayal of prophets or Apostles as "Semites."

8 Kurt Weitzmann, "Icon Painting in the Crusader Kingdom," *Dumbarton Oaks Papers*, xx, 1966, fig. 23, and p. 63.

9 See above, p. 65. And cf. Buchthal, *Miniature Painting in the Latin Kingdom*, p. 101. stressing that after the middle of the twelfth century "no new influx of such Islamic elements can be traced at all."

the heads. In fact, the two heads are of a finished, definite formulation that, to my knowledge, has no parallel in Crusader sculpture. The artist was so sure of his form that he gave the heads their definite formulation (up to the very polish of the faces) even before chipping away the remaining stone. It is impossible to believe that an artist or a school, faced with the task of formulating a new type, reached such a high degree of accomplishment in so short a time. Even before attempting to trace the possible sources of these heads the hypothesis of a native or Semitic type can be rejected.

The large size of our piece, the deep carving, and the angular relation of one head to the other suggest that it was intended to form the upper section of a jamb, or pillar, on both sides of which a standing figure was to be represented. This pillar, of which only the heads have survived, may have belonged, as some scholars believe,[10] to the same porch for which the capitals were carved; but since we have no information as to exactly where the heads were found, this assumption cannot be proved. Bearded figures extending the length of pillars were, of course, common in twelfth-century art, particularly in the south and southwest of France, but, needless to say, they are found also in the sculpture of the other regions of France. Enlart mentions the famous examples of Moissac, Souillac, Romans, St. Jean-le-Vieux in Perpignan, and Morlaas; Deschamps adds the pillar from St. Guillaume-du-Désert, now in the courtyard of the University of Montpellier,[11] and more examples could easily be added. The difficulty is that in some of the places the pillars are adorned with four figures, while in Nazareth only two sides were apparently decorated with statues. Another difficulty is that the heads of figures decorating such jambs are usually placed at greater distance from each other than those of Nazareth.[12] Perhaps for these

10 Cf. Enlart, *Les Monuments des Croisés*, ii, p. 303.

11 Enlart, *ibid.*, ii, p. 303 ff.; Deschamps, "La sculpture française," p. 97.

12 I shall consider only the examples adduced by Enlart and Deschamps. The figures of Jeremiah and St. Paul on the trumeau of the southern porch of Moissac (Kingsley Porter, *Romanesque Sculpture of the Pilgrimage Roads* [Boston, 1923], ills. 363–364) are completely detached from each other, each figure appearing on a separate face of the trumeau. On the jambs of Romans (Kingsley Porter, ills. 1334–1335) there are two figures on each jamb, but the heads are considerably farther apart than in our Nazareth heads. At St. Jean-le-Vieux in Perpignan the two figures stand side by side, and the distance between the heads (which are missing) is quite large (Kingsley Porter, ills. 619–620). The figures from the western portal of Ste. Foy in Morlaas (Basses-Pyrénées) are also completely detached from each other. One of the groups in Morlaas, representing two Apostles (Kingsley Porter, ill. 460), is closest in arrangement to our heads. Although the distance between the heads is wider than in Nazareth, the angular relation of one figure to the other probably shows what our artist has intended. The pillar in Montpellier (Kingsley Porter, ill. 1397) has four figures. Even this short list shows that within the pattern of a pillar decorated with figures there was quite a variety of nuances and proportions.

reasons Enlart considered the possibility that these heads might have been intended to decorate a column in a cloister, as can be so frequently seen in southern France. If they indeed come from a cloister, they were probably intended for an angle pillar which had only two sides.[13] I believe, however, that the size of standing figures, in proportion corresponding to the heads discussed, would have been too large for that purpose, hence the location in a portal seems more probable. But whatever the intended location, it is obvious that the Nazareth heads belong to the broad tradition of twelfth-century art that found its main expression in southern France.

Since pillars decorated with two or more figures are so common and occur in different regions, the very fact that the two heads belong to such a column cannot help us to establish their artistic origin. The attribution of the heads to a school must rest only on stylistic evidence, i.e. on what can be deduced from the sculptures themselves.

The similarity of the two heads to some of the faces on the Nazareth capitals has, of course, been noticed by scholars. The similarity is, in fact, so close as to suggest that both the heads and the Nazareth capitals (or at least some of them) are the work of the same master.[14] It is interesting that in this context the most significant capitals are those that are most clearly and typically Burgundian in style, i.e. the capitals representing the stories of Sts. Thomas and Peter. In these two capitals we find several times the same narrow and flat faces as in the two heads, the same emphatic contrast between the smoothness of the face and the deeply and regularly carved strands of hair and beard, the same linear treatment of the eye, and the same strange, ecstatic expression (figs. 16, *Figs. 16, 18, 23, 27* 18, 23, 27).

There are also some specific motifs which the two heads have in common with the Nazareth capitals. One of these motifs is arrangement of the hair. Note, for instance, Thomas' hair, which falls across the upper *Fig. 17* part of the ear (fig. 17) and curls at the ends precisely as in the two heads. Note also the eye shape in Thomas' face, the upper lid merging with the arch of the eyebrows, the lower lid consisting of a double line. The identical shapes of eye and nose (note especially the form of the nostrils) can best be observed when we watch both Thomas' head and *Figs. 17, 44* the left head in profile (figs. 17, 44). The linear ornament of Thomas' *Figs. 18, 44* beard and that of the left head's beard (figs. 18, 44) are also almost

13 Enlart, *Les Monuments des Croisés,* ii, p. 304.
14 Cf. above, note 4.

identical. A similar pattern recurs in the figure of Christ implored by the sinking Peter (fig. 27) and in the beard of Peter resurrecting Tabitha (fig. 23). In the two heads these motifs are more elaborate, more ornamentally stylized, and more consistent in detail. But this, of course, may be due to the difference in scale. Often, such a detail as a short beard occupies hardly more than half a centimeter on the capitals, and one can understand that the artist was limited in the use of his tools. In the two heads the larger than life scale enabled him to bring these forms to an accomplished realization.

Fig. 27
Fig. 23

The evidence mentioned supports, I think, the thesis that the hand which created the two heads carved some of the Nazareth capitals too. This, of course, further enhances the interest of establishing the artistic origins of the former.

Some of the features of style and physiognomy that characterize the two heads are rather widespread in Western, particularly French, art of the twelfth century, and may be found in different regional schools. Large skulls covered by hair parted in the middle, one of the most prominent elements of our heads, are met frequently in southern France and in the northern regions of Spain. I shall mention only a few examples. See, for instance, the head of the Crucified on a book-cover from Jaca (Huesca), now at the Metropolitan Museum in New York,[15] where the skull is oversized, the hair parted in the middle and falling in regular, parallel waves. Oversized skulls and a similar hair arrangement are also prominent in a capital of Elne (Pyrénées-Orientales).[16] Needless to say, the formula of hair parted along a central line and flowing in regular waves is an old and common motif, frequently found in illuminations, painting, and sculpture. However, sometimes, rather slight alterations of form give it an altogether different character. Suffice it to mention the statue of St. Paul in Ebreuil,[17] where the hair is parted as in the Nazareth heads, but does not fall diagonally. Due to the slight alteration, the forehead has a rectangular shape, giving the face a form that differs from that of our heads. Sometimes one finds in French sculpture of that period a head on which several of the physiognomic features typical of the Nazareth heads appear, but the spirit is different, and does not permit us to assume any connection between them. A good example is the head of the Deity carved on the keystone

15 Kingsley Porter, ill. 614.
16 *Ibid.*, ill. 1256.
17 *Ibid.*, ill. 1330.

175

of a crypt-vault in St. Gilles.[18] Many of its details closely resemble features of the Nazareth heads: the hair is parted in the middle and falls in diagonal strands; the forehead has a triangular shape; and the beard is similar to that of the left face in Nazareth. Despite these similarities of detail, the face at St. Gilles differs from our heads in general qualities. The physiognomic type is shorter and fuller, and the execution more plastic.

The closest resemblances to our heads are to be found, I think, in Burgundian sculpture. In an earlier and more primitive form, the type of our left head appears in a capital from Moutier-St. Jean, now in the Fogg Museum,[19] on which the offerings of Cain and Abel are represented: Cain's skull is domed (though not so high as in Nazareth); the hair is carved in regular straight strands with slightly undulated tips near the face; they cover the upper half of the ear; the forehead is low (though not so low as in Nazareth); the short beard is straight but ends in curls; and the profile has an obvious affinity to the profile of our left head. In Moutier-St. Jean the physiognomic type is less pronounced, less narrow and elongated than in Nazareth, but Cain's head looks like a first stage of a head that found its final formulation in the work under discussion. I do not suppose that a continuous series of stone sculptures leads directly from Moutier-St. Jean to Nazareth — they may be separate branches of a common development, although the close connections of Nazareth with Burgundian sculpture[20] suggest more direct relations. A large skull combined with a long pointed beard, reminiscent of our right face, is found in a capital at Gargilesse (Indre),[21] although here again the physiognomic type is fuller, less ascetic in spirit and less accentuated in form. The oblong type of face, showing a remarkable affinity in spirit to our heads, can be seen in a relief of La Charité-sur-Loire.[22] Here the profile displays not only the long, narrow form (note especially the long nose, continuing in an almost unbroken line the contour of the forehead), but also additional motifs familiar from the two Nazareth heads. See, for instance, the hair carved in parallel though somewhat wavy lines covering the upper part of the ear. One notices also the manner of carving, combining sharply cut forms with flat surfaces, that shows a similarity to the Nazareth heads.

18 *Ibid.*, ill. 66.
19 Kingsley Porter, ill. 66.
20 Cf. above, p. 162 ff.
21 Kingsley Porter, ill. 82.
22 *Ibid.*, ill. 135.

In our discussion of the Nazareth capitals we have also mentioned similarities to La Charité-sur-Loire,[23] therefore the affinity of the two heads to works of the same place supplies an additional suggestion (although no proof) of a connection between it and Nazareth. I should finally like to mention the head of Christ in the *Majestas Domini* at Dijon,[24] showing the long face, similar hair (covering the upper part of the ear), and a short beard with curled tips. Christ's face is more spiritualized than the heads of Nazareth, but this may be due to a conception of the theme.

In sum, then, Burgundian sculpture provides the closest parallels for our heads in style, as well as in physiognomic type and details. Therefore, a Burgundian origin of the artist who carved the heads may safely be assumed.

23 Cf. above, pp. 163 ff, 109.
24 Kingsley Porter, ill. 135.

III

Since the heads are not finished, they provide, as already said, a good specimen for the study of carving technique, and they also permit to infer—more clearly than the capitals of Nazareth do—what tools the sculptor employed in his work.

The heads clearly show that they have not been carved *in situ*, as was often the case with Romanesque sculpture, but in an atelier, i.e. that they constitute an example of the method usually called *avant la pose*. It should be mentioned that the same procedure can be discerned in the capitals.[25] Our heads further show that the decoration of the pillar for which they were originally intended was carried out in separate sections. The block from which the heads are carved has not been broken off by accident from a larger piece of stone, but was from the outset independent of the block on which the bodies belonging to these heads would have been carved. Such a procedure of carving large figures or monumental reliefs on several joined sections or slabs is, of course, well known in Romanesque art.[26]

A study of the two heads permits us to reconstruct, although only in general lines, the stages of carving. At first glance it is obvious that the work was not carved as a whole, but was completed part by part. Thus, the faces were given their final form, and polished to erase the marks of the chisel, the hair and beards completed in their definite pattern, while the adjacent parts were left in the initial stages of carving so that nothing of the intended form can be discerned. There is not the slightest indication as to how the draperies on shoulders and breasts were to

25 The *avant la pose* method has been investigated more frequently in the case of large reliefs. Cf., e.g., J. Adhémar, *La Madeleine de Vézelay* (Melun, 1948), p. 141 ff., and Meyer Schapiro, "The Sculptures of Souillac," *Medieval Studies in Memory of Kingsley Porter* (Cambridge, 1939), ii, p. 359 ff., and fig. 3.

26 Cf. Meyer Schapiro, "The Romanesque Sculpture of Moissac," *Art Bulletin,* xiii (1931), p. 348, and fig. 128.

look, while the beards touching on these supposed draperies are finished to the last lock. That this method of carving and finishing part by part was also employed in the heads themselves can be observed in a detail: the hair on both heads is completed in the form of regularly carved strands but for the one hairwave that covers the ear; here the projecting mass of stone is left almost completely untouched, the strands stopping short of it.

The method of carving here employed was certainly not the only one in use in French sculpture of the twelfth century. In the south of France one occasionally finds unfinished works of sculpture which show that they have been carved as a whole, stage by stage.[27] It is obvious that the method of carving and completing the work part by part, instead of stage by stage as a whole, presupposes a very high skill on the part of the sculptor as well as definitely crystallized models. Moreover, the sculptor must have been thoroughly acquainted with his models as well as with the process of reproducing them. This, in turn, confirms the impression we get of his style: the heads are not the work of a beginner, or of a school in its initial stages, but the product of a highly experienced and sophisticated master who draws upon a fund of deeply rooted and firmly established traditions. It is, paradoxically enough, precisely for this reason that we cannot say with any degree of certainty how the figures on which the heads were to rest would have looked.

Two or three main stages of stonework, and the tools employed in them, can be discerned on the two heads.

In the first stage, of which naturally almost nothing has been left, the artist roughly hewed out the form which he intended to give to his work, chiefly separating the masses of the two heads. One may assume, as has been proposed,[28] that in this stage the sculptor used a drill (probably of a large size), breaking down the walls between the holes made by it, and apparently also a punch, or broad and flat chisels of varying sizes, the traces of which are clearly visible in the angular sections at the lower part of the stone block (see especially the vertical mass at the

Fig. 45 left of the right head, fig. 45). The use of a drill in deep undercuttings is, of course, well known in French sculpture of that century (a good example is the famous trumeau of Souillac), although it was by no

27 Oakeshott, *Classical Inspiration in Medieval Art,* p. 83.
28 *Ibid.,* p. 119 ff. In Moissac, for instance, the drill is little used in a considerable part of the sculptures.

180

means a generally accepted technique.[29] Perhaps in the first stage of carving the artist also used a gouge or a chisel of moderate size with a rounded, hollow blade. This tool was used for chipping off smaller masses of stone, especially in the areas bordering on the heads. Traces of it can be seen below the beard of the left face. As I have said, these methods and tools were employed by the artist for the shaping of the rough form of the work.

In the second stage, the artist apparently proceeded immediately to give the heads their final form, leaving the other parts of the stone untouched. In this stage fine drills, chisels, and other pointed tools were employed; their different traces can be seen in different sections of the finished parts of the work. In the striation of the hair, for example, the sculptor seems to have used two different tools. In the hair of both heads one notices three or four main groups of strands, divided by a deeper grooving than the one dividing the auxiliary strands. The width of these strand-groups is approximately equal. This form suggests that the sculptor employed a gouge or punch to establish the general form and direction of the hair. Interestingly enough, at the upper part of the heads, where the distance between them is considerably narrowed, one does not find these deep marks. Apparently the narrow field did not enable the artist to employ a wide tool. A different instrument, probably a finer chisel, was used to carve the individual strands within the framework established with use of the larger tool. The second tool did not leave such deep marks as did the first. In the beard of the left face the broad tool was not used, probably because it would have destroyed the form of the curls. This beard is carved with the help of fine chisels only. However, the beard of the right face, which has a straight shape, again displays groups of strands that suggest the application of a tool similar to that used in the hair, though of a narrower size.

In the carving of the faces the artist used fine, sharp chisels and perhaps other pointed tools. The careful polishing has erased their marks, but in the left-hand face one can perhaps discern some slight traces of them (see the area to the right of the nose, fig. 44), particularly in raking light. In the carving of the eye the artist used both fine chisels and a fine drill. He obviously used chisels of different sizes for the hair and beards, and for the eyes. After a careful observation of the heads I con-

Fig. 44

29 Cf. *ibid.,* pl. 108, where the holes in the beard curls, and probably also in the corners of the eyes, can be seen clearly. The drilling of holes in the curls of a short beard appears in Cluny shortly after 1100. Cf. *ibid.,* pl. 12a.

clude that the drill was not extensively employed in carving them, the most obvious example of its application being the holes of the pupils. It is remarkable that the artist should not have employed the drill extensively, in the late-classic practice that survived in some regions of southern France, but should have achieved the effects of sharp, clean cutting mainly by the sophisticated application of a variety of chisels. In this respect he even differs from, e.g., the famous head of Christ on the tympanum of Vézelay, where holes are drilled in the curls of the beard, and drilling is perhaps applied in the corner of the eye.

.

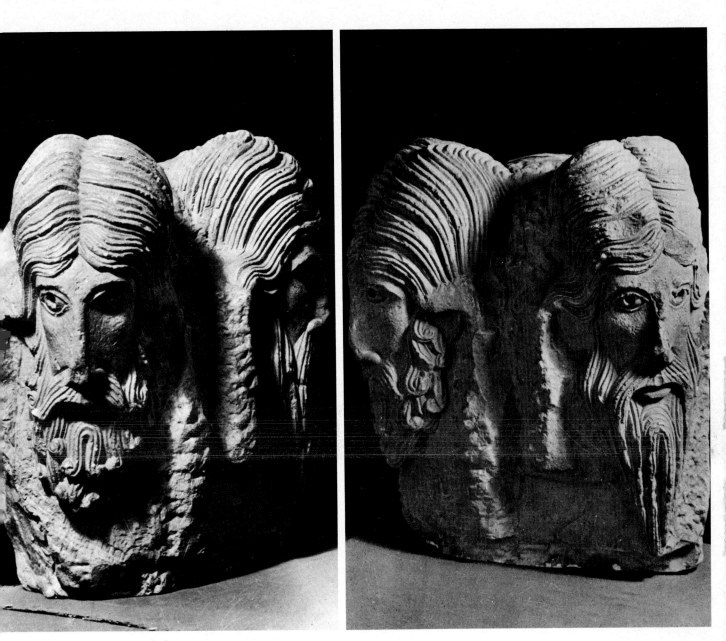

The Nazareth Heads, Greek Patriarchate, Jerusalem.
44 The left head; **45** The right head.

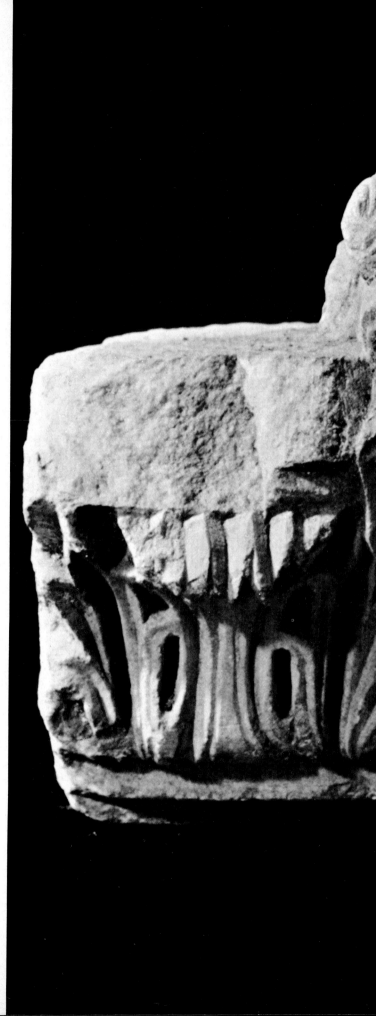

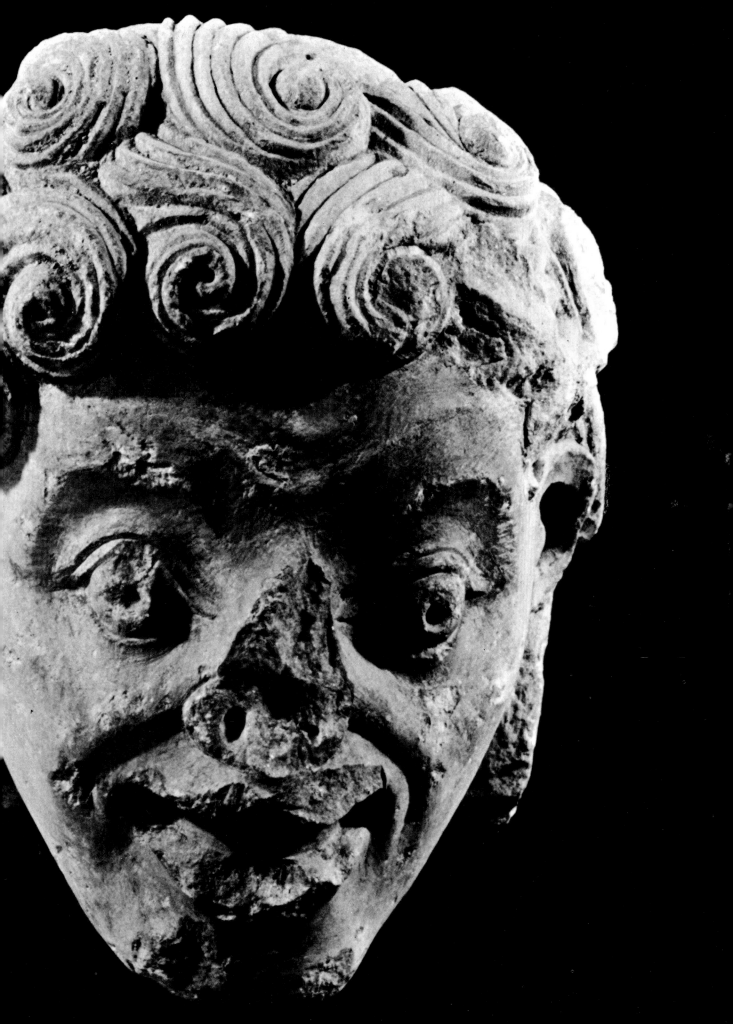

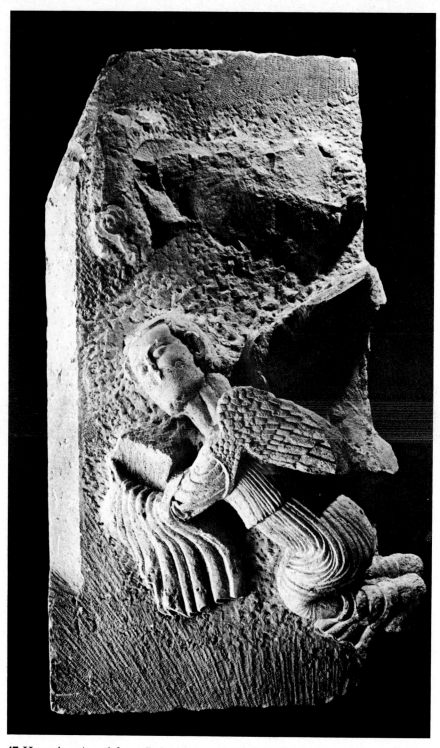

47 Hovering Angel from Belvoir Castle, Rockefeller Museum, Jerusalem.

TWO WORKS
FROM
BELVOIR CASTLE

The castle of Belvoir *(Videbellum* in Latin, and *Kaukab el-Hawa* in Arabic), which dominated the banks of the Jordan River in the upper Beth-shean valley, was one of the important Crusader fortresses in the Holy Land. Until a short time ago, the artistic remains of this site — prominent in military history —, were practically unknown. Enlart, in his large work on Crusader monuments, could devote only two and a half lines to Belvoir.[1] Recently, while conducting an extensive campaign of excavations at the castle, M. Ben-Dov discovered some interesting pieces of Crusader sculpture, which constitute an important contribution to our knowledge of this art. Before describing the works, a few general remarks may be of use.

The history of Belvoir enables us to assign a definite date to the sculptures. The first castle on the site was built during the reign of Fulk of Anjou (1131–1143), Queen Melisende's heir and King of Jerusalem. Originally, however, Belvoir was a rather small fortress which certainly had no large-scale architecture that could accommodate works such as those discovered during the excavation. In 1168 the castle, together with large tracts of land in its neighborhood, was sold to the Order of St. John, i.e. the Order of the Hospitallers. Only an order of this importance could have raised the considerable sums required to undertake a vast building campaign, and, in fact, a new and large fortress was erected after that date.[2] In 1184 an important Crusader historian, William of Tyre, described Belvoir as a "new castle."[3] In 1187, Saladin's

1 C. Enlart, *Les Monuments des Croisés dans le Royaume de Jérusalem* (Paris, 1928), ii, p. 63.
2 This brief account of the history of Belvoir castle follows the article by J. Prawer, "The History of the Fortress Kaukab el-Hawa-Belvoir," in *Yediot bahaqirat Eretz-Israel weatiqoteha,* xxxi (1967), pp. 236–249 (Hebrew).
3 Wilhelmus Tyrensis, *Historia Rerum in Partibus Transmarinis Gestarum,* xxii, 16: "castrum novum cui nomen est hodie Belveir." And in the French version (cf. *Guillaume de Tyr et ses continuateurs,* ed. P. Paris [Paris, 1879] xxii, 15); "un chastel neuf que l'en claime Biauveoir." Cf. Prawer, "History of the Fortress Kaukab el-Hawa," p. 239, note 12.

forces, invading the Latin Kingdom, attacked Belvoir. Since they were unable to capture the great fortress, they besieged it for a year and a half. In January 1189 the defenders of Belvoir capitulated and evacuated the castle. Later, the Crusaders were able to regain Belvoir, keeping it for some time, but no building activity whatsoever was undertaken, and the castle remained in ruins. The sculptures found there could have been carved only while the castle belonged to the Order of St. John, i.e. between 1168 and 1189.

But the period of the works' creation can be further limited, as both an inspection of the site and a look at its history suggest. The new castle of Belvoir was built in two monumental storeys; the lower one containing only the fortress, while a part of the upper storey constituted a church 26 m (85.3 ft.) long and 13 m (42.65 ft.) wide. (A detailed reconstruction will be given in M. Ben-Dov's forthcoming report.) The fragments of sculpture excavated belonged to that church, the construction of which could not have reached the stage at which these ornaments were set in place before the early or mid-seventies. But after 1182 the region of Belvoir was particularly troubled by the frequent raids of Saladin's forces, which often amounted to a genuine danger and forced the defenders of the castle to engage in large-scale battles. Conditions prevailing in Belvoir after 1182 could not have allowed for much artistic activity. The works of sculpture found there should, then, be dated to the years between roughly 1175 and 1182. Here the works will be discussed separately.

HEAD OF A YOUTH

One of the fragments found at Belvoir is a magnificent, larger than life, head of a youth (fig. 46), now displayed in the Rockefeller Museum in Jerusalem. It is carved in a dark yellowish marble, and bears some traces of color. The beholder cannot fail to be impressed by the high artistic quality of this piece. Its perfection of form, the liveliness of expression and the masterly carving make it, I believe, a masterpiece of late Romanesque art. Without losing its medieval character, the head reveals a surprisingly clear affinity with Greek art of the late archaic and early classic period. Like some of the works already discussed, it reveals the vision and hand of an accomplished master. It differs from them, however, in its artistic origin.

Fig. 46

Many general qualities and specific forms or motifs cause us to distinguish the Belvoir *Head of a Youth* from most of the other Crusader sculptures found in the Holy Land. The oblong shape of the beardless face of a youth is in itself not common in this art which, like most Romanesque sculpture, preferred bearded countenances. Also decidedly unusual is the general expressive quality, the depiction of smiling amazement. Looking at the head one has the impression that the artist attempted to catch the reflection of a fleeting emotion, perhaps of a joyful surprise. This impression is enforced by a comparison of the Belvoir head with the smiling face on the Acre vessel discussed above (fig. 4). While the smile of the face carved on the Acre vessel is, so to speak, stable and constant, in the Belvoir head it strikes us as momentary and sudden; in the former it is a "situation," in the latter it is an "event." Although it would hardly be correct to assume that the artist actually attempted to portray a fleeting emotion, the very fact that the beholder gets this impression indicates the difference in spirit between the Belvoir head and most of the other works discussed in this book. There are also individual motifs which point to a difference between

Fig. 4

the Belvoir head and most of the other heads and faces in Crusader sculpture. The most obvious is the treatment of the hair. As we have seen on several occasions,[4] the type of hair representation prevalent in Crusader sculpture consists of long, parallel strands; at a later period the strands sometimes tended to end in curls. The *Head of a Youth* is covered by large ringlets of a regular spiral form, recalling the shape of a shell. Each curl of the row framing the forehead has a small, round hole, neatly drilled in its center. The perfect stylization of the hair is perhaps an important element in relating the head to a specific school of European sculpture.

In contrast to the linear and ornamental treatment of the hair, the carving of the face is of a surprisingly soft, and organic form. The artist, although he certainly drew from traditional models, succeeded in giving to this head a naturalistic character, and a convincing expression of emotion. In fact, the beholder needs some time to discover the structure of a conventional pattern behind that lively physiognomic expression. The soft modeling of the forehead (one cannot speak of wrinkles or furrows), echoing the form of eyebrows, constitute a wavy line which has harder and more mechanical parallels in some schools of European sculpture; here, however, this motif strikes the beholder as natural. The eyebrows (slightly damaged, particularly on the left side) are not incised or flat (as for instance, in the Nazareth heads, figs. 44, 45), but slightly protuberant, their irregular shape imitating the form and even the texture of eyebrows in nature.

Figs. 44, 45

The eyes are interesting both in their intrinsic artistic value and in the comparison they enable us to make between this head and others found in the Latin Kingdom. They are rather small in size, their axes being slightly oblique (a feature found in Crusader sculpture only in the Acre vessel, figs. 3, 4, where the eyes are of an altogether different form and character). The small eye-balls protrude conspicuously. The almost perfectly round form of the eyes is further stressed by the shape of the lids, both of which are strongly curved. In this respect, too, the eyes of the *Head of a Youth* differ from most other Crusader heads, where the upper lid is usually straighter that the lower one.[5] The small holes denoting the pupils are drilled not in the center of the eye, but slightly below it, a feature which contributes to the expression of surprise and wonder of the whole face.

Figs. 3, 4

4 See above, pp. 105, 168.
5 Cf. above, pp. 15, 168.

192

One of the most prominent motifs of the face is the mouth. Although it is damaged, its shape and expression can still be clearly understood. Its general form as well as the particular feature of the raised corners indicate that it is smiling. In the Acre vessel we have already encountered the representation of a smiling mouth (fig. 4). However, one can hardly find a better example of the development of facial expression in twelfth-century European sculpture, as reflected in the artistic production of the Latin Kingdom, than in comparing these two representations of smiling. In the Acre vessel, the motif of smiling is a formula that still bears most of the characteristics of stereotype. The lips are flat, and of approximately equal width from corner to corner. In the head from Belvoir the lips are (or rather were before the mutilation) of a full, plastic form, their shape varying from a bulky roundness in the center of the mouth to narrow dimples in the corners. In spite of the damage suffered, one can still clearly perceive the difference between the lips, the lower one being softer, the upper one tauter. In Acre, on the other hand, both lips have basically the same character. In the Belvoir head the mouth is also adapted in a masterly fashion to the prominences and dimples of the neighboring regions, the smile, so to speak, radiating over the whole face.

Fig. 4

It is also interesting to compare the deep furrows leading from nose to mouth, a motif that belongs to the formula of smiling, in the faces of Acre and Belvoir. The *Head of a Youth* suggests an observation of nature, be it by the master who worked in the Latin Kingdom, or by the European artists by whom he was trained. In the Belvoir head these furrows issue from above the nostrils (as in nature) while in Acre their starting point is not clear. In the *Head of a Youth* these furrows are also more clearly differentiated from the rest of the face than in Acre, but without becoming a deeply grooved line, as is so often the case in Romanesque sculpture. In fact, the furrows are complex continuities of prominences and hollows, transforming a line into organic tissue.

As is so often the case in Romanesque sculpture, the ears are too small and their relation to the face is somewhat awkward. In this head, however, they are almost completely integrated in the ornament of the hair. Does the *Head of a Youth* belong to the same artistic tradition as the roughly contemporary capitals and two heads of Nazareth? Is it also permeated by a Burgundian spirit, and does it have close parallels in the great art of that French school? For reasons of historical probability one is tempted to look for evidence in affirmation of such a hypothesis.

193

If this were the case, one might picture a workshop led by Burgundian artists operating in the northern part of the Latin Kingdom (to which both Nazareth and Belvoir belonged), and possibly executing all the sculptural work in the region. However, it is difficult to discover a Burgundian spirit in the Belvoir head. The conception of the face as a flat surface, the strong emphasis on lines that create calligraphic effects, the ascetic expression — all these elements which are so characteristic of Burgundian art of that period, and are strongly reflected in the Burgundian-inspired works of the Holy Land — cannot be detected in our head. The *Head of a Youth* is softer in carving, more naturalistic in representation, and more humanly emotional in expression than almost anything we find in Burgundian sculpture of the twelfth century. One should also add that a certain classic quality which is so striking in the Belvoir head is not typical of, or at least does not prevail in, Burgundian sculpture.

I was unable to discover in twelfth-century European art any works that might exactly parallel our head, or agree with it in all respects. However, most of the works which reveal an affinity with the Belvoir head point to a different tradition, to the broad region of Provence, and the schools influenced by it, rather than to Burgundy.

This can be seen in the general spirit as well as in typical details and motifs. The treatment of the hair of the Belvoir head finds its closest parallels at St. Gilles. The famous head decorating the entablature of the west façade of St. Gilles Abbey is covered by round, spirally shaped ringlets, in the center of which a round hole is drilled.[6] The physiognomic type of the St. Gilles head also shows partial similarity to ours. Although at St. Gilles the face is fuller than in the *Head of a Youth*, it also has the characteristic features of the low forehead and wide chin. In the head of St. Gilles we find, moreover, the significant and uncommon motif of smiling, although it is true that the rendering of this motif is not exactly alike in both places. The carving of the eyes is also different: at St. Gilles they are not so protuberant as in Belvoir, the pupils are exactly in the middle, and the holes representing them are larger. The Provençal head also lacks the deep furrow from nose to mouth. On the other hand, the carving of the mouth is similar in Provence and in the Holy Land (see especially the dimples in the corners of the mouth). In our context it is also significant that the head at St.

6 Kingsley Porter, *Romanesque Sculpture of the Pilgrimage Roads*, ill. 1322.

Gilles is patterned after a classical model,[7] thus indicating the same attitude toward classical art that is suggested in the Belvoir head. A most important element in tracing the similarity of the works is the fact that the *Head of a Youth,* paralleling that of St. Gilles, seems to have been part of an entablature.

The typical treatment of the hair seems to have been widely diffused along the southern coast of France, and in some regions of northern Spain. At St. Gilles itself one finds several examples. A head on an architrave of the central portal, although different from ours in type and expression, shows a similar treatment of the hair.[8] In a relief representing the Betrayal of Christ, one figure (second from left) has the same spirally curled hair.[9] In Nimes, which is near St. Gilles, the figure of Cain has a similar hair pattern,[10] and in a more primitive (or perhaps deteriorated) form one finds it in the figure of St. Peter at Maguelonne,[11] situated in the same region.

Although this style of hair seems to be typical of Provençal art, it is also encountered in other regions. I should like to mention in particular the figure of an angel at St. Benoit-sur-Loire whose hair has been carved in the same style, and may even have some connection with the facial type of the Belvoir head.[12]

Another important motif is the smiling expression. It need not be re-emphasized that the smiling face is not common in twelfth-century sculpture, although we have found several examples of it.[13] Probably the best known example is the face of Daniel in the group of prophets in the Portico de la Gloria of Santiago di Compostella.[14] Daniel's hair is carved in a form similar to that of our head, although in Santiago the curls frame the whole face, while in Belvoir only the upper part of the head is framed. Daniel's forehead is higher than that of the Belvoir head, but both faces have the wide and slightly rectangular chin, the somewhat protruding cheekbones, and the deep furrow between nose and mouth (in Santiago, as in Belvoir, this furrow clearly emerges from

7 Cf. E. Panofsky, *Renaissance and Renascences in Western Art* (Copenhagen, 1960), p. 59 ff., and figs. 27, 28.

8 Kingsley Porter, ill. 1323.

9 *Ibid.,* ill. 1319.

10 *Ibid.,* ill. 1383.

11 *Ibid.,* ill. 1287.

12 *Ibid.,* ill. 1523.

13 See above, p. 59 ff.

14 Kingsley Porter, ills. 829, 829b. And cf. José Gudiol Ricart and Juan Antonio Gaya Nuno, *Arquitectura y Escultura Romanicas (Ars Hispaniae,* v) (Madrid, 1948), fig. 511.

above the nostril); both heads show the same soft modeling. It is also interesting to compare the shape and expression of the eyes in both pieces. The eyes of Daniel at Santiago di Compostella are flatter, and their contour is not so rounded as in the *Head of a Youth*, but the pupils are also drilled slightly beneath the center, giving to the whole face the same expression of surprise and wonder. The area around the eyes, the form of the lids, the widely spaced eyes and raised eyebrows are also similar in Santiago and in Belvoir. Even more important is the mouth. As far as the mutilation of the Belvoir head allows to deduce, the modeling of the mouth is similar in both heads. The upper lip is almost straight, while the lower one is fleshier and fuller, almost round in the middle of the mouth and narrowing at the corners. In sum, a certain family likeness between these two heads seems obvious.

The figure of Daniel, as well as those of several other prophets in the Portico de la Gloria of Santiago di Compostella, are attributed to an individual artist of great force, Mateo, who worked in the late twelfth and early thirteenth centuries.[15] It is not our task to discuss Mateo's sources or originality, neither do we intend to relate the *Head of a Youth* to this master, or his immediate followers. It is, however, well known that Mateo drew from many sources, and was particularly influenced by the art of southern France. He also exerted a wide influence. The smiling face is, indeed, encountered in several places in the region where Mateo worked. Thus, in a capital of Oviedo, representing the Three Marys at the Tomb,[16] the angel to the left is similar in physiognomic type and in the treatment of the hair to the Belvoir head, and his smiling mouth may be related to our work. It is interesting to note that this capital is characterized by a great variation and articulation of facial types and emotional expressions. One should also mention the figure of Daniel in the Cathedral of Orense (western portal, northern jamb),[17] and that of St. John the Evangelist in the same Cathedral (western portal, southern jamb).[18] These smiling heads are not only closely related to the Daniel of Santiago di Compostella, but they also have a general affinity with the head from Belvoir.

The smiling face, of course, occurs also in other parts of France in the middle and second half of the twelfth century, the best known example

15 Cf. *Ars Hispaniae*, v, p. 346 ff.
16 Kingsley Porter, ill. 819.
17 *Ibid.*, ill. 855.
18 *Ibid.*, ill. 856.

being the so-called "archaic smile" of figures on the west front at Chartres.[19] However, the *Head of a Youth* differs from the Chartres figures both in spirit and in detail. The hair of the Chartres figures is carved in an altogether different shape, the mouth is narrower and more linear, and the eyes are of a different character. A connection between the Belvoir head and those of Chartres does not seem likely.

In sum, the examples discussed show that heads of a physiognomic type and facial expression similar to those of the Belvoir head frequently occur in the Romanesque art of southern France and the northern regions of Spain. These heads were created at the same period, or somewhat earlier, as that carved by the anonymous artist working in Belvoir castle at the time indicated by the historical circumstances. We further recall that artists or models from southern France reached the Latin Kingdom in the second half of the twelfth century.[20] Considering these facts, which admittedly amount to suggestions rather than to clear-cut evidence, one may venture to assume a connection between the *Head of a Youth,* and the art of that broad region of southern Europe.

19 Often reproduced. For a good reproduction of a detail, cf. W. Oakeshott, *Classical Inspiration in Medieval Art* (London, 1958), pl. 109.
20 Cf. above, pp. 162, 159.

HOVERING ANGEL

Another interesting work of sculpture discovered by M. Ben-Dov on the site of Belvoir Castle is a relief representing a hovering angel (fig. 47). It is a rather large piece, the yellowish stone slab being 115 cm. (44.85 in.) high, 58 cm. (22.62 in.) wide, and 31 cm. (12.09 in.) deep. In looking at the relief one is particularly impressed by the plastic bulk of the figure. The angel stands out 28 cm. (10.92 in.) from the slab, and appears as if it were almost sculptured in the round.

Fig. 47

Both in motif and in style of execution, the figure of the angel is rather uncommon in Crusader sculpture. In fact, no other representation of an angel has been found in what used to be the territory of the Latin Kingdom. The slanting position and bent knees of the Belvoir angel indicate that he is hovering. Although this is not the most common attitude of a hovering angel in the art of the twelfth century (hovering angels are usually in a more horizontal position), the Belvoir angel cannot be understood as kneeling. Not only the general impression but also some details speak against this interpretation. If the artist had intended to represent a kneeling angel, he would probably have indicated the ground or some other object on which the knees might rest. In the area under the angel's knees there is, however, no mass of stone that could have been given the form of ground or of a large object. Moreover, the artist started polishing this area, providing clear evidence that he did not intend to add anything to it.

It cannot be determined whether a male or female angel is here represented. But since angels of both sexes occur in medieval art[21] this question is of no great significance. One also notices that the angel

21 We need not go here into the vast literature on angels in art. Cf. Th. Klauser's entry "Engel (in der Kunst)," in *Reallexicon für Antike und Christentum*, v, (1962) cols. 258–322; and K. Wirth, "Engel," in *Realenzyklopädie zur deutschen Kunstgeschichte*, v, cols. 341–555.

has no halo, but this, too, is common since early medieval times, especially in sculpture.[22]

The angel's head is not finished, but its outline and general character are clearly discernible. As far as I know, none of the many heads produced by Crusader artists in the Holy Land yield any close parallel to that of the Belvoir angel. In its large size, square shape, narrow eyes, prominent jaw and large, flat cheeks, it differs from most of the artistic models used by sculptors working in the Latin Kingdom.

The drapery is of great interest. The sculptor distinguishes very clearly between two types of folds: one consists of the delicate, fine, and narrow folds of the garment worn by the angel, the other of the broad folds of the heavy cloth covering his hands and the lower part of his legs. The spirit in which the artist treats the drapery is remarkable. The overall quality of the drapery suggests an understanding of the body and an observation of nature, although in fact only very few anatomical or naturalistic details are represented. Among the latter, note especially the slight twist of the folds on the angel's thighs which result in a strong optical effect of foreshortening, and the billowing curve of the cloth covering his hands which suggests the natural effect of the hovering pose on the drapery. The impression of organic and naturalistic representation is furthered by a certain ease in the position of the angel, particularly in the soft turn of his head. There can, however, be no doubt that both the angel's posture and the drapery forms are based on traditional models.

The same mixture of naturalistic spirit and conventional forms characterizes the one completed wing (the other wing being only very roughly outhewn). A very interesting detail, which may be of some importance in tracing the artistic origin of the figure, is the way in which the wing is fastened to the angel's body. While the wings are usually shown growing from the angels' shoulders, in our relief the wing seems to be attached to the sleeve and is, so to speak, worn by the angel. It belongs to the drapery rather than to the angel's body. This detail produces a certain theatrical effect (actors portraying angels on the medieval stage may indeed have had their wings attached in a similar manner) and betrays the spirit of a profane, secular "objective" realism, which is not without parallels in the art of the period.[23]

22 Cf. Klauser, "Engel," col. 291. In sculptures, the angel's halo was often painted.
23 For a secular spirit in the representation of religious themes in Romanesque art, cf. Meyer Schapiro, "From Mozarabic to Romanesque in Silos," *Art Bulletin,* xxi (1939), p. 313 ff., especially p. 339 ff.

A large, hardly touched, mass of stone juts at the upper side of the slab. It is difficult to make out what the artist intended to represent here, but it is evident, I think, that this is not simply an amorphous mass of stone that would have been chipped away had he finished his work. This is borne out by the fact that the chisel marks stop short of the rather complex outline of this mass, an outline which is certainly not the incidental result of an interruption in the carving process. It is also interesting to notice that the artist started polishing the upper edge of the slab, an action which he would probably not have undertaken had he intended to remove the bulk of stone immediately beneath the polished area. Most interesting, however, are some details that are carved on the upper left side of the slab. The unfinished form there (carved in somewhat greater detail than in the upper center of the slab) seems to suggest, however vaguely, the figure of a tumbling animal, perhaps a ram. The spiral shape that can be seen more clearly may represent the ram's horns. However, the carving in the upper part of our relief has been left in such a rudimentary stage that it does not permit even the suggestion of an hypothesis.

The *Hovering Angel* is an unfinished work which supplies precious insights into the working procedures of a late twelfth-century sculptor. Together with the other unfinished works discussed in this book[24] the Belvoir relief may permit us to draw some conclusions as to the carving technique prevalent in the Crusader Kingdom in the third quarter of the twelfth century.

One notices first that the process of carving was carried piecemeal in some areas down to the final touches, while in others the roughest and most elementary forms are hardly outlined. Thus, the angel's body and one of his wings are practically finished, the delicate pleated folds of the garment and the feathers of the wing being finished to the last detail. The angel's head and the object he holds in his hand remain in more initial stages of carving, and the large mass on the upper half of the slab is barely outlined, and cannot be identified.

Even the purely technical procedures were undertaken part by part. In the central section of the slab we see chisel marks, remnants of an early stage of carving. But both on the upper and lower parts of the relief the artist had started the process of polishing, using a finer tool, probably a file, which erased the marks of the chisel. The last stage of polishing can be seen in the face. It is interesting to note that, although

24 See above, p. 179 ff.

the polishing of the face is completed, the mouth, and some other small features, are not yet carved.[25] Looking at this detail one asks whether polishing was necessarily the last stage in the artist's work. In areas that contain small forms, as for instance a face, it was perhaps done before these small features were carved. As we have seen above,[26] the principal stages of carving can be located in several unfinished works of Crusader sculpture, but none of them provides such a clear example as the Belvoir angel. Here are displayed, in the same slab, practically all the stages of carving, from the tracing of the bare outline to the final polishing.

The technique of carving sculptures part by part necessarily leads to some conclusions as to the broader methods of the artists and their habits of thought. A procedure in which one part of the work is completed while the other is not even clearly outlined presupposes, needless to say, articulate and definitely established models with which the sculptors must have been intimately acquainted. Even if the models have not survived, we cannot doubt the artist's traditional attitude toward them. As far as the technique of carving is concerned, the relief then provides important and clear testimony. In other respects, such as in iconography and artistic origin, it poses more difficult problems. Naturally, the unfinished state of the relief makes these questions more complex. Had we seen the work in its completed form, many a problem could have been easily solved, or would not have arisen at all.

The first question, of course, is whether the relief, as we now see it, represents the whole work, or is only a fragment of a larger composition. The relief itself does not provide enough evidence to answer this question conclusively, but the overall composition, the movement of the angel in a specific direction, and the slanting posture of his body suggest that he was not to be completely isolated. The incompleteness of our relief is suggested by another small detail: the angel's feet, projecting from the slab, are carved in full volume. Since the whole figure of the angel was certainly not intended as a sculpture-in-the-round (the artist started the polishing of the background, and we may be sure that he would have avoided this arduous process had he intended to transform the angel into a sculpture-in-the-round), we may safely assume that another slab was to come behind the angel's feet. Such a lack of

25 The nose of the Belvoir angel is broken off, but the lower part of the face shows no signs of damage that could explain the lack of a mouth.
26 Cf. p. 179 ff.

strict coordination between masonry and carving occurs in Romanesque sculpture, especially in larger works.[27]

But what were the other parts to have looked like? Was the *Hovering Angel* part of one continuous relief, for instance a tympanum, or was he rather part of an architectonic decoration, with another figure at some distance corresponding to him? One can imagine that there might have been another angel, moving in the opposite direction, to form a symmetrical pair with the one that has come down to us. The motif of the antithetical angel-pair was, of course, common in Romanesque art, particularly in southern France and in Italy.[28] But the *Hovering Angel* from Belvoir certainly differs from the most famous motif of this type, two symmetrically hovering angels holding a *clipeus*; the object in his hand is carried only by him, and does not allow for another angel to share in it.

The inspection of the site may supply some further information. The place in which the work was excavated strongly suggests that the angel belonged to the façade of the church of Belvoir.[29] Since the relief is too large to have been part of a tympanum, it probably belonged to the entrance porch of the church. The shape of the stone slab reinforces this assumption. As Ben-Dov has suggested, the diagonal cut of the upper edge of the slab was the basis on which an arch was to rest, or actually rested. This would be further proof that the angel decorated a porch.

In the twelfth century, reliefs representing figures are, of course, encountered in the decoration of porches. Usually, these figures do not represent angels, but prophets and saints. But we also know of angel figures on both sides of the entrance porch of a church.[30]

The specific action, or meaning, of our angel is difficult to establish. In the twelfth century angels appear in such a variety of types and contexts that it is almost impossible to ascribe the *Hovering Angel* from Belvoir to one of them on the sole ground of what can be seen in the relief. In that period, one often finds saints with angels who crown them, or hold candles, and the like, as independent iconographic motifs.[31] Our angel can hardly belong to this type, since nothing

27 An interesting example may be found in the tympanum of Souillac. See Meyer Schapiro's study in *Medieval Studies in Memory of A. Kingsley Porter* (Cambridge, Mass., 1939), ii. p. 359 ff.

28 Cf. Gunnar Berefelt, *A Study of the Winged Angel* (Stockholm, 1968), p. 81 ff.

29 Details will be found in M. Ben-Dov's forthcoming report.

30 For an interpretation of this motif, cf. Sauer, *Symbolik des Kirchengebäudes*, p. 366 ff.

31 Cf. Wirth, "Engel," col. 443 ff.

indicates that another figure was to be represented below him. However, if one takes into account the lack of accord between masonry and carving, which I have just mentioned, as well as the fact that the Belvoir angel formed part of the upper section of the entrance porch, such a possibility cannot be altogether excluded. Another motif to which our figure could be related is that of the angel bearing the instruments of the Passion.[32] If we could identify the object which the *Hovering Angel* holds in his hand, we could probably be more definite about his meaning and function. But unfortunately the unfinished shape of the object is only that of a square block, and bears no indication of its intended shape.

In general character as well as in several individual features our relief recalls the well-known image of the angel serving in the celestial liturgy. The most obvious of these features is the angel's posture which combines the suggestions of hovering and of bowing, and thus recalls the ceremonial movement of *proskynesis*. As one knows, angels serving in the celestial Mass were not represented in actual *proskynesis*, i.e. prostrate, but as slightly bowing which is, so to speak, the initial stage of *proskynesis*.[33] Angels as diacons of heaven are often represented with their hands covered, and, like their counterparts on earth, they fulfill the function of bearing liturgical vessels (paten, chalice, etc.).[34] The object held by the Belvoir angel was perhaps to have acquired the form of such a vessel.

As already stated above, the sculptures found in Belvoir must be dated to the "late seventies or very early eighties" of the twelfth century. They are thus roughly contemporary with the Nazareth capitals, or perhaps a few years earlier. But although the distance between Belvoir and Nazareth is not great, the sculptures in the two places do not seem to belong to the same workshop or school, or even to the same broad regional tradition of French art. Like the *Head of a Youth*, the *Hovering Angel* does not show features typical of Burgundian art. The fine, delicate folds of the angel's garment are not turned into a highly complex calligraphic pattern, as one finds so often in Burgundian sculpture; they are more subdued, suggesting both the texture

32 *Ibid.*, col. 392.
33 Cf. Klauser, "Engel," col. 303 f.
34 Cf. Wirth, "Engel," col. 385 ff., especially col. 414. Cf. also Reau, *Iconographie de l'art chrétien*, II, i, p. 31 ff. The connection of angels with certain sections of the church is, of course, well known. For some references to the image of "Angelus enim Domini stetit super portam," cf. Wirth, "Engel," cols. 399 ff.

of light fabric and the organic quality of the body beneath it. The heavy cloth that covers the angel's hands is not widely billowing, as for instance, at St. Julien de Danzy, Vézelay, and La Charité-sur-Loire,[35] but expresses material weight, betraying the artist's more naturalistic conception. The angel's movements and gestures are both restrained and relaxed; they lack the tension and complexity characterizing gestures in Burgundian art. Our angel hovers lightly, he bends his knees organically and turns his head naturally. The Burgundian spirit that prevails in the Nazareth capitals cannot be found in the *Hovering Angel* from Belvoir.

Elements and conceptions showing an affinity to the Belvoir angel may be found in the art of southern France, of Catalonia and Aragon, and perhaps of some regions in Italy. Most of the works of these regions that suggest themselves as comparisons are somewhat earlier than the Belvoir angel; they adhere more closely to conventional patterns, and lack the natural ease characterising our angel. Nevertheless, they show a similarity in approach and in specific forms to the Belvoir angel. See, e.g., the symmetrical angels framing the figure of an unknown bishop in the Cathedral of Elne.[36] In that monument, the folds of the angels' garments are not as fine as in Belvoir, but the artist there also tried to follow the organic structure of the body and the movements of the figure, without turning the forms into ornamental patterns. The angel to the right of that group wears a garment ending in horizontal bands which, although not so heavy as at Belvoir, indicates a similar form. Motifs and forms similar to our figure can also be found in the angels of a tomb in Ales-sur-Tech.[37] Here the angels are both more dramatic in movement and yet more conventional and linear in form, but there is a marked similarity between their posture and that of the angel from Belvoir. Works of sculpture produced in that broad region provide many additional examples of a similar spirit, especially in the carving of folds.[38]

Besides works of southern France and the bordering regions of Spain, one is also reminded of certain Italian examples which seem to provide interesting parallels for significant details in our figure. The physiognomic type of the Belvoir angel (square face, protruding angular jaw-

35 Cf. Kingsley Porter, ills. 44, 111, 115, 117, 118.
36 *Ibid.*, ills. 623, 625.
37 *Ibid.*, ill. 627.
38 Cf., e.g., Kingsley Porter, ills. 596, 598 (light cloth, the folds being naturally adapted to the form of the body), and perhaps also ill. 553.

bones, small eyes) occurs, for example, in a relief on the lintel above the main door of Borgo San Donnino, in the faces of the angels carrying the soul of the beheaded St. Donninus to heaven.[39] A somewhat similar physiognomic type is displayed by the figure symbolizing St. Matthew on the fragment of a *Majestas Domini* in the Camposanto of Pisa.[40] More distant, but still worth mentioning, is the similarity of the Madonna's face in a relief of Rutigliano (Bari).[41]

Probably more important is another characteristic detail which I have already mentioned, i.e., the manner in which the wing is attached to the angel's sleeve. I was unable to find in European art an exact parallel to the form of this motif in Belvoir, where the wing is clearly attached to the whole width of the sleeve. But similar forms are encountered, although rarely, in the sculpture of southern Italy and Tuscany. A certain connection between wing and sleeve is suggested in the figure of an angel of Rutigliano (Bari),[42] an impression resulting perhaps from a similar ornamental pattern that covers both sleeve and wing. Another South-Italian example, in which the specific form of such an articulate connection is found, is in San Leonardo (Foggia).[43] In a relief representing Balaam and St. Michael, the angel's left wing seems to be attached to a kind of harness covering his shoulder. However, the most interesting example is found in the fragment from the Camposanto in Pisa which I have just mentioned. The figure symbolizing St. Matthew wears a wing which continues in the form of a wide cord wound around the figure's shoulder. It is remarkable that the ornament decorating the cord is the same as that on the edge of the wing. The specific method of attaching the wing to the figure is here different from that found in the Belvoir angel (the winding of a cord instead of fastening to the sleeve), but the Pisan relief shows the same spirit of objective realism which we have found in the *Hovering Angel* from the Crusader fortress. That this is not an isolated instance seems to be suggested by a detail in Bonannus's bronze door of the Duomo of Pisa. In the Baptism scene[44] the higher angel seems to wear his wing in a manner similar to that which can be seen in the Pisan *Majestas Domini* fragment. Since this type of

39 Cf. Berefelt, *A Study of the Winged Angel,* fig. 80. This physiognomic type is encountered several times in Borgo San Donnino. Cf. Crichton, *Romanesque Sculpture in Italy* (London, 1954), figs. 38, 39b, 43 (the Madonna above Ezekiel).
40 Kingsley Porter, ill. 181.
41 *Ibid.,* ill. 259.
42 *Ibid.,* ill. 164.
43 *Ibid.,* ill. 216, and see also pl. 214.
44 Cf. Crichton, fig. 60a. The small size of the panel makes the outline somewhat blurred.

objective realism in representing a wing worn by an angel seems to be very rare, the similarity of invention is of some importance. The detail in the Camposanto relief acquires particular significance when we recall that in the twelfth century Pisa had many colonies in the Eastern Mediterranean, had close connections with Sicily, and at the same time looked Westwards and was brought into contact with the art of southern France through the colonies she had established in Provence.[45]

In mentioning these parallels I do not mean to suggest that the Belvoir angel was carved by a Pisan artist. The *Hovering Angel* differs from Pisan sculpture in many respects. It will be enough to compare the drapery of our figure with that on the Camposanto relief to convince us that the two works were not only carved by different hands, but are the product of different schools. I consider that what can be seen on our relief does not permit us to attribute it clearly to any particular school of European sculpture. However, on the basis of the widely scattered examples I have mentioned, I believe, the *Hovering Angel* from Belvoir is not Burgundian, but rather points to tendencies and traditions which prevailed in southern regions of twelfth century Europe. In spite of the close geographical proximity of Belvoir and Nazareth, the works of sculpture produced in these places ultimately go back to different sources.

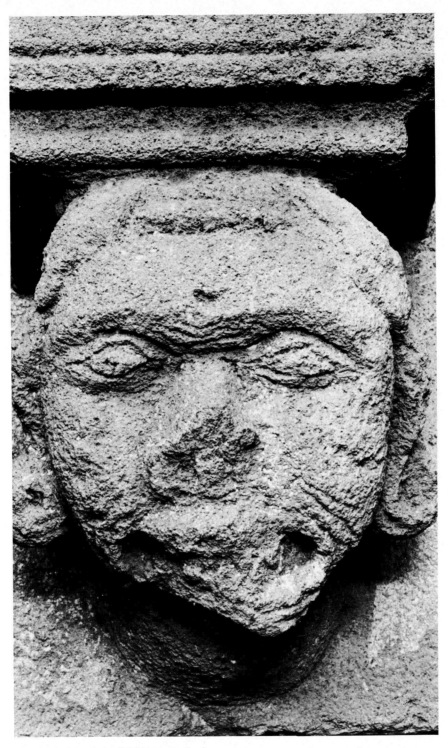

48 Head, Municipal Museum, Acre.

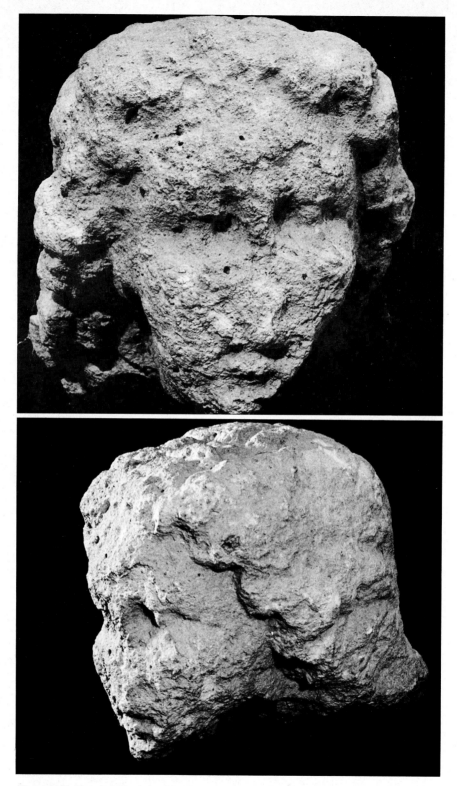

49 and **50** Head, Municipal Museum, Acre.

TWO
LATER HEADS
IN ACRE

Scholars of medieval art may find some interest in a few additional fragments of Crusader sculpture found in the Holy Land, although the poor state of preservation of these pieces does not permit to say much about them or to reach any definite conclusions as to their provenance and historical significance. The two heads to be briefly discussed are now in the Municipal Museum of Acre.

I

Some twenty years ago the head reproduced in fig. 48 was found in Acre, built into the front wall of a rather modest house. The house, many centuries later than the head, was of course not the original setting of this piece of sculpture. Obviously, it had been picked up somewhere by an art-loving inhabitant of Acre and used, or rather re-used, for decoration. Hence, the head's provenance could not be traced. An investigation of the location of the house in the light of what is known of the historical topography of Acre did not yield any results. However, since the head is heavy and even in its original state cannot have been particularly attractive, it is hardly conceivable that it had been carried from a distant place or region to the house where it was found. We may, then, be fairly certain that the anonymous art-lover found it in Acre itself, probably in the immediate neighborhood.

Fig. 48

The head has an almost square shape. It is 28 cm. (10.92 in.) high, and 24 cm. (9.36 in.) wide. The console which it supports is original, and was found built into the wall, together with the head. The console bore nothing on it when it was discovered. Head and console are carved in local sandstone of a dark greyish hue. Despite the fact that the stone is of a porous and soft quality which is easily damaged or broken, the marks of the pointed chisel have not been erased by the centuries. In this

213

context it is interesting to note that judging from what has survived in the Holy Land, Crusader artists did not carve in such soft stone, at least not before 1187.[1] The inferior quality of the stone certainly is one of the reasons for the sculpture's poor state of preservation. Another reason is that the head has been exposed to the weather for many centuries. As one sees in the photograph, the left side of the chin and the tip of the nose are broken, and the whole area of chin and mouth is badly damaged. This however, does not seem to have been done on purpose (iconoclastic Moslems have often mutilated Christian sculpture, especially the heads) but is probably the result of accident and time. It should be mentioned that no traces of color can be discerned on the head.

The poor state of preservation makes it difficult to describe it in sufficient detail. I shall therefore make only a few observations, based on a study of the original, which may supplement the photograph. Time and accident have, no doubt, worn off many details, but they have not changed the basic shape of the beardless head. As already mentioned, the face is of an almost square shape, which is further emphasized by the rectangular forehead, the almost horizontal line of the eyebrow arcades (which form here no arc at all), the wide temples that do not recess, the broad nose, and the more or less straight line of the cheeks. When viewed in profile, the head appears as a heavy, cubic mass, the face sloping down into space, so as to emphasize the expression of effort in supporting the console. However, when seen *en face* the face looks rather flat, and displays a different expression. The hair that frames the face further emphasizes the square shape. It is carved rather flat at the top of the head, but widens somewhat near the lower part of the cheeks, as if the artist wished to counteract the slight curve that narrows down the lower half of the face.

The eyes are rather small, but are set widely apart. Their somewhat irregular form, the left eye being slightly higher than the right one, is interesting for historical reasons. In several works of twelfth-century sculpture produced in the Holy Land the eye has a form which is common in Romanesque art, i.e. the upper lid is comparatively straighter and the lower one more curved.[2] In the head now under discussion the form of the eye is closer to nature, the upper lid showing a stronger curve than the lower one. This detail may indicate that the

1 For the types of stone chosen by Crusader artists in the twelfth century cf. above, pp. 69, 167.
2 See above, pp. 15, 168, 192.

214

head, in spite of its rather poor workmanship, belongs to a later period than the magnificent sculptures discussed so far. It is interesting to notice that, although the artist employed a pointed tool to incise the rather naturalistic form of the eye, he drilled no holes to indicate the pupils.

Interesting is the area dividing the forehead from the lower half of the face. Here one can see that the artist employed two different means. On the one hand, he shaped the form by purely "sculptural" means, i.e. by combining projecting masses (forehead, eyeballs, nose) and sunken areas. But, on the other hand, he also relied on cleanly incised lines, betraying an approach that differs from that of the sculptor. The lines in this portion of the head are not traces of the process of carving, but have been incised on purpose, and possess a value and rhythm of their own. The wavy line, beginning with an arc rising above one eye, then dropping above the nose to rise again above the other eye, is an ornamental pattern, the value of which is not annulled by the curvature of the masses. As one sees on the photograph, this line is repeated several times at short intervals. The form of the eyes themselves is included in this ornamental pattern.

The independent value of line is further suggested by the three curious incisions on the lower right cheek. Again, these lines are not the initial stage of a more plastic carving, probably of a moustache: in this spot there is no mass left that would protrude from the face and permit deeper carving. The three incised lines, then, belong to what should be considered the "final stage" of the head.

The most interesting element of the face is the mouth. Although badly damaged, one can reconstruct its form and even infer the tools used in carving it. The mouth is placed slightly asymmetrically, tending more to the right, a feature which is further stressed by the fact that the left side of the chin is broken, and the lines of the moustache are visible only in the right. Although the corners of the mouth rise, the face in general, and the mouth in particular, bear not the expression of smiling or laughing. The corners of the mouth are the most deeply and neatly carved spots in the face. Since the head has been worn by long exposure to the weather, one cannot be sure as to the tools that have been used in carving it. On inspection however, it seems likely that here the sculptor used a rather wide drill. In the original state, the upper lip probably hung down at the center of the mouth, a feature often met with in European sculpture. On the right half of the face one still sees the

broad mass of the fleshy lower lip, reaching to the very corner of the mouth. The mass of stone in the center of the mouth, damaged but still clearly visible, represents the tongue; it is also asymmetrical, tending slightly to the right. The triangular shapes at the upper side of the mouth probably represent teeth. The hollows at the corners of the mouth emphasize the mass of tongue and teeth.

The hair is carved in long, regular strands, the whole mass of hair being further shaped in three great waves — as can be seen from the sides. The front-view does not betray anything of the luxuriance of the hair. Here it is no more than a narrow frame for the face. In the center of the lower lock on the left-hand side of the face one sees what is probably the mark of a drill.

The damage which the head has suffered does not permit to express any judgment as to the quality of the workmanship. It is true that one tends to think that, contrary to most of the works discussed so far, the present head is of rather poor workmanship (and this in spite of the fact that the artist was aquainted with such advanced techniques as the use of the drill). Thus, one notices a certain gap between the shaping of masses and the carving of lines. In the region of the eyebrows the shapes of masses and lines harmonize, but in the eyes themselves they sometimes diverge. The incised lines instead of a plastic representation of the moustache also betray a certain lack of consistency, which may be the result of poor workmanship falling back to primitive form. But, as already mentioned, the bad state of preservation does not enable us to express an opinion; much of what seems inconsistent and indicative of a lack of sureness of hand may have looked different when the head was complete and new.

In spite of these limitations, the head bears a powerful expression. In spirit and style it constitutes a mixture of realism and stereotyped formulae. The slanting position of the head (to be seen mainly in profile views) lends a psychological immediacy to the action of supporting. In this respect it recalls many Romanesque Caryatid-figures who seem to be permeated by stirring emotions, or who visually manifest the effort of supporting.[3] In the Acre head, even the open mouth and protruding tongue (a well-known traditional formula of a different meaning) seem to contribute to the expression of the effort made in supporting the console and the figure that originally stood on it. This immediacy of expression suggests an observation of nature, or at least

3 For Caryatid figures, cf. above, p. 22 ff.

the ability to give the work a "naturalistic" quality.

On the other hand, the slight distortion of the face, especially the form of the mouth, recalls not only famous physiognomic formulae, but many actual heads that are to be found in Romanesque art throughout Europe. Corbels of twelfth-century buildings, shaped in the form of heads that have significant features in common with the one in Acre, are so numerous and well known that only a few examples, selected at random, need be mentioned. To suggest an early example of this type I refer to the head of a "leering old woman" of Moissac.[4] Although differing from our head in many respects, the form of the mouth—that most prominent physiognomic motif—is somewhat similar. Both in Moissac and in Acre the raised corners of the mouth are round dimples and are the most deeply carved spots on the head, and in both places the upper lip is depressed in the middle, describing the form of twin arcs. A similar head, the most prominent feature of which is a pouting mouth, can be seen on the west inner wall of the porch in Moissac.[5] Romanesque art in southern France, and the neighboring regions of Spain, provides ample examples of heads which have this and other features in common with the head in Acre. A mask-like head supporting a console in the Cathedral of Salamanca,[6] although more clearly devilish and more closely adhering to traditional formulae than the head in Acre, probably belongs to its artistic ancestry. Looking at the head in Acre one is also reminded of the faces of devils and sinners in the representation of the Last Judgement at Conques.[7] The faces of these figures show, of course, the prominent feature of the open mouth. Remarkable in these faces are also the deeply grooved lines in the cheeks, representing wrinkles.[8] These wrinkles could easily have deteriorated into the lines we see in the Acre head.

In the Holy Land I have found no other console-supporting heads that could be closely related to the head of Acre. However, there is little doubt that many of them must have been carved in Crusader times.

4 Cf. Meyer Schapiro, "Romanesque Sculpture of Moissac," fig. 124, and p. 508.

5 *Ibid.*, fig. 108, left upper side.

6 Kingsley Porter, *Romanesque Sculpture of the Pilgrimage Roads*, ill. 738. See also the laughing face on a capital of Tarragone (Kingsley Porter, ill. 610) and perhaps also the devilish face on a capital of Santillana del Mar (Kingsley Porter, ill. 863).

7 Kingsley Porter, ills. 400 (the head between the devil and the sinner approaching the mouth of hell), 401 (the figure to the right).

8 Without intending to suggest any hypothesis as to the provenance of the head, I should like to mention that in the later history of Acre knights and pilgrims coming from these regions played an important part.

II

An additional head (figs. 49, 50), now in the Municipal Museum of Acre, is in such a poor condition that an adequate study of it is unfortunately impossible. Nevertheless, since it may bear some interesting historical testimony, it is here reproduced.

Figs. 49, 50

The head is about life-size. It is carved in a local sandstone, similar to that of the head discussed above, but of a slightly brighter hue. Nothing is known of the conditions under which it was discovered.

Its poor state of conservation suggests, at first glance, that we are faced with an unfinished piece of sculpture. Upon closer inspection, however, this impression cannot be sustained. Some parts of the head suggest a highly advanced stage of carving, or actually a finished state (cf. the eye in fig. 49, the mouth). The very delicate carving of the rather flat parts of the face, perceptible through the damage (cf. the cheek-bones, or the upper lid on fig. 49), proves, I think, that the head was finished. Even some particulars of the damage suffered indicate that the head was completed. The broken-off nose could certainly not have belonged to an unfinished state. One also notices that the lower part of the jaw is broken off (fig. 50), a feature which again cannot be explained by an unfinished state of the head but only as the result of destructive action.

Fig. 49

Fig. 50

The poor state of the head seems to stem from two different causes. As already mentioned, it is likely that this head, like so many others, was mutilated by the inconoclastic conquerors of the Latin Kingdom. However, the head must also have suffered erosion, possibly from being exposed for a long time to water (on the sea-shore?), which completed the destruction. The small and deep holes in the hair (upper left part of fig. 49) were probably drill marks widened and made irregular by the action of water. The softness of the stone certainly contributed to the process of destruction.

Fig. 49

Despite the mutilations inflicted by man and nature, a careful observation of the head may lead to some interesting, though necessarily general, conclusions. In the first place one notices the plastic conception of the head (clearly visible in the profile view, fig. 50). In fact, the proportion of depth here slightly exceeds that of height, a feature that points to the later thirteenth century. Romanesque heads, even if they have colossal skulls, are never so deep, and the artist obviously thinks in terms of flat surfaces.[9] Another element in the Acre head that points to the late thirteenth century is the treatment of the hair. Instead of the regular, parallel strands of the Romanesque pattern prevailing in the sculpture of the Latin Kingdom,[10] the hair of this head is shaped in large, deeply carved curls (fig. 49) which stand away from the face. A similar treatment of the hair is frequently encountered in different schools of French sculpture of the thirteenth century.[11] The head further shows the very short mouth with soft, fleshy lips, and the organic transition from the lips to the neighboring parts of the face that is so well known from many French Gothic figures from the middle of the thirteenth century onwards. In spite of bad mutilation, the naturalistic quality of the mouth can still be clearly felt.

Fig. 50

Fig. 49

All this evidence, certainly not conclusive, suggests that the head was created in the second half of the thirteenth century, perhaps by a French artist.

Did the head belong to a statue, or was it an isolated piece? No answer can be given to this question. On the head itself no helpful evidence can be discovered. With the broken away lower part any indication that might have been useful in answering this question has disappeared. Several isolated thirteenth-century heads, serving different purposes, are known in different regions of France. They are often executed in stone, and are about life-size.[12] However, the fact that the Acre head is a complete sculpture in the round may suggest that it was part of a whole figure or bust.

Nor can it be established whether the head has a religious meaning or is of a secular character. There are, of course, many angel-heads of that period similar in character to our head, but there are also many secular figures from that period of like appearance. Although it cannot be proved. I believe the head belonged to a secular figure.

9 See above, p. 168. And cf. also p. 83 ff.
10 See above, p. 168.
11 Cf. Marcel Aubert, *Description raisonée des Sculptures i, Moyen Age* (Paris, 1950), figs. 142, 145, 160.
12 *Ibid.*, figs. 119, 120–124 (decoration of lamps), 145, 149, 151, 159–162.

III

The historical significance of the heads is rather modest; they do not in any respect change our general conception of the Crusader art of that period. As one knows, Acre was the capital of the Latin Kingdom between 1192 and 1291, and new buildings were erected and probably decorated by Crusaders coming to the city from almost all parts of Christian Europe. The two heads, if they are indeed of the thirteenth century as seems to be the case, are an additional illustration of the fact that the Crusaders continued their artistic activity. But they also show that the artists working in the late Latin Kingdom did not reach the high artistic level and did not possess the high technical skill which characterized Crusader art in the preceding century. Needless to say, no conclusion can be reached on the ground of fragmentary finds. However, the dimension and ambition of the two heads is clearly more modest than those of the works created in the former century, the stone is cheaper, and the workmanship seems to be poorer. The only interesting insight, which, however, is a vague intimation rather than an actual knowledge, is a certain turn toward the secular. While Crusader art of the twelfth century is almost completely religious, the two thirteenth-century heads seem to reflect a more secular attitude, and a deeper interest in secular figures.

A CONCLUDING REMARK

A study of the kind presented in this book does not allow the author to write a concluding chapter, the works of art discussed being both too diverse and fragmentary for this purpose. Some of them are masterpieces of Romanesque sculpture while others are of a more modest quality. The overall picture we are able to form in studying them is far from complete. Further excavations may bring to light new works that may modify many of the opinions accepted at present. Obviously the time for summing up Crusader sculpture has not yet come, and any general statement is perforce vague and of a temporary character.

The works of art discussed in this book form a group only in a specific and external sense: they were found, and certainly produced, within the limits of a quite narrow area in the north of the Latin Kingdom, — the region extending from Acre on the Mediterranean seaboard, through Nazareth in the Galilee to Belvoir on the Jordan River. But, to stress this point again, in spite of the limited area, the works that have come down to us do not display a uniform character nor do they represent a specific Crusader style. They reflect different trends of style, which suggest they originated in different traditions of European sculpture. It seems certain that the sculptors who worked in the Latin Kingdom came from Europe as trained craftsmen, carrying with them, and perpetuating in the Holy Land, the models and customs of work acquired in their native countries. There is nothing to suggest that some of the works discussed were executed by local artists who brought in elements alien to, or differing from, the Western traditions. As far as figural sculpture is concerned, we cannot speak of "Crusader art" in the sense in which this term might be applied to manuscript illumination and icon painting. The figural sculpture of the Crusaders preserved a distinctly Western character.

The chronology of these works, which in most cases can be fairly

223

clearly established, is of some interest. Most of the works we have discussed were created during a rather short period of time, in the majority of cases the "seventies of the twelfth century." The short span of time may, indeed, explain the lack of unity. The works were carved, one imagines, by artists who were brought to the Latin Kingdom to decorate newly erected buildings. Contrary to illuminators and painters, they found no local tradition that could have induced them to change their style; neither did they have the time to blend the fully crystallized traditions they had brought with them. It is understandable that under such circumstances artists working in neighboring places did not create a common style.

It is precisely for these reasons, however, that the works discussed in the above pages are of significance for the study of twelfth-century sculpture. They sometimes provide precious insights into aspects of this art which is more difficult to study in Europe than in the Holy Land. Owing to the fact that in the latter so many unfinished works have survived, we have a rare chance of investigating the methods of carving.

An assessment of the place of these monuments in the history of medieval European art is a task for the future. However, what has so far been found in the Holy Land proves that Crusader sculpture was not a provincial art, lagging behind developments in the main centers of the period. Not only was Crusader sculpture contemporary in every sense with the sculpture of Western Europe, but the quality of some of the works created in the Latin Kingdom suggests that some of the established masters and great artists of the period must have come to the East to decorate the churches of the Christians in *Outre-mer*.

BIBLIOGRAPHY
AND INDEX

SOURCES

Augustinus, St.: Contra Faustum Manicheum Libri XXXIII. In: *Migne, P. L.,* 42, cols. 207–518.

Bruno Astensis: Expositio in Exodum. In: *Migne, P. L.,* 164, cols. 233–378. Expositio in Genesim. In: *Migne, P. L.,* 164, cols. 147–234.

Cyprianus, St., *Des Heiligen Kirchenvaters Caelcilius Cyprianus sämtliche Schriften,* Munich, 1918–1928. (Bibliothek der Kichenväter, 34,60)

Cyrillus, St., *Des Heiligen Cyrillus Bischofs von Jerusalem Katechesen.* Kempten, 1922. (Bibliothek der Kirchenväter, 41).

Delaborde, H.F., *Chartes de Terre Sainte provenant de l'Abbaye de N.D. de Josaphat,* Paris, 1880.

Delaville le Roulx, J.M.A., *Cartulaire général de l'Ordre des Hospitaliers de S. Jean de Jérusalem,* (1100–1310), 1894–1906.

Dionysius Areopagita, St., De ecclesiastica hierarchia. In: *Migne, P.G.,* 3, col. 370–584.

Durandus, Gulielmus, bp. of Mende, *Rationale divinorum officiorum,* Venetia, 1482.

Eusebius, *Ecclesiastical History.* Engl. ed. by H.J. Lawler and J.E. Leonard, New York, 1927.

Eusebius Pamphilus, bp. of Caesarea, *Praeparationis evangelicae libri XV,* Lipsiae, 1842–43.

Gollancz, H., *The Book of Protection being a Collection of Charms,* London, 1912.

Gregorius Turonensis episcopus, De miraculis S. Martini. In: *Migne, P.L.,* 71, col. 913–1008.

Gulielmus, arch. of Tyre, *A history of deeds done beyond the sea,* New York, 1943.

Guillaume de Tyr et ses continuateurs, Paris, 1879–80 (Hist. générale des croisades par les auteurs contemporains).

Hieronymus, St., Commentaria in Amos. In: *Migne, P.L.,* col. 989–1096.

Homerus, *The Iliad,* Ed. W. Leaf. Amsterdam, 1960.

Honorius Augustodunensis: Gemma animae liber I. In: *Migne, P.L.,* 172, col. 541–616.

Speculum Ecclesiae, In: *Migne, P.L.,* 172, col. 815–836.

Innocentius III: De sacro Altaris Mysterio Libri Sex. In: *Migne, P.L.,* 217, col. 775–914.

Isidorus, Hispalensis ep., De ecclesiasticis officiis. In: *Migne, P.L.,* 83, col. 737–826.

Jacobus de Varagine, *Legenda aurea vulgo historia Lombardica dicta.* Ed. Th. Graesse. Dresda, 1846.

James, M.R. (tr), *The Apocryphal New Testament,* Oxford, 1924.

Joannes Chrysostomus: In principium actorum. In: *Migne, P.G.,* 51, col. 63–112.

Leo Magnus, Sermo 49. In: *Migne, P.L.,* 54, col. 301–305.

Leonardo da Vinci, *Das Buch von der Malerei.* Ed. H. Ludwig. Vienna, 1882. (Quellenschriften für Kunstgeschichte und Kunsttechnik des Mittelalters, 15–17).

Origenes, Selecta in Psalmos. In: *Migne, P.G.,* 12, col. 1054–1686.

Pausanias, *Descriptio Graeciae.* Lipsia, 1900.

Plutarchus, *Vitae parallelae.* Lipsia, 1914–39.

Prudentius, Contra Symmachum. In: *Migne, P.L.,* 60, col. 174–276

Rozière, Eugène de, ed. *Cartulaire de l'Eglise du Saint Sépulcre de Jérusalem,* publié d'après les manuscrits du Vatican par Eugène de Rozière. Paris, 1849.

Sicardus: Mitrale seu De officiis ecclesiasticis summa. In: *Migne, P.L.,* 213, col. 13–136.

Tertullianus: De baptismo. In: *Migne, P.L.,* 1, col. 1197–1224.

Zeno Veronae, St., Tractatus. In: *Migne, P.L.,* 11, col. 253–528.

STUDIES

Adhémar, Jean, *Influences antiques dans l'art du Moyen Age français,*
London, 1939. (Studies of the Warburg Institute, 7).
La Madeleine de Vézelay. Melun. 1948.

Alberti, L.B., *Leone Battista Albertis kleinere Kunsttheoretische
Schriften,* Ed. Janitschek. Vienna, 1877.

Asin Palacios, Miguel, *Dante y el Islam.* Madrid, 1927.

Aubert, M., *Description raisonée des sculptures*... I, Moyen Age.
Paris, 1950.
La sculpture française du Moyen Age et de la Renaissance, Paris and
Brussels, 1926.

Bauerreis, Romuald, *Fons sacer:* Studien zur Geschichte des frühmittel-
alterlichen Taufhauses auf deutschschprachigem Gebiet, Munich, 1949.
(Abhandlungen der Bayerischen Benediktiner Akademie, 6).

Bayet, Ch., *Recherches pour servir à l'histoire de la peinture et de la
sculpture chrétienne en Orient, avant la querelle des iconoclastes,* Paris,
1879. (Bibliothèque des écoles françaises d'Athènes et de Rome, fasc.10).

Berefelt, Gunnar, *A Study of the Winged Angel;* the origin of a motif.
Stockholm, 1968.

Bertaux, E., *L'art dans l'Italie méridionale,* Paris, 1904.

Boase, T.S.R., *Castles and churches of the crusading kingdom,*
London, 1967.

Bologna, Ferdinando, *Early Italian painting.* London, 1963.

Braun, J., *Der christliche Altargerät in seinem Sein und seiner Entwick-
lung,* Munich, 1932.

Buchthal, H., *Miniature painting in the Latin Kingdom of Jerusalem,*
Oxford, 1957.

Burdach, K., *Reformation, Renaissance, Humanismus,* 2nd ed.
Berlin-Leipzig, 1926.

Cabrol-Leclercq, *Dictionnaire d'archéologie chrétienne et de liturgie,*
Paris, 1924–53.

Cecchelli, Carlo, Note iconographiche su alcune ampolle bobbiesi, *Rivista di archeologia cristiana,* 4/1927.

Conant, K.J., *Carolingian and Romanesque architecture:* 800–1200, Baltimore, Md., 1959. (Pelican history of art).

Crichton, G.H., *Romanesque sculpture in Italy,* London, 1954.

Cumont, F., *Etudes syriennes,* Paris, 1917.

Dahlmann, J., *Die Thomas-Legende,* Freiburg, 1912.

Deschamps, P., La sculpture française en Palestine et en Syrie à l'époque des croisades. In: *Monuments et Mémoires de Fondation Piot,* 31, pp. 91–118.

Dictionnaire des antiquités grecques et romaines, Ed. Daremberg-Saglio. Paris, 1877–1919.

Didron, M., *Iconographie chrétienne; Histoire de Dieu,* Paris, 1843.

Dvořák, Max, *Geschichte der italienischen Kunst im Zeitalter der Renaissance,* Munich, 1927–1928.

Einem, H. von, *Das Stützengeschoss der Pisaner Domkanzel,* Köln, 1962. (Arbeitsgemeinschaft für Forschung des Landes Nordrhein-Westfalen, Geisteswissenschaften, Heft 106).

Elbern, V.H., Der eucharistische Kelch im frühen Mittelalter, *Zeitschrift des deutschen Vereins für Kunstwissenschaft,* 17/1963, pp. 1–76, 117–188.

Enlart, C., *Manuel d'archéologie française,* 2nd ed. Paris, 1920. *Les monuments des Croisés dans le Royaume de Jérusalem;* architecture religieuse et civile. Paris, 1925–28.

Erich, Oswald, *Die Darstellung d. Teufels in der christlichen Kunst,* Berlin, 1931.

Francovich, Geza de, *Benedetto Antelami, architetto e scultore e l'arte del suo tempo,* Milan, 1952.

Garrucci, Raffaele, *Storia dell'arte cristiana nei primi atto secoli della chiesa,* Prato, 1880.

Gerke, F. *Griechische Plastik in archaischer und klassischer Zeit,* Zürich, 1938.

Der Tischaltar des Bernard Gilduin in St. Sernin in Toulouse, Wiesbaden, 1958. (Akademie der Wissenschaften und Literatur; Abhandlungen der Geistes- und Sozialwissenschaftlichen Klasse, 1958, 8).

Germer-Durand, J., "La sculpture franque en Palestine," Paris, 1911. *(Etudes palestiniennes et orientales. Conférences de Saint-Etienne,* 1910–1911).

Glaue, Paul, *Zur Geschichte der Taufe in Spanien,* Heidelberg, 1928.

(Sitzungsberichte der Heidelberger Akademie der Wissenschaften, Phil.- Hist. Klasse, 1927/28, Abh. 2).

Goldmann, Z. Crusader sculpture in the Municipal Museum of Acre, *Maaravo shel ha-Galil,* 1961, pp. 159–161 (in Hebrew).

The Hospice of the knights of St. John in Acco, *Archaeology,* 19/1966, pp. 182–189.

Gudiol i Ricart, Josep., *Arquitectura y Escultura Romanicas,* Madrid, 1948. (Ars Hispaniae; historia universal del arte hispanico, 5).

Heisenberg, A., *Grabeskirche und Apostelkirche,* Leipzig, 1908.

Heyd, W., *Histoire du commerce du Levant au Moyen Age,* Leipzig, 1923.

Jungmann, J.A., *Symbolik der katholischen Kirche,* Stuttgart, 1960. (Symbolik der Religionen, 6).

Katzenellenbogen, A., *Allegories of the Virtues and Vices in Medieval Art, from early Christian times to the 13th century,* New York, 1964.

Kautzsch, R., *Kapitell Studien; Beiträge zu einer Geschichte des spätantiken Kapitells,* Berlin, 1936.

Kenner, Hedwig, *Weinen und Lachen in der griechischen Kunst,* Vienna, 1960 (Sitzungsberichte der Österreichische Akademie der Wissenschaften; phil.-hist. Klasse, 234. Bd. 1, 2. Abh.).

Kitzinger, E., The Hellenistic heritage in Byzantine art: *Dumbarton Oaks Papers,* 17/1963, pp. 95–115.

Klauser, Th., "Engel" (in der Kunst), In: *Reallexicon für Antike und Christentum,* 5/1962, col. 258–322.

Koehler, W., *Die karolingischen Miniaturen,* I: *Die Schule von Tours,* Berlin, 1930.

Kraus, F.X., *Die Miniaturen des Codex Egberti in der Stadtbibliothek zu Trier,* Freiburg, i. Br., 1884.

Krautheimer, R., San Nicola in Bari und die apulische Architektur des 12. Jahrhunderts. *Wiener Jahrbuch zur Kunstgeschichte,* 9/1934, pp. 5–42.

Krücke, A., *Der Nimbus und verwandte Attribute in der frühchristlichen Kunst,* Strasburg, 1905. (Zur Kunstgeschichte des Auslandes, 35).

Ladner, G.B., Vegetation symbolism and the concept of Renaissance. In: *De artibus opuscula XL: Essays in honor of Erwin Panofsky,* ed. by Millard Meiss. New York, 1961.

Lawrence, Marion, *Sarcophagi of Ravenna,* New York, 1945. (Monographs on archaeology and fine arts, 2).

Mâle, E., *L'art réligieux du XIIe siecle en France,* 6th ed. Paris, 1953.

231

L'art réligieux du XIIIe siècle en France, Paris, 1910.

Manitius, M., *Die Geschichte der lateinischen Literatur des Mittelalters,* Munich, 1931.

Masolino, G., *Torcello: the Jewel of the Lagoon.* Venice, 1964.

Mayer, L.A., Saracenic Arms and Armour, *Arms Islamica,* 10/1943, pp. 1–12.

Mersmann, W., *Der Schmerzensmann,* Düsseldorf, 1952.

Michel, A., *Histoire de l'art depuis les premiers temps chrétiens jusqu'a nos jours,* Paris, 1905–1926.

Michon, E., Les sarcophages de Saint-Daussin des Soissons...In: *Melanges offerts à M.G. Schlumberger,* Paris, 1924, pp. 376–385.

Morey, Ch.R., *Early Christian art,* Princeton, 1942.

Müller, N., *Realenzyklopädie für protestantische Theologie und Kirche,* Leipzig, 1899.

Oakeshott, W., *Classical inspiration in Medieval Art,* London, 1959.

Paeseler, W., Giottos Navicella und ihr spätantikes Vorbild. *Römisches Jahrbuch für Kunstgeschichte,* 5/1941, pp. 51–162.

Panofsky, E., *Die deutsche Plastik des XI. bis XIII. Jahrhunderts,* Munich, 1924.

Early Netherlandish painting, Cambridge, 1953.

Renaissance and Renascences in Western Art, Stockholm, 1960.

Studies in Iconology, New York, 1939.

Pauly-Wissowa, *Real-Encyklopädie der klassischen Altertumswissenschaft,* Stuttgart, 1894–1967.

Petrucci, A., *Cattedrali di Puglia,* 2nd ed. Rome, 1964.

Porter, Arthur Kingsley, *Lombard architecture,* New Haven, 1917.
Romanesque sculpture of the pilgrimage roads, Boston, 1923.

Pradel, F., *Griechische und süditalienische Gebete, Beschwörungsformeln und Rezepte des Mittelalters,* Giessen, 1907. (Religionsgeschichtliche Versuche und Vorarbeiten, III, Heft 3).

Prawer, J., "The history of the Fortress Kaukab el-Hawa-Belvoir," *Yediot bahaqirat Eretz-Israel weatiquoteha,* 31/1967, pp. 236–249 (in Hebrew).

Raby, F., *A history of Latin Christian poetry from the beginnings to the close of the Middle Ages,* Oxford, 1927.

Réau, L., *Iconographie de l'art chrétien,* Paris, 1955–59.

Reinach, S., Le rire rituel. *Cultes, mythes et religions,* 6, Paris, 1912, pp. 109–129.

Salvini, R., *Wiligelmo e le origini della scultura romanica,* Milan, n.d.

Sauer, J., *Symbolik des Kirchengebäudes und seiner Ausstattung in der Auffassung des Mittelalters,* Freiburg, 1902.

Saxl, F., Atlas der Titan im Dienste der astrologischen Erdkunde, *Imprimatur,* 4/1933.

English sculpture of the Twelfth Century, London, 1954.

Schapiro, Meyer, From Mozarabic to Romanesque in Silos, *Art Bulletin,* 21/1939, pp. 313–374.

The Parma Ildefonsus; a Romanesque illuminated manuscript from Cluny and related works, New York, 1964. (Monographs on archaeology and fine arts, sponsored by the Archaeological Institute of America and the College Art Association of America, 11).

A relief in Rodez and the beginnings of Romanesque sculpture in Southern France. In: *Studies in Western Art; Acts of the Twentieth Congress of the History of Art,* Princeton, 1963, v. 1, pp. 40–66.

The Romanesque sculpture of Moissac, *Art Bulletin,* 13/1931, pp. 249-352, 464–531.

The sculptures of Souillac; In: *Medieval studies in memory of A. Kingsley Porter,* Cambridge, Mass., 1939, v. 2., pp. 359–387.

Schaube, W., *Handelsgeschichte der romanischen Völker des Mittelmeergebiets bis zum Ende der Kreuzzüge,* Munich-Berlin, 1906.

Schlee, E., *Die Ikonographie der Paradiesesflüsse,* Leipzig, 1937. (Studien über christliche Denkmäler, N.F., Heft 24).

Schlosser, J., *Schriftquellen zur karolingischen Kunst,* Vienna, 1892.

Schrade, H., Frühchristliche und mittelalterliche Kunst: ein Literaturbericht (ii). *Deutsche Vierteljahrsschrift für Literaturwissenschaft und Geistesgeschichte,* 7, Heft II, 1929, pp. 348–422.

Seznec, J., *The survival of the pagan gods . . .,* New York 1953. (Bollingen series, 38).

Seymour, C., XIIIth century sculpture at Noyon and the development of the Gothic caryatid, *Gazette des beaux arts,* 26/1944, pp. 163–182.

Sybel, Ludwig von, *Christliche Antike,* Marburg, 1906–09.

Thiele, G., *Antike Himmelsbilder,* Berlin, 1898.

Tikkanen, J.J., *Die Beinstellung in der Kunstgeschichte: ein Beitrag zur Geschichte der Künstlerischen Motive,* Helsingfors, 1912.

Toesca, P., *Storia dell'arte italiana,* v. 1: Il Medioevo, Turin, 1927.

Underwood, P.A., The fountain of life in manuscripts of the Gospels, *Dumbarton Oaks Papers,* 5/1950, pp. 41–138.

Viaud, P., *Nazareth et ses deux églises,* Paris, 1910.

Viollet-le-Duc, E.E., *Dictionnaire raisonné de l'architecture française du*

XIe au XVIe siècle, Paris, 1867–73.

Wackernagel, M., *Die Plastik des XI. und XII. Jahrhunderts in Apulien,* Leipzig, 1911.

Watzinger, C. & Wulzinger, K., *Damaskus die antike Stadt,* Berlin, 1921.

Weitzmann, Kurt, The classical in Byzantine art as a mode of individual expression. In: *Byzantine art–an European art,* Athens, 1964, pp. 151–177.

Icon painting in the Crusader Kingdom, *Dumbarton Oaks papers,* 20/1966, pp. 51–83.

The Joshua Roll–a work of the Macedonian Renaissance, Princeton, 1948.

Thirteenth century crusader icons on Mount Sinai, *Art Bulletin,* 45/1963, pp. 179–203.

Wirth, K., "Engel"; In: *Realenzyklopädie zur deutschen Kunstgeschichte* 5, col. 341–555.

INDEX

235

236

237